# GUSTAV KLIMT.

## IN SEARCH OF THE "TOTAL ARTWORK"

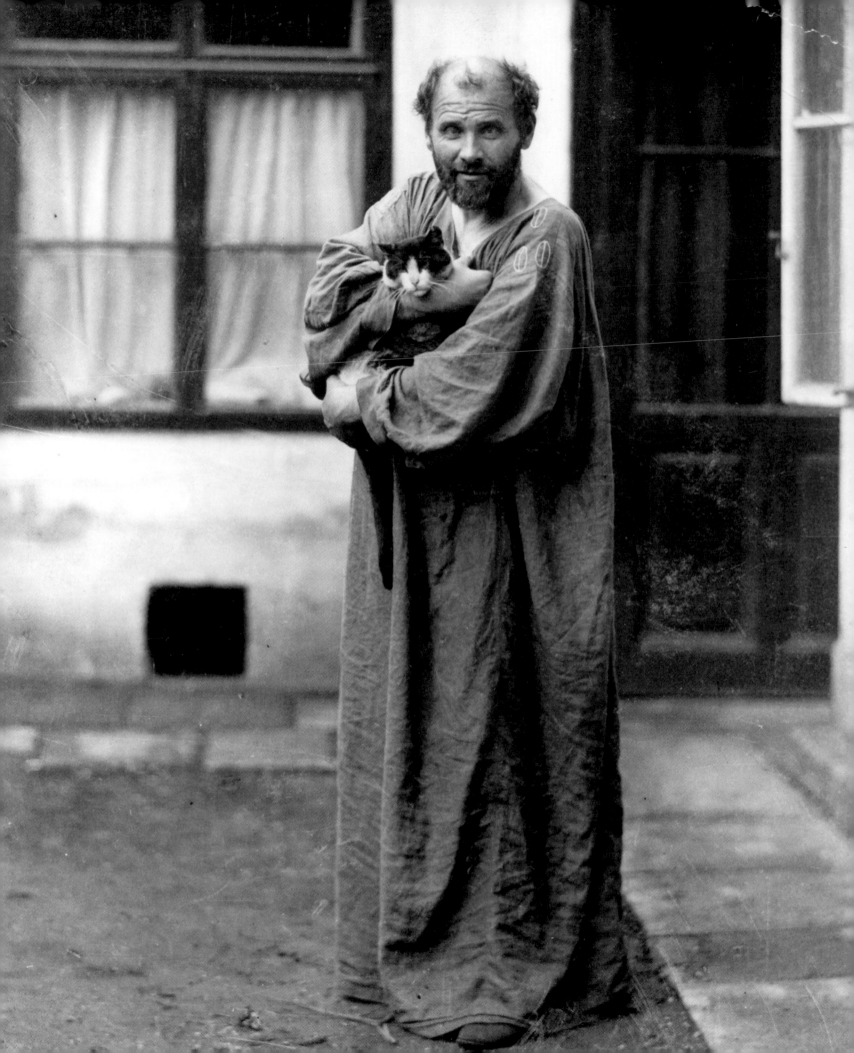

# GUSTAV KLIMT.
## IN SEARCH OF THE "TOTAL ARTWORK"

EDITED BY JANE KALLIR,
CO-EDITED BY ALFRED WEIDINGER

PUBLISHED UNDER THE AUSPICES OF
ÖSTERREICHISCHE GALERIE BELVEDERE, WIEN

HANGARAM ART MUSEUM, SEOUL ARTS CENTER, SOUTH KOREA
FEBRUARY 1 – MAY 15, 2009

**PRESTEL**

MUNICH · BERLIN · LONDON · NEW YORK

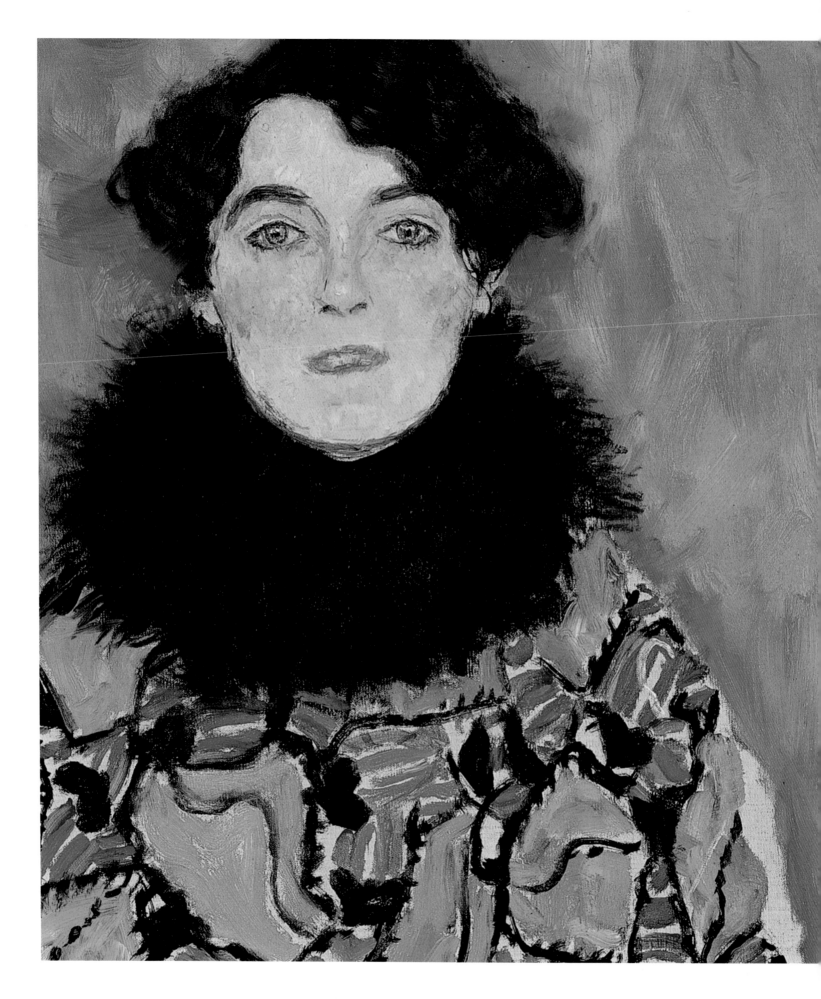

# CONTENTS

## ESSAYS

## PLATES

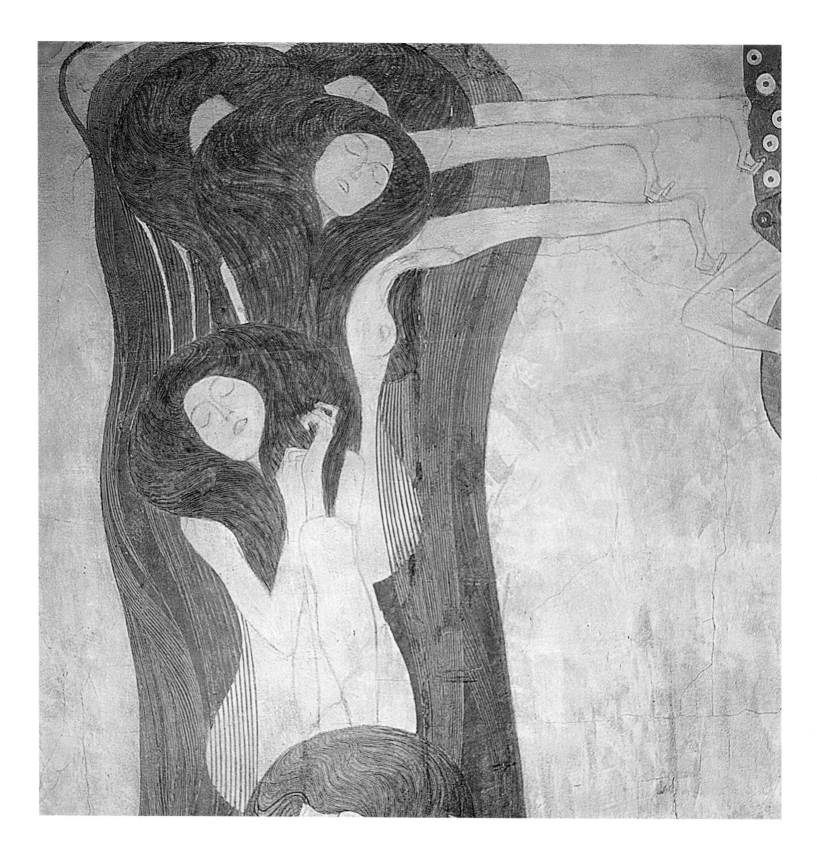

**Beethoven Frieze – Reconstruction of the 1903 Installation at
the Vienna Secession (Detail: The Arts), 1901–02**
Casein, gold pigment, black and colored chalk, graphite, stucco
and various materials (glass, mother of pearl, gold) on plaster,
full length: 34,14 m (13,92 x 6,30 m), height: 2,15 m,
Belvedere, Vienna

# FOREWORD BY TEIT RITZAU, DIRECTOR OF ARTEG

■ "To the Age its Art, to Art its Freedom" was the motto of the
■ Vienna Secession, founded in 1897 with Gustav Klimt as its
first President. The Secession's members, who included the
most renowned Austrian artists of the early 20th century, tried to
build a modern bridge between art and a rapidly changing world.
One of the most striking and provocative of several means to this
end was the forthright depiction of nudity in paintings and draw-
ings. For Klimt and others in Vienna, the female – in all her
so-called "Naked Truth" – stood at the center of a battle for a more
modern and liberal society. To today's audiences, this may well
be the most striking legacy of Klimt's art and life. But Klimt, who
has been called "the visual spokesman of his era", was a multifa-
ceted painter who mastered it all – from classical academic paint-
ing to the most direct and intimate drawings – with an incredible
attention to skill, design and detail.

The present exhibition is the most comprehensive – and only –
major retrospective that has ever been staged of Gustav Klimt's
work, not only in South Korea but in all of Asia. In addition to
exploring all aspects of Klimt's achievement as a painter and
draftsman, the exhibition recreates the framework of "Vienna
1900": a place and a time when artists tried to erase the tradi-
tional separation between the fine and the applied arts and create
a "Total Artwork" instead. Three major installations illustrate the
concept of the "Total Artwork": Klimt's monumental and famous
Beethoven Frieze, originally displayed at the Secession in 1902,
and the Wiener Werkstätte and Poster Rooms, both from the
1908 *Kunstschau*. Klimt's influence on the younger generation is
highlighted in a room dedicated to contemporaries such as Egon
Schiele, Oskar Kokoschka and Koloman Moser.

Many of the major Klimt paintings, as well as the special instal-
lations, were brought to Seoul courtesy of the Belvedere in Vien-
na. Other great museums and collectors from around the globe
also contributed to our exhibition, enabling us to present the
most important aspects of Gustav Klimt's work throughout his
life. Given that there are no more than 200 or so Klimt paintings
existant worldwide, many of which are too fragile to travel, this
was a Herculean task that would have been impossible without
the cooperation of numerous individuals. We are especially
grateful to our partner in this project, the Belvedere in Vienna
(represented by its Director, Agnes Hüsslein Arco, and Dr. Alfred
Weidinger); to our curators, led by Jane Kallir of the Galerie
St. Etienne in New York; to my friend Nikolaus Barta for his con-
tinuous support; to all the museums and private lenders that
agreed to lend their priceless artworks; and to the staffs of MHHD,
Donga Daily and ARTEG, all of whom had to endure much hard-
ship to achieve the final result.

**The Wiener Werkstätte Room**
Reconstruction of the Installation
at the "Kunstschau 1908."
Belvedere, Vienna, 2008/09

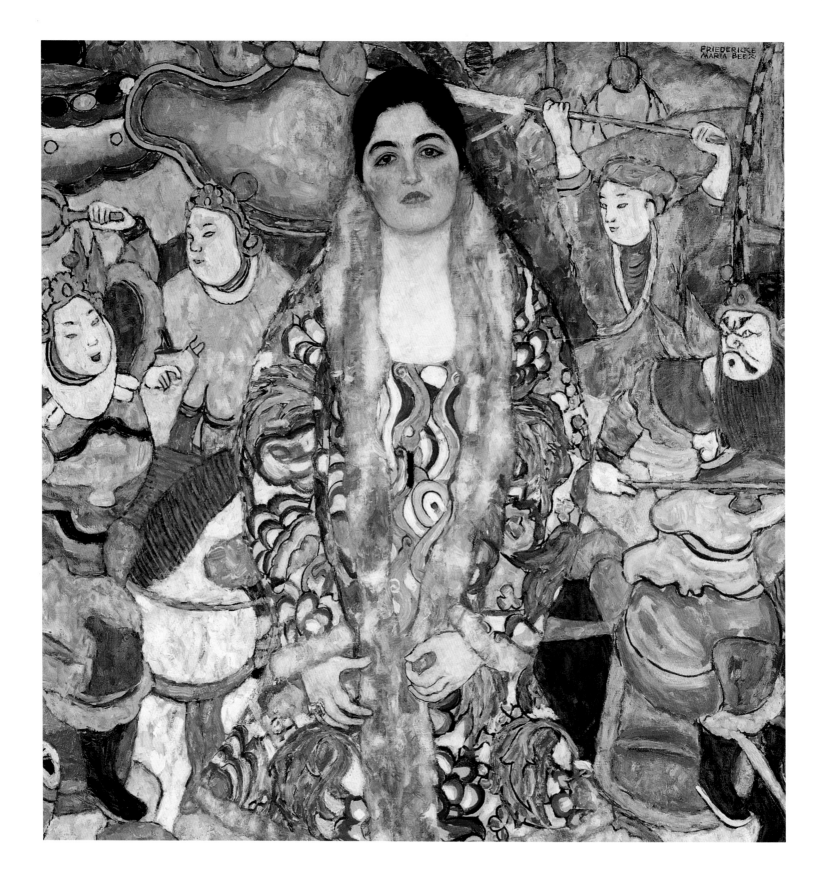

**Friederike Maria Beer-Monti,**

**Detail, 1916**

Oil on canvas, 168 x 130 cm,

Mizne Blomental Collection,

Tel Aviv Museum of Art

# FOREWORD BY ALFRED WEIDINGER

■ Vienna in 1900: a synonym for contrasts – on the one
■ hand, a multi-racial state which was slowly disintegra-
ting, dominated by conservative powers whose aim was
the preservation of the status quo, and on the other a society
permeated by innovative currents in the fields of sciences, art
and culture. These two poles may not have supported each
other, but they tolerated each other and were perhaps even de-
pendent on each other to some extent. And so Sigmund Freud
was regarded as the forerunner of psychoanalysis; intellectuals
like Hugo von Hoffmansthal, Karl Kraus and Arthur Schnitzler
conquered the field of literature; and in the world of music,
personalities like Arnold Schönberg and Gustav Mahler shaped
the cultural scene. At this time, too, architecture blossomed
forth in a new golden age; the names of Josef Hoffmann and
Adolf Loos are just two representatives of the discipline. What
Schönberg achieved in music was supplied by Wittgenstein in
philosophy. The fine arts were dominated by the triumvirate
of the *Wiener Moderne*: Gustav Klimt; the expressive Oskar
Kokoschka; and Egon Schiele. The various currents and influ-
ences clearly formed a highly sensitive and fertile environment,
a breeding ground for new developments.

Austria is famous in Asia above all for its music, but is also
very popular for its Art Nouveau. Conversely, it is also true that
the influence of East Asian art can be clearly seen in the works
of Gustav Klimt. After the presentation of over 200 Japanese
objects at the World Exhibition in Vienna in 1873, the entire
land was caught up in a craze for all things Asian. Restaurants
and festivals appeared with Asian themes, and applied arts
and graphics attempted to adapt the ornamental creations of
East Asian art. Even successful artists took an interest in art
from Asia, and it was very much *en vogue* to own a few such
works oneself. Gustav Klimt, too, owned a small but not unim-
portant collection of Asian artifacts. One of the suppliers was

the famous art dealer and the founder of Japonism in Europe,
Samuel Bing, whom Klimt met personally at the World Exhibi-
tion in Paris in 1900. In Gustav Klimt's later portraits of wom-
en in particular, the influence of Asian art on both his style
and his choice of subject is obvious. Especially, for example, in
the portrait of Friederike Maria Beer (1916), which depicts war-
like scenes in the background based on a Korean vase from the
Koguryo period. The present exhibition, the first of its kind in
the Far East, is thus a welcome reunion of cultures.

Guandi, the God of Wealth, with
Guan Ping and Zhon Cang, Qing
Dynasty, end of 19th century
Watercolor and gouache on paper,
170 x 91 cm, private collection,
(Estate of Gustav Klimt)

# ESSAYS

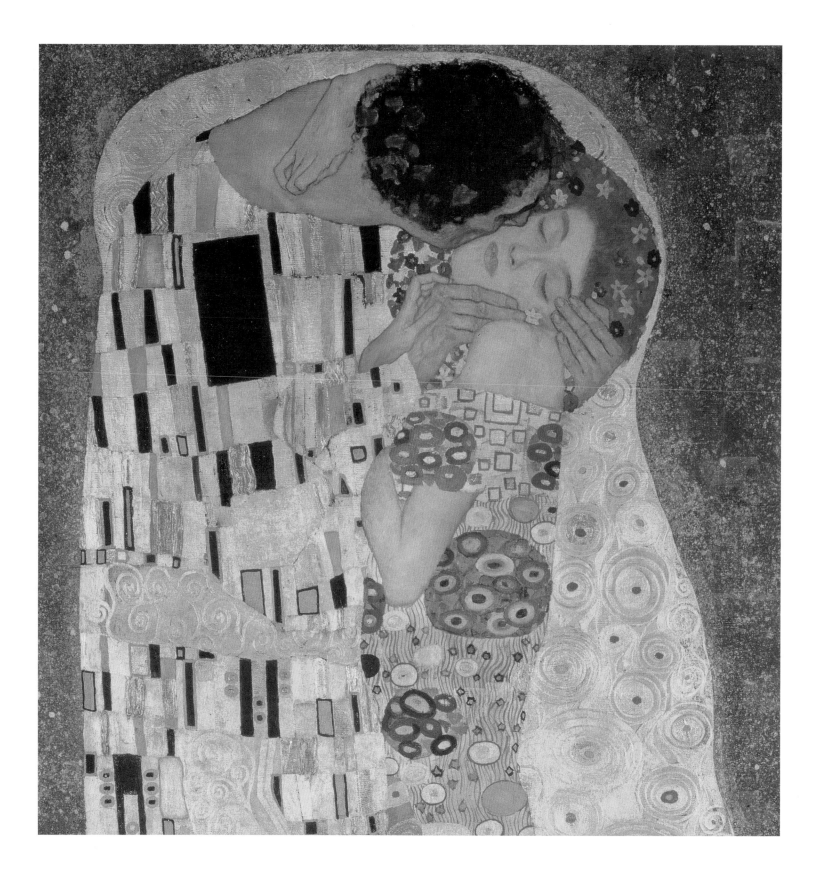

1

**The Kiss, Detail, 1908**

Oil on canvas, 180 x 180 cm,

Belvedere, Vienna

# GUSTAV KLIMT:
# A VANISHED GOLDEN AGE BY PETER SELZ

■ Gustav Klimt's art – glittering, yet restless; sensual and erotic, but apprehensive – was the product of an overripe
■ civilization prior to its downfall. Klimt, a brilliant painter, was the visual spokesman of his era.

Vienna at the turn of the twentieth century was a commanding focal point of European culture. The Habsburg emperor of the Austro-Hungarian dual monarchy presided over a realm that extended from the Italian to the Russian borders and included populations of Germans, Hungarians, Czechs, Slovaks, Italians, Poles, Slovenes, Croats, Bosnians and Jews. The elaborate bureaucracy that ruled over this uneasy multicultural conglomeration permitted only a limited amount of freedom of expression. "Everything about our thousand-year-old Austrian monarchy appeared grounded upon eternity, the State itself the ultimate guarantor of continuity ... Anything radical, anything violent seemed impossible in this Age of Reason," wrote the novelist Stefan Zweig, exiled to Brazil and nostalgic for a vanished era, shortly before he committed suicide in 1942. This apparent stability was a great illusion. The Habsburg Empire broke asunder after World War I. Before the Great War, however, Vienna was the domicile of a fertile and vibrant culture of major artists and intellectuals, men who were to leave an important imprint on the history of the mind.

There were the writers. The poet Hugo von Hofmannsthal hoped that aesthetic beauty might bring harmony to the inescapable devastation of the old aristocratic culture, writing, "We must take leave of a world before it collapses." Arthur Schnitzler authored psychodramas in which free sexual relations broke down social hierarchies. Sigmund Freud hailed Schnitzler as an esteemed colleague. Freud, the inventor of psychoanalysis, revealed the activity of the libido as the source of sexual desire and creative energy. As a scientist, he offered rational explanations for the irrational.

Freud's willingness to discuss sex openly found an echo in Klimt's drawings and certainly in the artist's libertine lifestyle. Among the writers was also the provocative satirist Karl Kraus, who had a more negative outlook. A spokesman for purity in language, Kraus attacked the hypocrisy and corruption of the Empire, which he called an "experimental station for the collapse of mankind."

Vienna also took the lead in architecture. Josef Hoffmann, a great advocate of unity between the arts and crafts, co-founded the Wiener Werkstätte in 1903 and became Klimt's collaborator on several projects. Otto Wagner, a significant early city planner and architect, simplified the design of buildings. This more functional approach was carried forward by Adolf Loos, who helped inaugurate the International Style, and who protested against the ornamentation that was an essential element of Klimt's enterprise. In music, Gustav Mahler's great harmony, composed to "resume the music of the spheres," would be contravened by Arnold Schoenberg's breakthrough to dissonance and atonality. And in painting, Oskar Kokoschka and Egon Schiele turned from Klimt's ornamental symbolism to a more subjective, intense and modernist Expressionism.

Gustav Klimt represented the summit of a culture which was soon to be bygone. He was the painter of Vienna's Golden Age. Born in 1862, he came from the lower bourgeoisie – his father was an engraver. Klimt underwent a traditional training at the Kunstgewerbeschule (School of Applied Arts), where he acquired a good knowledge of the history of art. Having completed his studies, he received commissions for architectural decoration together with his brother Ernst, including the grand staircase of Vienna's famed Burgtheater (fig. 2, page 21) on the Ringstrasse (then newly built, and including an extraordinary array of monumental buildings). At the same time, Klimt also produced traditional portraits, allegorical paintings, and fine drawings.

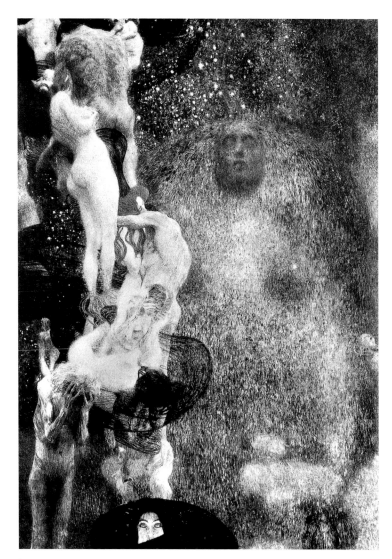

2

**Philosophy, 1899–1907**

Oil on canvas, 430 x 300 cm; signed, lower right;
ceiling painting for the Auditorium at the University of Vienna.
Destroyed by fire at Schloss Immendorf, 1945

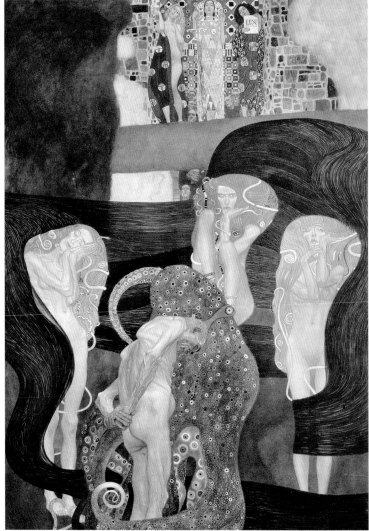

3

**Jurisprudence, 1903–1907**

Oil on canvas, 430 x 300 cm; signed, lower right;
ceiling painting for the Auditorium at the University of Vienna.
Destroyed by fire at Schloss Immendorf, 1945

In 1897, together with other progressive artists and the proto-modern architects and craftsmen, he founded the Vienna Secession, of which he became president. In 1898 the Secessionists built their own building, inscribed with the motto: "Give our time its art and art its freedom." The Secession also published its own journal, *Ver Sacrum* (Sacred Spring). Klimt produced striking illustrations and posters for *Ver Sacrum* and the Secession (plates 99, 100 and 102), which were exhibited all over Europe.

Having established an important reputation, Klimt was commissioned by the Ministry of Education to create paintings depicting the faculties of *Philosophy* (fig. 2), *Medicine* (fig. 3, page 44) and *Jurisprudence* (fig. 3) for the ceiling of the ceremonial hall of the new Beaux-Arts University building. He decided to do

this by means of allegories, and in the spirit of Enlightenment show the victory of light over darkness. But heaven and earth become entangled in these murals. The public did not like what they saw when paintings were shown at the Secession gallery. The professors could not understand Klimt's personal and somewhat arcane iconography. There were all these figures, some nude, huddled together, twisting in limbo or floating in space. The debate about the murals went as far as Parliament. Eventually, the painter annulled his contract and even offered to repay any funds he had received. One of the panels received a gold medal at the Paris World's Fair in 1900. The canvases, subsequently acquired by a private collector, were stored at an Austrian castle that was burned to the ground in 1945 by retreating SS troops.

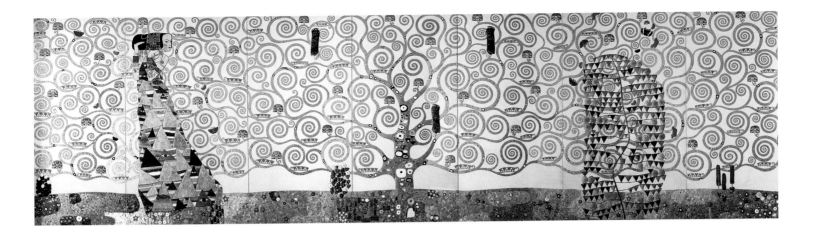

4

**Stoclet Frieze, Left Wall: Expectation, 1910**

Mixed technique, 200 x 738 cm,

Palais Stoclet, Brussels

In 1902 the artist embarked on a new project, the *Beethoven Frieze* (plates 20, 20a and 21), which was to be part of a special Secession exhibition celebrating the composer. For this *Gesamtkunstwerk* (total artwork), the famed German artist Max Klinger created a Wagnerian statue of Beethoven (fig. 10, page 26), which was unveiled at a performance of the composer's "Ode to Joy" from the Ninth Symphony, conducted by Gustav Mahler. The French sculptor Auguste Rodin came to Vienna and visited the exhibition in Klimt's company. Klimt's *Beethoven Frieze* was a large composition occupying three walls, decorated with gold and semi-precious stones. The frieze, with its alternation of figure and void, was a visual transcription of the ideas and emotions of the choral piece. Departing from naturalistic representation, the artist pictured the solemnity of the music. An embracing naked couple in the frieze anticipates the figures in the *Stoclet Frieze*.

In 1905 Klimt accepted one more grand commission, which was to decorate the dining room of the Palais Stoclet in Brussels, another *Gesamtkunstwerk* designed by Klimt's friend and Secession colleague, Josef Hoffmann. There were no financial constraints on the Stoclet commission, so Klimt was able to use gold, semiprecious stones, faience, mosaic and coral for his frieze. In keeping with the planar wall surface, the artist eliminated any three-dimensional illusion in his design (fig. 4).

The three motifs – the tree of life, the dancer, and the embrace – are subordinated to a flat ornamental composition of curves, volutes and arabesques. Klimt's talent for the ornamental finds full expression in the "Oriental splendor" of the abstract surface of the frieze. On the left, embroiled in the décor, *Expectation* looks toward *Fulfillment* (figs 14 and 15, page 29). In the latter, male and female are

ornamentally melded into a single figure, an icon that found its culmination in Klimt's world-famous canvas *The Kiss* (figs. 1 and 5).

In 1889, before he embarked on the University murals and while still in his twenties, the artist painted *Moving Water* (plate 17). The evocative display of undulating, sinuous forms in this picture is the very essence of Art Nouveau (called Jugendstil in Germany and Secessionsstil in Austria). Klimt also turned to allegory in his famous *Judith* of 1901 (plate 19). He depicts the Old Testament widow who the freed the Israelites by ingratiating herself with the Assyrian general Holofernes and then decapitating him. Eyes half-shut, lips open, half naked, Judith is the sensual femme fatale, more courtesan than heroic woman. Her hand strokes the disembodied head of Holofernes, which is barely visible on the lower right. To enhance the display, she is surrounded by rich golden decoration.

Early in his career Klimt painted portraits in a realist manner (plates 1 to 5), but after the turn of the twentieth century he created a uniquely individual, sumptuous style to depict the refined ladies of the upwardly mobile Viennese bourgeoisie. He might use Asian wall hangings as decorative backdrops, or, in what became known as his "Golden style," ensconce realistic portrait heads and hands in a shell of golden ornament. Sometimes the body all but vanishes into an exuberant display of silver and gold, as in the famed Portrait of *Adele Bloch-Bauer I* (fig. 7), recently acquired by the Neue Galerie New York. The dexterity with which Klimt's portraits are painted and the luxury and preciousness of these likenesses affirmed the subjects' aura of high social standing and accounts for their enduring appeal.

Gustav Klimt was also a remarkable painter of landscapes, which his brush transformed into carpets of color (plates 26–29).

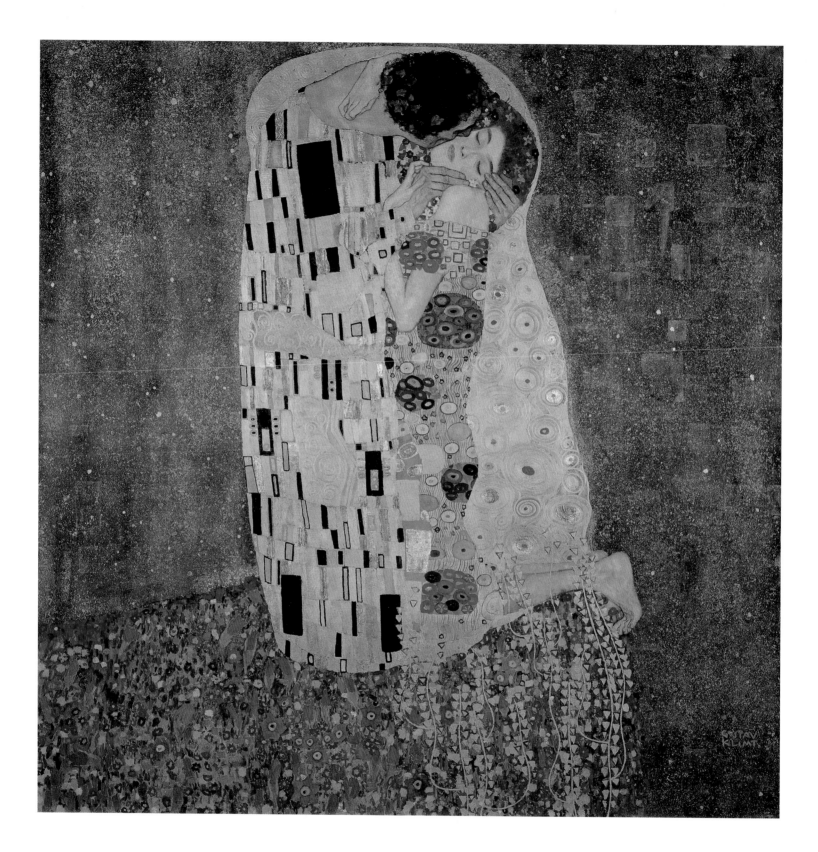

**5**

**The Kiss, 1908**

Oil on canvas, 180 x 180 cm,

Belvedere, Vienna

There are no people and little air to disturb the dense areas of calm in these gardens. Square in format, most of the landscapes have a high horizon line that shuts out any reference to a world beyond. With their lack of spatial depth, they can be seen as belonging to the modernist code of affirming the picture plane.

In 1917 Gustav Klimt, now at the height of his reputation, was elected to honorary membership in the academies of fine arts in both Vienna and Munich. Like other Symbolist painters at this time – Paul Gauguin in France, Edward Munch in Norway, Ferdinand Hodler in Switzerland – he became interested in depicting the cycle of life, as exemplified by *Death and Life* (fig. 6) and *Adam and Eve* (plate 31). In the latter, the woman has shed all ornamental garments and appears entirely naked, leaning for protection against Adam, who stands behind her. Both figures tilt their heads to the left and appear to question their destiny.

A year before he died in 1918, Klimt painted *Baby* (plate 32), a picture in which the child's head is virtually submerged in a labyrinth of decorative blankets and pillows. The painting is an opulent arrangement of colors, tending toward abstraction, but still held in the realm of the real.

Gustav Klimt's work can be seen as the culmination of a long tradition of European art, going back to the Byzantine. But the

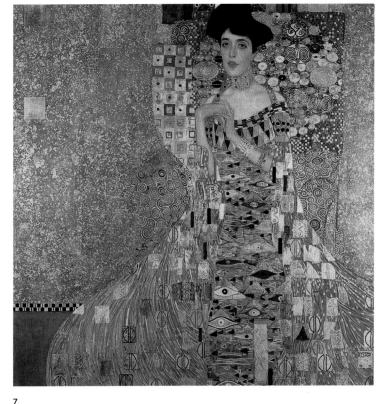

7

**Adele Bloch-Bauer I, 1907**

Oil, silver, and gold on canvas, 138 x 138 cm,

Neue Galerie New York. This acquisition made available in part through the generosity of the heirs of the Estates of Ferdinand and Adele Bloch-Bauer

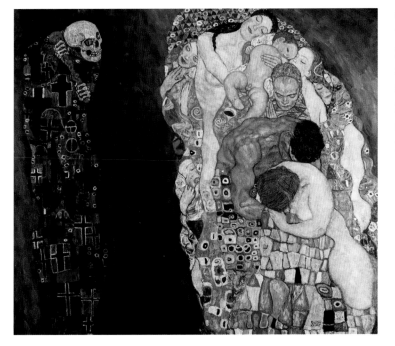

6

**Death and Life, 1910–11, reworked 1916**

Oil on canvas, 178 x 198 cm,

Leopold Museum, Vienna

structure of the "Old World" embodied in this master's decorative harmonies was about to be shattered. The Expressionists – painters like Oskar Kokoschka and Egon Schiele (plates 130 and 132), who had great respect for the older artist – were among the animators of this fracture. Along with other artists, writers and intellectuals, they had become painfully aware of the profound alienation that permeated all aspects of life beneath the masks of progress, prosperity and ornamentation.

1

**Fritza Riedler, 1906**

Oil on canvas, 153 x 133 cm; signed and dated, lower right,

Belvedere, Vienna

20

# IN SEARCH OF THE "TOTAL ARTWORK": KLIMT, THE SECESSION AND THE WIENER WERKSTÄTTE BY JANE KALLIR

Gustav Klimt, the foremost painter of *fin-de-siècle* Vienna, was many things to a great many people: award-winning public muralist; co-founder of the Vienna Secession; leader of his generation of fine and applied artists; darling of *nouveau-riche* society; inspiration to the younger Expressionists. Yet while Klimt's oeuvre, which includes ambitious allegories, sumptuous portraits and serene landscapes, may seem far-ranging, it is in fact unified by the Austro-Germanic concept of the *Gesamtkunstwerk*. The ideal of the *Gesamtkunstwerk*—or total artwork—was a response to the socio-economic upheavals of the nineteenth century. A broad-based philosophical attempt to impose order on an inherently chaotic, frightening world, the *Gesamtkunstwerk* combined a utopian quest for unity with a Romantic belief in the artist as a quasi-spiritual leader. Its manifestations ranged from the practical reintegration of design and manufacturing (which had been separated by industrialization) to totalitarian political ideology.

The German composer Richard Wagner established the theoretical underpinnings of the *Gesamtkunstwerk* in a series of essays written between 1849 and 1851. He believed that the desired level of unity could only be achieved if artists learned to master several skills or, alternatively, if they subordinated themselves to a single overriding concept. Wagnerian opera, melding drama, literature, music, set design and so forth, was an attempt to address this issue.

In the visual arts, architecture was the mother of the *Gesamtkunstwerk*, and one of the first Austrian expressions of the concept may be seen in the string of public edifices built along Vienna's Ringstrasse in the late nineteenth century. Echoing the unity of conception found in Gothic cathedrals, these structures were decorated with monumental interior murals, and while no single maestro called the shots, common recourse to historical styles and motifs served as a coordinating filter.

## : SETTING THE STAGE: TRAINING AND EARLY CAREER

Gustav Klimt, the son of a poor Bohemian goldsmith, was heir not only to the legacy of the Ringstrasse, but to the *Gesamtkunstwerk* tra-

2

**Shakespeare's Theater, 1886–1888**

Oil on plaster, c. 280 x 400 cm,
ceiling painting in the southern staircase
of the Burgtheater, Vienna

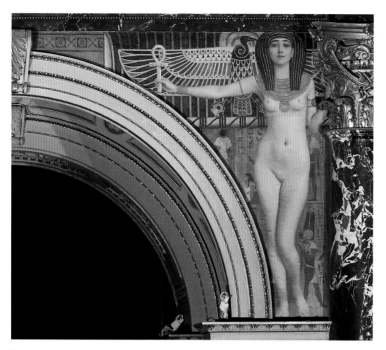

**3**

**Egyptian Art I, Girl with Horus and Thot in the Background, 1890–1891**

Oil on plaster, c. 230 x 230 cm; signed, upper left; spandrel painting in the
staircase of the Kunsthistorisches Museum, Vienna

dition exemplified by its majestic buildings. Educated not at the
prestigious Vienna Academy of Fine Arts, but at the more commer-
cially oriented Kunstgewerbeschule (School of Applied Arts), Klimt
was exposed to a progressive curriculum that gave equal weight to
crafts and the "high" arts of painting, sculpture, and architecture.
While still in school, he established a formal workshop together
with his younger brother Ernst (who entered the Kunstgewerbe-
schule the following year) and another fellow student, Franz
Matsch. The so-called *Künstler-Compagnie der Gebrüder Klimt und Matsch*
(Artists' Company, Klimt Brothers and Matsch) was soon receiving
commissions to design curtains and murals for provincial theaters
(plate 9). Before too long, the trio came to be seen as the natural
successors to Hans Makart, Vienna's foremost muralist.

Shortly before Makart's premature death in 1884, the *Künstler-
Compagnie* was invited to help complete one of his last, unfinished
projects: the murals for the quarters of the Empress Elisabeth at
the Hermesvilla in the Lainzer Tiergarten. This prestigious com-
mission helped the young artists secure their first major Vien-
nese assignment: a cycle of paintings for the new Burgtheater
(fig. 2; plates 34 and 35). Klimt received the Emperor's Golden Or-
der of Merit for his contributions to this project in 1888, and a sec-
ond prominent commission in the Imperial capital followed soon
thereafter: In 1890 the *Künstler-Compagnie* was asked to complete
the staircase decorations for the Kunsthistorisches Museum, an-
other of Makart's unfinished efforts (fig. 3).

Gustav Klimt's career was derailed from this promising, if rel-
atively conventional, track by the sudden death, in 1892, of
his brother and partner Ernst. Gustav entered a period of ar-
tistic withdrawal that strained his relationship with Franz
Matsch more or less to breaking point. Nevertheless, in 1893 the
*Künstler-Compagnie*'s two surviving partners agreed to share one fi-
nal assignment, a series of murals for the University of Vienna.
The commission entailed the production of a series of canvases
depicting various University faculties, which were to be installed
on the ceiling of the school auditorium. Working independently
from Matsch on his three given subjects, *Philosophy* (fig. 2, page
16), *Medicine* (fig. 3, page 44) and *Jurisprudence* (fig. 3, page 16), Klimt
produced a group of images that precipitated a scandal unlike
anything ever before experienced in the staid Imperial capital.
University professors and art critics alike were befuddled by the
paintings' absence of mollifying historical or literary references,
and appalled by the nudity and in some cases blatant ugliness
of the figures. After enduring years of protracted protests, Klimt
finally renounced the commission in 1905.

Klimt's changing allegiances were further evidenced by his roles
in the founding of the Vienna Secession in 1897, and the Wiener
Werkstätte in 1903. Though both organizations encompassed a
variety of stylistic viewpoints, they were united in their opposi-
tion to the Historicism that had dominated the work of Hans Ma-
kart and his Ringstrasse-era contemporaries. Rather than aping
past styles, the emerging Viennese avant-garde sought to create a
new, modern art. After breaking with their predecessor, the Kün-
stlerhaus, the artists of the Secession built their own exhibition
hall, to which they brought work by foreign modernists, hereto-
fore unknown in Vienna. Also key to the development of the Vi-
ennese avant-garde was the Secession's attempt to integrate the
fine and applied arts. This approach found its ultimate flowering
in the Wiener Werkstätte, a design collective that transferred the
Wagnerian notion of the *Gesamtkunstwerk* from the stage to the
home. In keeping with Wagner's precepts, Werkstätte artisans
were encouraged to master multiple crafts and to design compre-
hensively coordinated interior environments.

## :THE LEGACY OF THE RINGSTRASSE PERIOD

In the context of his later career, Klimt's collaboration with the
*Künstler-Compagnie* may seem anomalous, but these early years
were in many respects paradigmatic for the artist. Conceptually,
this period offered a promise of cooperation and mutual goodwill
that, though repeatedly broken, never lost its seductive allure.
Permanently embittered by the University scandal, Klimt none-
theless remained committed to the ideal of official patronage. He
was still mourning its loss as late as 1908 when, on the occasion of
a round-up of contemporary art called the *Kunstschau* (Art Show),
he characterized such exhibitions as a second-rate alternative to

public commissions.[1] The goal of the Secession and the Wiener Werkstätte was to provide a forum in which artists could work creatively, unhampered by the banality of official taste and supported by a cadre of like-minded patrons. In joining forces with these organizations, Klimt had not so much altered his way of working as found more hospitable venues for the expression of his ideals.

Stylistically, too, Klimt's years with the *Künstler-Compagnie* presaged aspects of his subsequent work. Although the *fin-de-siècle* avant-garde loudly repudiated the Historicism of the Ringstrasse period, Klimt never entirely abandoned historical styles but merely severed them from their original contexts. Through his early training, he had become extremely adept at assimilating historical material, and his later compositions are interlaced with elements drawn from such disparate sources as the Imperial armor collection, antique statuary, Greek vases, Byzantine mosaics, Korean textiles, Japanese prints and Chinese screens. Another lesson that Klimt learned from Historicism was a reverence for allegory, though he tried to reach beyond stale iconographic traditions to present universalized statements about the human condition. And, last but not least, Historicism, as practiced by Makart and his less illustrious contemporaries, offered a decisive model for Klimt in the manner in which it combined painting with architecture.

The melding of painting and architecture was both practical—in that it demanded specific aesthetic solutions—and conceptual, in that it required an intellectual understanding of two very distinct art forms. Klimt had become skilled at dealing with these issues during his years as a muralist-for-hire. The architectural settings in which he worked were real, yet their forms were abstract; his paintings, on the other hand, were only pictures, yet they had

5

**Two Girls with Oleander, 1890–92**

Detail, oil on canvas, 55 x 128,5 cm,

The Wadsworth Athenaeum, Hartford CT

a realistic appearance. The attempt to resolve this paradox, to reconcile reality and illusion, lies at the heart of all of Klimt's subsequent work. It is one of the aspects that suited him so well to collaborations within the realm of the applied arts.

Klimt was acutely aware not only of the distinction between a picture and its setting but of the inherent tension, within the picture, between the three-dimensional figure and its two-dimensional ground. His earliest independent commission, a series of drawings for *Allegorien und Embleme* ("Allegories and Emblems," published by Martin Gerlach between 1882 and 1884), already shows a characteristic preoccupation with framing and abstract form (fig. 4). Sometimes Klimt placed extra emphasis on his frames (on occasion designed by himself or his brother Georg), thereby accentuating the boundary between the artificial image and its environment. On the other hand, Klimt might incorporate geometric forms echoing the frame or architectural surround within the image itself, thus minimizing the aesthetic distance between the two (fig. 5; plates 10 and 11). Recognizing that a blank canvas is an essentially artificial device, Klimt in his mature compositions preserved the integrity of the picture plane by filling his backgrounds with two-dimensional geometric or painterly ornaments. The faces and flesh of his human subjects, however, remained realistically rounded and shaded (fig. 1).

Klimt was never able to eliminate entirely the inherent conflict between figure and ground. He came closest, perhaps, in his landscapes, because these subjects could most readily and completely be reduced to abstract form (plates 26–29). However, just as Klimt could never revert to the sham of illusionistic verisimilitude, he could not embrace full abstraction either. His one purely abstract work – the rear panel for the dining room of the Palais Stoclet (fig. 6) – invites comparison with the relief that Hoffmann designed for the Secession's *Beethoven exhibition* (fig. 7). Both were,

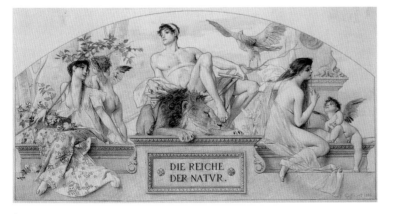

4

**The Realms of Nature, 1882**

Graphite with white highlights, 27,5 x 53,1 cm,

Plate 39 from "Allegorien und Embleme", Wien Museum, Vienna

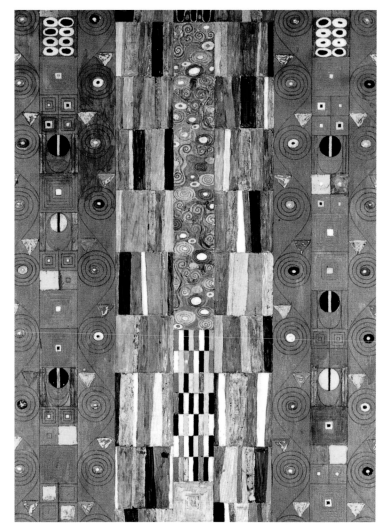

**6**

**Cartoon for the Stoclet Frieze (Back Wall, Detail), 1905–1911**

Gold and silver leaf on brown paper, 196 x 90 cm,

MAK – Austrian Museum of Applied Arts/Contemporary Art, Vienna

**7**

**Josef Hoffmann, Sculpted Wall Relief, 1902**

Designed for the Secession's "Beethoven Exhibition"

so to speak, accidental works of abstract art, their aesthetic conviction undermined by their obvious function as applied wall decoration. Klimt's figural works, on the other hand, teetered precariously between realism and abstraction. While making concessions to the representational mandate of "high" art, the artist simultaneously flirted with the geometric formal devices that at the time were the province of the "low."

## :ART AND CRAFT:
## EMBRACING THE "GESAMTKUNSTWERK"

Gustav Klimt's affinity to the applied arts manifested itself in innumerable ways throughout his life and work. His background as a goldsmith's son and his training at the Kunstgewerbeschule oriented him to the crafts early on. By the 1890s, Klimt's destiny had become intertwined with the family of Hermann August Flöge, an artisan originally from Hanover who had made good

in the Austrian capital as a manufacturer of meerschaum pipes. Ernst Klimt married Helene Flöge in 1891, and soon thereafter, his brother Gustav began a long-term liaison with Helene's sister Emilie. In 1904, Helene, Emilie and their older sibling Pauline opened the fashion salon Schwestern Flöge, an enterprise with which Klimt was intimately connected. Not only did Gustav design dresses for Emilie (fig. 8),[2] but it is likely that her collection of folk textiles influenced the colorful abstract patterns in his paintings.[3] Klimt's multifaceted skills as a designer made him an ideal propagandist for the Secession. He created advertising posters for its exhibitions (plates 99, 100 and 102), illustrations for the house organ Ver Sacrum, and it has been said that he even contributed to Josef Maria Olbrich's concept for the Secession building (fig. 9; plate 98).

At the Secession, Klimt associated less with his fellow painters than with the faction that came to be known as the "Stylists:" those, like Josef Hoffmann and Koloman Moser, whose primary interest was the applied arts and who were firmly committed to the concept of the *Gesamtkunstwerk*. The idea of the Secession as a temple to art manifested itself in specialized installations intended to coordinate the architectural setting with the works on display. Whereas Klimt had once been compelled to conform to the dictates of Ringstrasse architecture, henceforth he and the architects would willingly engage in mutual collaboration. The communal labors of the defunct *Künstler-Compagnie* would be superceded by a new community of artists and artisans.

The fact that the Secession included architects and artisans, as well as fine artists, and on occasion exhibited crafts, was a source both of artistic strength and of institutional weakness. A

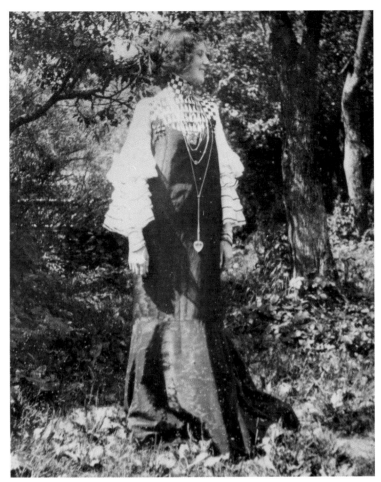

8
**Emilie Flöge in a "Concert Dress" designed by Gustav Klimt, 1907**

Photograph by Gustav Klimt

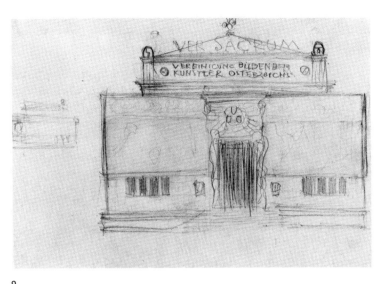

9
**Designs for the Secession Building, 1897**

Black chalk and watercolor, 112 x 177 cm, Wien Museum, Vienna

from the conservatism of official taste, since the private collectors who supported the Secession had far more progressive sensibilities than did Habsburg bureaucrats. Nevertheless, the Secession was still a public building, its potential and intended audience the broad mass of citizens whose tastes the Secessionists hoped to educate and elevate. Although the Wiener Werkstätte assimilated the Secession's educational mission, it soon became evident that only the well-to-do could afford the Werkstätte's standards of taste, workmanship and materials. As a result, in the final phase of Klimt's career, not just the source of his revenue but also his audience became a largely private one.

The three stages of Klimt's career are, as it happens, conveniently illustrated by his three most important architectural commissions: the University paintings (figs. 2 and 3, page 16; fig. 3 page 44), the *Beethoven Frieze* (plates 20, 20a, 21, 44 and 45) and the *Stoclet Frieze* (fig. 13), designed, respectively, for the Austrian Ministry of Education, the Secession and the Wiener Werkstätte. Even the materials selected for these three projects demonstrate the artist's shift in values. The University pictures were painted, conventionally, in oil on canvas. The *Beethoven Frieze* was essentially a *fresco secco* (casein on dry plaster) augmented with gold and inlaid stones, while the *Stoclet Frieze* was a true mosaic, executed by the workshop of Leopold Forstner according to large cartoons on paper by Klimt.

The University paintings were Klimt's last official commission, and their style was very different from that of the comparatively bland allegories that had accounted for his prior success in that realm. As allegories go, the artist's depictions of the faculties of *Philosophy*, *Medicine*, and *Jurisprudence* are admittedly a bit obscure. The paintings contain few of the historical or literary references

growing rift developed between the conventional easel painters (the so-called "Naturalists") and the Secession's *Gesamtkunstwerk* polymaths. Financial considerations further augmented the split over aesthetics and mediums. The founding of the Wiener Werkstätte by Hoffmann and Moser in 1903 had broadened the economic base of the Stylists, and their association, through the Secession artist Carl Moll, with the commercial Galerie Miethke was seen by the Naturalists as an unacceptable conflict of interest. In 1905, after a failed attempt to buy the Galerie Miethke outright, the Stylists resigned from the Secession. Hereafter, Klimt's sole significant organizational affiliation was with the Wiener Werkstätte.

## :ART AND ARCHITECTURE:
### CREATING THE "GESAMTKUNSTWERK"

The context of Klimt's work – for which he created and into which his paintings were received – may be delineated by three principal phases. As a commissioned muralist, he had initially produced paintings for vast public spaces and been dependent on public patronage. The founding of the Secession, however, freed Klimt

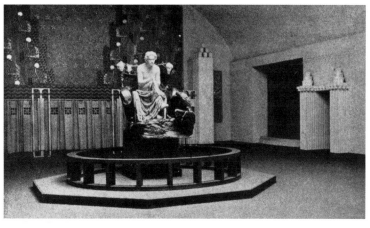

10

Josef Hoffmann, Central Room designed for the
Beethoven Exhibition at the Vienna Secession, 1902

in most cases preceded their creation. With the exception of the Klinger statue, the paintings and sculpture were intended to "conform to the concept of the room." As noted in the catalog, "The idea is to subordinate the parts of the conception to the whole through prescribed relationships and narrowly defined boundaries."[4]

In its allegorical orientation, as well as in its hodgepodge of classical borrowings, the *Beethoven Frieze* kept faith with the University paintings and all the Historicist works that had preceded them. Lest the viewer be in doubt as to the frieze's meaning (as were the professors when confronted with the University cycle), the exhibition catalog provided a programmatic explanation. The work occupied three walls of its own oblong room, and the three panels were meant to be "read" in sequence. The first panel juxtaposes *The Longing for Happiness* with *The Suffering of Weak Mankind*, and concludes with a plea to a literal "knight in shining armor" (said to resemble the controversial composer and director of the Vienna Opera, Gustav Mahler). The second panel, occupying the short end wall, depicts *The Forces of Evil*, including "Disease, Madness, Death, Desire and Lewdness, Licentiousness and Nagging Grief." In the final long panel, all ends well: "The longing for happiness finds appeasement in Poetry." A chorus of angels rejoices, and humankind is saved by the concluding "Kiss for the Whole World" (illustrating a verse from the German poet Friedrich Schiller's "Ode to Joy," which Beethoven set to music in his Ninth Symphony).[5]

Yet, despite the ambitious allegorical content of the *Beethoven Frieze*, Klimt took great pains to subordinate the form of his composition to the architectural requirements of the assignment. Recalling the raised frieze that the Scottish designer Charles Rennie Mackintosh had created for the Secession's eighth exhibition (fig. 11), Klimt's mural ran along the top of the walls, above eye level (fig. 12). The porosity of the plaster surface caused the casein pigment to sink into the ground, so that the painting almost literally became one with the wall. The stylized flatness of the figures further accentuated this effect. On the other hand, the genuine jewels and gold insets seemed to sit above the plaster surface, their palpable bulk both echoing and contrasting with the duller painted ornamentation. It is almost as though Klimt were deliberately teasing his audience, asking them to discern what was real and what was not. Klimt's double-edged approach to illusion and reality was perhaps never more effectively deployed than in this allegory about art and life. Form and content were here perfectly matched.

that traditionally served as guideposts for interpreting such lofty themes. Klimt's interpretations are instead entirely personal, and in each case extraordinarily pessimistic. Humankind is a mass of suffering bodies whose plight cannot be ameliorated by the mortal disciplines taught by any of the three faculties in question. No wonder University professors were up in arms in opposition to these images!

The argument that the University paintings, in addition to being disturbingly sexual, were inappropriate for the purpose at hand is to some extent supported by the compositions themselves. Stylistically, Klimt's work was no longer compatible with that of his collaborator and former partner, Franz Matsch. And only Klimt's first canvas, *Philosophy*, made much of a concession to the fact that the works were intended to be mounted on the ceiling. *Medicine* and *Jurisprudence* were clearly best viewed head on, and indeed it is possible that Klimt already knew, after the uproar that greeted *Philosophy* upon its first public showing in 1900, that none of these works would ever be installed on the University ceiling. *Jurisprudence*, the last of the cycle, was substantially reworked after Klimt renounced the commission in 1905.

The *Beethoven Frieze* was Klimt's ode to the artist as persecuted redeemer, just as the *Beethoven exhibition* (which housed the frieze) was the Secession's most comprehensive realization of the *Gesamtkunstwerk* as an artistic temple. The 1902 exhibition was intended to enshrine the German artist Max Klinger's sculpture of Beethoven, who himself personified a kind of ideal artist-saint (fig. 10). The installation was designed by Hoffmann and included, in addition to Klinger's statue and Klimt's frieze, art by various other members of the Secession. The approach differed from that of all prior Secession exhibitions in that the design of the space, rather than accommodating pre-existing art works,

If Klimt's enshrinement of the artist-hero was intended as a response to the University scandal (which was then in full bloom), the *Beethoven Frieze* certainly did not win him any converts from

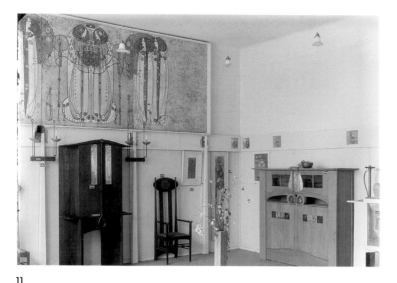

11

Charles Rennie Mackintosh, Room designed for
the Eighth Secession Exhibition, 1900

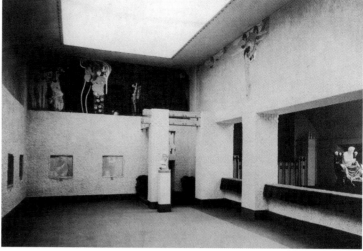

12

Beethoven Frieze, as originally installed at the
Vienna Secession in 1902

among the already disaffected conservatives. As with the University canvases, the public's main objections revolved around the blatant sexuality of some of the female figures and the perceived ugliness of others. "Klimt has once again produced a work of art that calls for a doctor and two keepers," wrote one typical critic. "His frescoes would fit well in a [psychiatric] institute....The representation of 'Lewdness' on the back wall is the last word in obscenity. And to think that this is Klimt's path to Beethoven!"[6]

Unlike the younger artists of the Expressionist generation, such as Schiele and, in particular, Oskar Kokoschka, Klimt did not mean to offend, and the continuing controversy surrounding his work wounded him to the core. His unhappiness was exacerbated by the Secession split, which demonstrated that Klimt's group could not even count on support from their fellow artists. On every level, however, the Wiener Werkstätte promised to address and redress these issues. Here at last a true *Künstlergemeinschaft* (artistic community) would be created, an entity that would unite like-minded artists and patrons, and exclude all the rest. Private patronage would guarantee artistic freedom, though it would also largely confine the artists' reach to the private sphere.

Klimt's *Stoclet Frieze* reflected perfectly, in form, content and circumstances, this retreat into the private realm. Still smarting from the earlier attacks on his work, Klimt did not even allow the mural to be publicly exhibited in Vienna. Those in the know – presumably comprising only friendly parties – could visit the frieze at the mosaic workshop of Leopold Forstner before it was shipped to its intended site, the Brussels mansion of the industrialist Adolf Stoclet. Here Klimt's frieze would virtually disappear from view.[7]

Whereas the *Beethoven exhibition* had been the Secession's most complete realization of the *Gesamtkunstwerk* as an art temple, the Palais Stoclet was the Wiener Werkstätte's most successful interpretation of the *Gesamtkunstwerk* as domestic environment. In Adolf Stoclet, Josef Hoffmann found a client who was both willing and financially able to accede to the architect's every dictate, and he proceeded to mastermind a totally coordinated interior. Between 1905 and 1911, an enormous team of Wiener Werkstätte artists and artisans created everything from carpets to coffee spoons. Not a single aspect of the wall ornamentation, furnishings or fixtures escaped Hoffmann's attention. It is even said that the Wiener Werkstätte established its fashion department because Mme. Stoclet's clothing clashed with the decor of the mansion.[8]

Klimt had bowed to Hoffmann's architectural conception when he designed the *Beethoven Frieze*, but the creations of both the painter and the architect had been subordinated to the higher goal of "Art." By comparison, Klimt's *Stoclet Frieze* was destined for the dining room of a Belgian mansion, which had no more lofty purpose than the comfort of its owner and his guests. If the *Stoclet Frieze* was not exactly upstaged by the ancillary accoutrements of the dining room (which naturally were more numerous than had been the case with the Beethoven installation), it nevertheless blended harmoniously with the interior decor. The mosaic stones and tiles were conceptually of a piece with Hoffmann's marble walls. The *Stoclet Frieze* was clearly part of the decorative reality of the room it inhabited, rather than evoking the parallel world of artistic illusion which had formerly given depth to Klimt's allegorical visions.

The *Stoclet Frieze* had an allegorical program, but it was far simpler than that of the *Beethoven Frieze*. The composition centers on

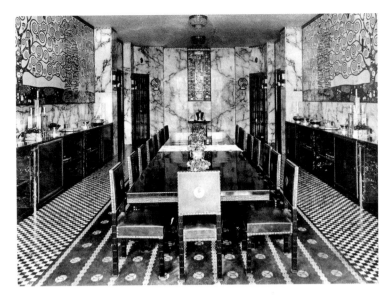

**13**

**The Stoclet Frieze, 1909–1911**

As installed in the dining room of the Stoclet Palais, Brussels.

Copper plates, silver plate, semi-precious stones, gold mosaic and colored ceramic on white marble ground, long wall: 200 x 740 cm, narrow wall: 183 x 89 cm

two primary vignettes, *Expectation* (fig. 14) and *Fulfillment* (fig. 15; reprising the Kiss for the Whole World, which had, in the meantime, also been essayed in what is today's Klimt's most famous canvas, *The Kiss*; fig. 5, page 18). *Expectation* and *Fulfillment* are entwined in the *Tree of Life*, whose spiraling golden branches give decorative unity to the whole. The dark and ugly forces of the *Beethoven Frieze* are wholly absent here. *Expectation* gives way to *Fulfillment* with not even a struggle. Nothing inappropriate disturbs the Stoclet family's dinner guests.

The bland form and content of the *Stoclet Frieze*, as well as its complete reliance on materials that are more often associated with the "low" than with the "high" arts, would seem to substantiate the architect Adolf Loos's persistent attacks on his rivals at the Wiener Werkstätte. In Loos's view, the *Gesamtkunstwerk* concept granted neither art nor craft its proper place. "The work of art," he wrote, "wants to shake people out of their sense of comfort. The house must serve comfort."[9] Klimt himself had trouble with the dining-room commission, presumably because his tempera and metallic leaf designs had to anticipate and make concessions to the much harsher medium of mosaic. "Stoclet is growing like an abscess on my neck," he wrote Emilie Flöge in July 1910.[10] After finally completing the full-scale cartoons (which, in frustration, he let Emilie touch up), Klimt worked closely with Forstner's workshop on the interpretation of his designs. In the end, nevertheless, Klimt was not entirely satisfied with the result. Offered another similar commission by the Wiener Werkstätte, he turned it down. The *Stoclet Frieze* was the artist's final large-scale mural.

## :CONCLUSION: ON THE ROAD TO MODERNISM

Seen as a group, the University paintings, *Beethoven Frieze* and *Stoclet Frieze* illustrate the potential and perils of the *Gesamtkunstwerk*. Of the three commissions, the *Beethoven Frieze* is probably the most successful. The University paintings take too little account of their architectural setting; the *Stoclet Frieze*, arguably, too much. The Beethoven frescoes, on the other hand, achieve just the right balance between art and architecture--proving that it is, indeed, possible to create an art work that is absolutely one with its space, yet nevertheless as complex, profound and moving as any more conventional easel painting.

The *Beethoven Frieze* may, to some extent, be seen as a forerunner of the installation art that would flourish toward the end of the twentieth century. Like these later works of art, the Beethoven installation was clearly intended as an aesthetic experience; it did not pretend to serve a utilitarian function. Whether or not Klimt consciously rejected the *Gesamtkunstwerk* model put forth by the Wiener Werkstätte after completing the Stoclet commission, there must be some significance in the fact that thereafter he retreated to the more conventional world of paint and canvas. Implicitly if not explicitly, the artist's subsequent paintings acknowledge the fact that art, to be art, must occupy its own separate realm, apart from the everyday and practical. Klimt's later paintings, however, continued to be informed by his earlier architectural sensibilities: to balance two-dimensional considerations against three-dimensional ones. Gradually, he developed a more painterly approach. His figural subjects now rested in nests of lush flowers and impastoed swirls (plates 30–32) instead of the flat geometric planes of former years. Nevertheless, the contrast between realistically rendered flesh and a more abstract, ornamental surround remained as pronounced as before.

Negotiating trade-offs between illusion and reality was, in a sense, the fine-art equivalent of the form-versus-function dichotomy that was played out in the *fin-de-siècle Gesamtkunstwerk*. But whereas the applied-art incarnation of the *Gesamtkunstwerk* ultimately proved as problematical as Loos had predicted, its fine-art counterpart provided an endless source of inspiration for Klimt. The fact that he could never resolve the conflict between illusion and reality in his work was not a weakness, but rather the source of the artist's enduring strength. It is, finally, Klimt's duality--his effective bridging of the moribund world of academic realism and the coming world of abstraction--that accounts for his greatness.

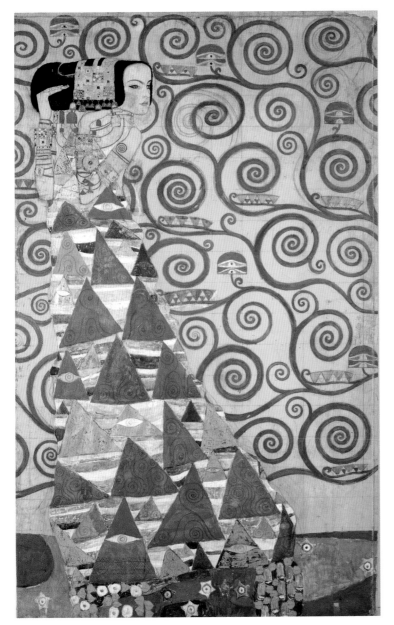

**14**

**Expectation, Cartoon for the Stoclet Frieze, 1905–1911**

Gold and silver leaf on brown paper, 195 x 120 cm,

MAK – Austrian Museum of Applied Arts/Contemporary Art, Vienna

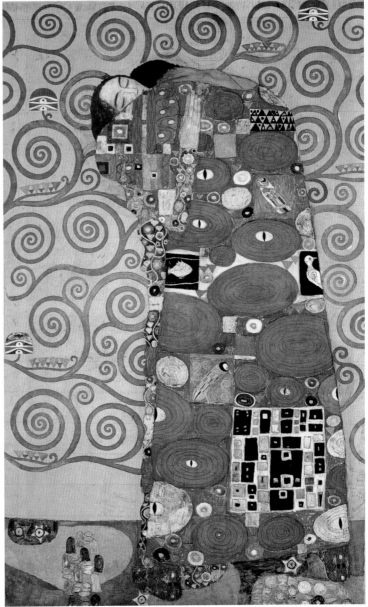

**15**

**Fulfillment, Cartoon for the Stoclet Frieze, 1905–1911**

Gold and silver leaf on brown paper, 195 x 120 cm,

MAK – Austrian Museum of Applied Arts/Contemporary Art, Vienna

1  Christian M. Nebehay, *Gustav Klimt: From Drawing to Painting* (New York: Harry N. Abrams, 1994), p. 169.

2  According to Wolfgang Fischer in *Gustav Klimt und Emilie Flöge* (Vienna: Verlag Christian Brandstätter, 1987), pp. 95–97, the dresses, photographed for publication in *Deutsche Kunst und Dekoration*, were intended not for manufacture by the Flöge Salon, but merely to help promote it.

3  Fischer 1987, pp. 47–48 (see note 2).

4  *XIV. Ausstellung der Vereinigung bildender Künstler Österreichs* (Vienna: Secession, 1902), pp. 9–10.

5  *XIV. Ausstellung der Vereinigung bildender Künstler Österreichs*, pp. 25–26.

6  Nebehay 1994, p. 108 (see note 1).

7  The Palais Stoclet has become one of the most frequently reproduced of the Wiener Werkstätte's commissions, though in its day it was surprisingly little publicized. Klimt's frieze, of course, has always been off limits to the general public and is known chiefly from reproductions of the cartoons.

8  Jane Kallir, *Viennese Design and the Wiener Werkstätte* (New York: Galerie St. Etienne – George Braziller, 1986), p. 22.

9  Carl E. Schorske, *Fin-de-Siècle Vienna* (New York: Alfred A. Knopf, 1980), p. 339.

10  Fischer 1987, p. 162 (see note 2).

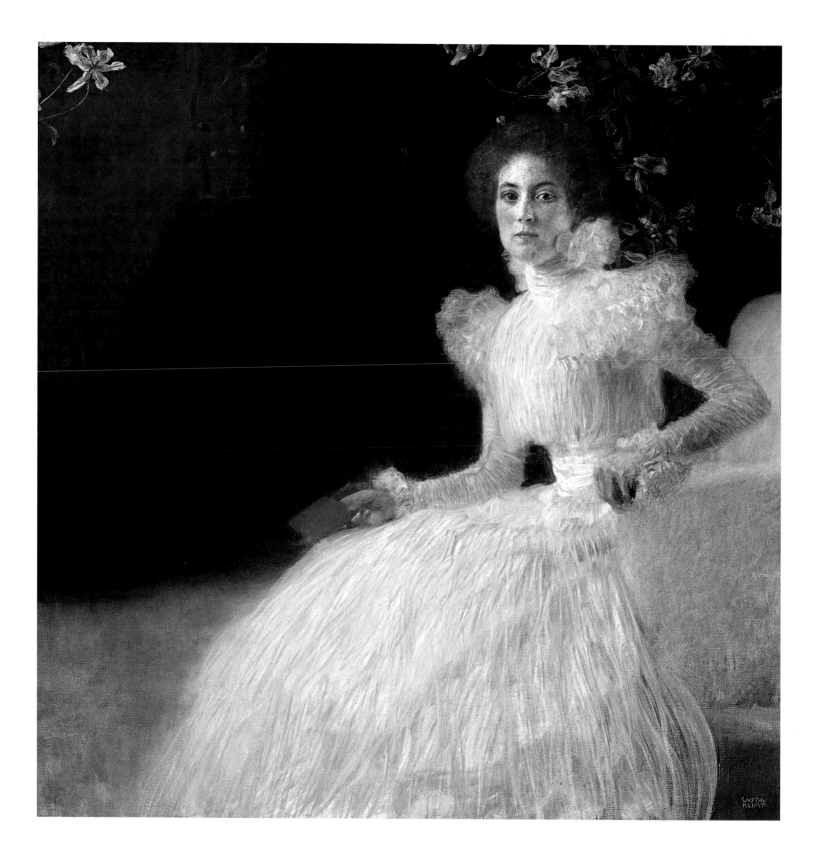

1

**Sonja Knips, 1898**

Oil on canvas, 145 x 146 cm,

Belvedere, Vienna

# WOMEN AND NATURE IN THE WORK OF GUSTAV KLIMT

BY ALFRED WEIDINGER*

■ In more than three thousand – sometimes erotic – draw-
■ ings, Klimt, the psychological portraitist of the female,
convincingly showed that understanding women and their
sensibilities was a serious concern for him. He found a way of
intensifying this visible reality in his paintings too, manifesting
itself in his ability to depict emotions. Absolutely personal, cryp-
tic allusions made by the artist, which reveal more about his
emotional state than could be seen in his earlier works, can be
found in both Klimt's portraits of women and his landscapes.
In the portraits he presents a pictorially abstracted equivalent of
the personality of the sitter on the one hand, while revealing a
coded visualization of his personal relationship to the model on
the other. In his landscapes, which appear at first glance to be
devoid of figures, the artist subtly integrates representations of
women and girls.

## :"... ONE WOULD LIKE TO PERCEIVE HER TRUE BEING"

In the preliminary study for *In the Morning* (fig.2) made in 1892,
Klimt depicted the metaphorical connection between flowers
and women which was a subject popular at that time, par-
ticularly in literature: he gave a sunflower the appearance of
a small face by placing eyes, a nose and a mouth in its corolla.
The sunny gaiety of the flower was the equivalent of the
vivacious joy of a girl admiring a bouquet of flowers on a crisp,
sunny morning.

The obviousness of this relationship, as shown in this early water-
color, takes on a much more subtle form in Klimt's later pictures
of women that is difficult for the unversed viewer to interpret.
The use of sophisticated symbols and metaphors enabled Klimt
ultimately to achieve an almost complete equation and identifi-
cation of a girl or young woman with a flower. In this way he in-
vested his female portraits with extremely personal secrets, pack-

aged in such a way that only very few of his contemporaries were
capable of deciphering them. In Klimt's paintings, in which men
are merely viewers or receptors outside the actual picture, these
aspects, which have always traditionally existed, have become
compounded to give an expression of his own personal state of
mind.

Similar considerations underlie Klimt's portrait of *Sonja Knips*
(fig. 1) which he painted in 1898. Comparable to the poetic sym-
bolism found in the Pre-Raphaelite Dante Gabriel Rossetti's

2

**In the Morning,1892**

Drawing,

private collection

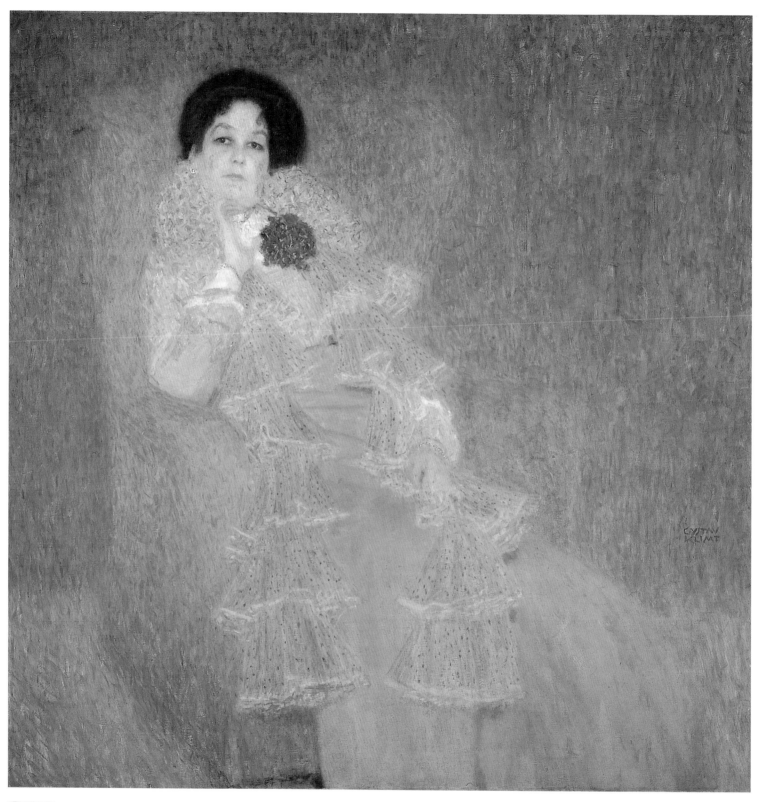

**3 and 3a**

**Marie Henneberg, 1901/02, and corresponding signet**

Oil on canvas, 140 x 140 cm, Stiftung Kunstmuseum Moritzburg

des Landes Sachsen-Anhalt, Halle a.d. Saale

painting *Lady Lilith*, luxuriant lilies appear to unfold out of the area of the shoulder and neck of the woman which – transferred and abstracted into a vegetal form – symbolize the character of the sitter and, thereby, can be understood as a veiled comment by the artist.

The floral arrangement sophisticatedly introduced into the portrait of *Sonja Knips* is naturally reproduced as compared to his portrait of *Emilie Flöge* (fig. 5) painted four years later. Klimt developed a considerably more abstract formulation of her personality in the ornamental, geometric and, at the same time, vegetal forms which appear to grow out of her body. From this time onwards, similarly abstract formulas relating to the sitter can be found in a considerable number of other portraits. This characteristic is particularly striking in the portraits *Margarethe Stonborough-Wittgenstein*, *Fritza Riedler* (fig. 1, page 20) and *Adele Bloch-Bauer I* (fig. 7, page 19). In these enigmatic forms, Klimt – knowingly or unknowingly – visualized the ideal expressed by Hermann Bahr in 1901: "Instinctively, one ponders over a beautiful woman; one would like to know more about her than can be expressed in words; one would like to perceive her true being."[1]

The idea of reflecting the personality of the sitter in an abstract way as a geometrical or vegetal symbol in the background has its origins in the intensive studies Klimt undertook for the works made for the Kunsthistorisches Museum in Vienna in 1890/91. His commission included representing the individual collections of the museum, in easily intelligible forms, in the spandrels and intercolumniations on the north and west of the main staircase.[2] However, it was precisely through working on a concept for the content for these thankless – and well-nigh impossible – surfaces of secondary importance that Klimt reached a level of maturity and fulfilled his task with bravura. He decided on the depiction of individual figures from a specific era and, in the background – mainly in the area of their heads and upper-bodies – painted the relevant metaphors for the individual departments of the artistic collection (fig. 3, page 22). With the exception of the portrait of *Joseph Pembaur* which was painted at around the same time, in which Klimt alluded to the sitter's profession as a musician by including a lyre in the background, the artist would only employ this specific decorative principle from now on in his portraits of women.

When he visited Klimt's atelier and saw the first stage of his painting *Hope I* (fig. 4, page 45), the art historian Hans Koppel observed back in 1903 that Klimt consciously oscillated between ornaments, vegetation, the subject and symbolic values: "Apart from a few small details, it is finished, but it will not be shown at the exhibition: he wants to repaint the background. It was originally a land-

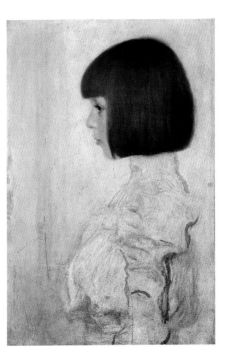

**4 and 4a**
**Helene Klimt, 1898,**
**and corresponding signet**
Oil on cardboard, 60 x 40 cm,
Kunstmuseum Bern, on loan
from a private collection

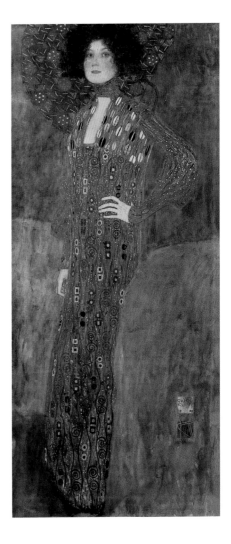

**5**
**Emilie Flöge, 1902**
Oil on canvas, 181 x 84 cm,
Wien Museum, Vienna

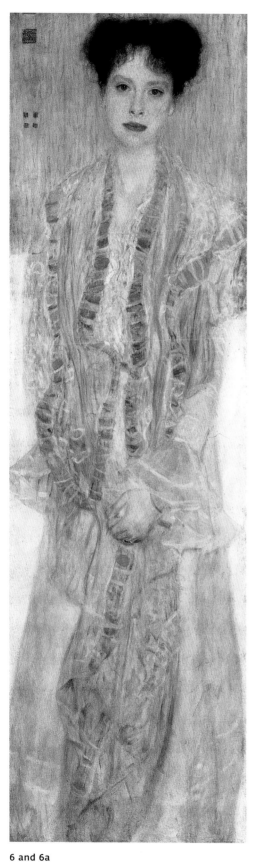

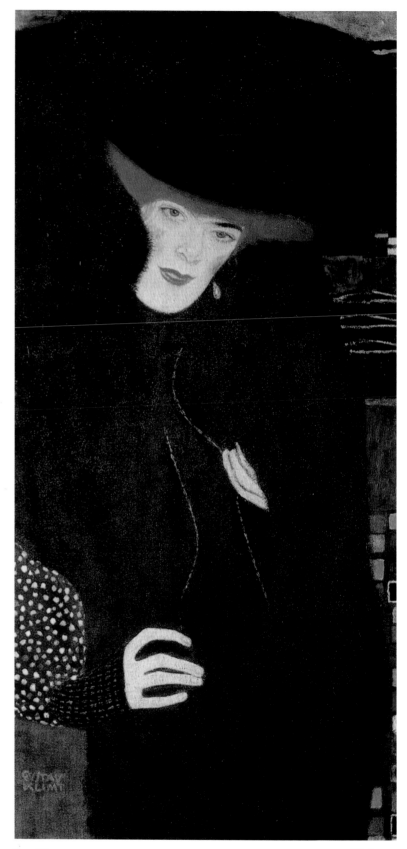

6 and 6a

**Gertrud Loew (Gertrud Felsöványi), 1902,**

**and corresponding signet**

Oil on canvas, 50 x 45,5 cm,

private collection

7 and 7a

**Portrait of a Lady in Red and Black,**

**1907/08, and corresponding signet**

Oil on canvas, 96 x 47 cm,

private collection

scape but now it shows a patterned carpet; this should be developed into characteristic heads which illustrate specific formal principles."[3]

The extent to which Klimt took the abstraction of his sitters can be seen when comparing these portraits of women with the signets which he designed for the ladies who commissioned his works. They were tailor-made for them and can be assigned with certainty. The abstract-vegetal symbols were published by Klimt in 1908 in his portfolio *Das Werk Gustav Klimts* (figs. 3–4 and 6–7).[4]

Klimt only once makes an allusion to his own person and relationship to nature from which a much more personal viewpoint of his landscapes can be ascertained. This is the "Golden Knight" (figs. 9, 10) in the first draft of the *Stoclet Frieze* where a small open window in his body reveals a blossoming tree. The almost identical symbol, which he drew in the painting *The Golden Knight* – probably under the influence of the sketches for the mosaic frieze in Brussels – confirms this phenomenon. Klimt saw himself as an artist in the figure of the knight. His heart and soul were inseparably bound to nature!

## :KLIMT'S CONCEPT OF SYMBOLISM: "THERE IS SOMETHING IN THE SOUL THAT IS A ROSEBUSH ..."

Klimt personified nature in his landscapes in the same way that he vegetalized the subjects of his portraits. Women and girls in the landscape can already be seen in Klimt's first commissions such as the stage curtain for the Municipal Theater in Reichenberg in 1882/83, the paintings *Fable* 1883 and *Idyll* 1884, the painting on the ceiling of the auditorium of the Municipal Theater in Carlsbad in 1886, as well as other paintings executed mainly by the *Künstler-Compagnie*.[5] These are predominantly generously structured, usually multi-figured, allegories in which the landscape either functions as a setting in the background of the painting or as an area in which the protagonists present themselves. It was only in the painting *Children with Flowers* (fig. 11) of 1896 and, even more so in some of the watercolor sketches painted in 1898 for the March issue of the magazine *Ver Sacrum*, that the considerably greater importance of nature becomes apparent. The actual idea behind the paintings is the tender transfiguration of the beauty of girls and young women in the landscape.

Klimt's sophisticated feeling for form was a great advantage in his search for new, less obviously formal solutions for the implementation of this theme of transformation. Regardless of whether he was painting a landscape or a portrait, Klimt could make use of the same creative form. It therefore comes as no surprise that

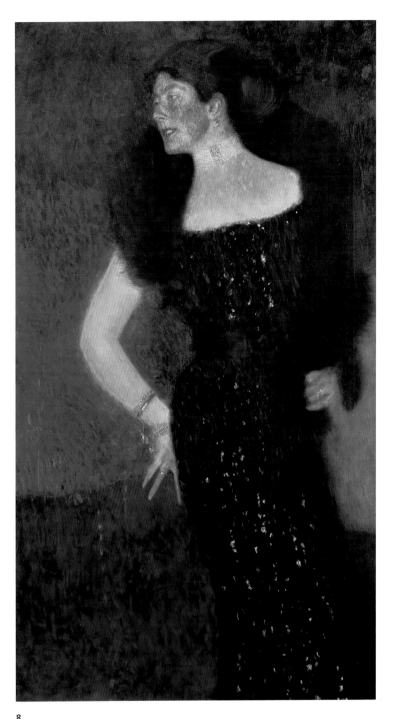

8
**Rose von Rosthorn-Friedmann, 1900/01**
Oil on canvas, 140 x 180 cm, private collection

authors have repeatedly attempted to compare the composition of the portraits with that of the landscapes.[6]

In this connection, Alice Strobl's thoughts in identifying the curved, linear contour in the foreground of a landscape sketch (fig. 12) as a standing woman, and explicitly indicating the portrait of *Rose von Rosthorn-Friedmann* (fig. 8 and plate 18) painted in 1900/01,[7] are particularly significant.

9

The Stoclet Frieze: small, unfinished

sketch with The Knight, 1908

Detail, pencil, watercolor and

opaque paint, gold bronze,

MAK – Austrian Museum of Applied Arts/

Contemporary Art, Vienna

In the works produced at Attersee, Klimt was especially tempted to portray women in, or in front of, landscapes where they formed connections of symbolic importance. With the exception of some isolated examples such as *Judith I* (plate 19) and the first state of *Hope I*, Klimt decided on a clear separation between allegory and pure landscape. However, he did not abandon the idea of dealing with people – as a rule, young women – in the landscape.

A comparison shows that Klimt had found a solution in his search for the coding and conversion of the physically perceivable image of a human in a manner which for him appeared appropriate and personally valid. This was expressed for the first time around 1903 in tall rose formations. Their silhouettes are reminiscent of a stylized human – or female – form which can be interpreted as a symbol of life, and represent the condensation of all of the beauties of nature. Once again, it was Hermann Bahr who put these thoughts into words in his 1901 'Address on Klimt': "In the outside world, a rosebush is something quite specific; speaking philosophically: it represents an idea within it. This idea is also present in the inner world: there is something in the soul that is a rosebush."[8]

Klimt would never burden external appearances with inner feelings which were only meaningful to him and not intrinsic. However, he did not depict appearances devoid of feeling, but gave them precisely the appearances essentially contained within. "Seeing that he cannot touch anything without – although probably completely unbeknown to him – giving it a spirit and a soul, he is what one calls an idealist."[9]

In the painting *Roses under Trees* (fig. 14) Klimt consummated this synthesis between nature and the subject – a procedure which can be identified in numerous landscape paintings from the following years. The solitary floral arrangements on the opposite banks of a lake, far away and unreachable for Klimt, often remind one, all too clearly, of human forms – for example in the paintings *Schloss Kammer Park on the Attersee III*, *Schloss Kammer Park on the Attersee IV* and *Houses at Unterach on the Attersee* (fig.17). Oskar Kokoschka also dealt with similar anthropomorphic connections in his fairytale *Dreaming Youths*,[10] which was published by the Wiener Werkstätte, as did Egon Schiele who, in 1911, described his ideas on transformation as follows: ". . . At the top of the garden everything is green and there are human-like flowers and still more flowers. Outside, in a vibrant field of color, the colored forms melt together; brown, bushy farmers on the brown path and yellow girls in the blossoming May meadows. Do you hear?"[11]

This phenomenon of metamorphosis is most pronounced in Klimt's 'portrait', *The Sunflower* (fig. 13). A single flower

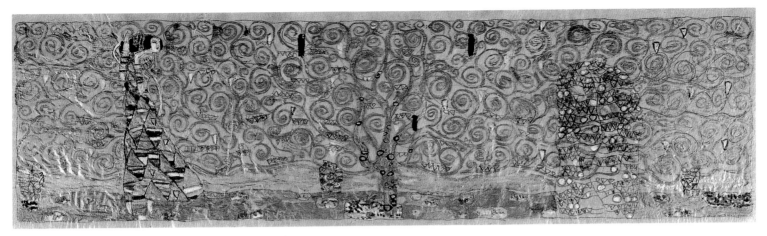

10

**The Stoclet Frieze: small sketch with The Dancing Girl (finished), 1905**

Pencil, watercolor and opaque paint, gold bronze on transparent paper,

MAK – Austrian Museum of Applied Arts/Contemporary Art, Vienna

becomes the central motif of the picture in front of an impenetrable, ornamental vegetal wall. The flowery expanse of meadow develops into an agglomeration of flowers and grass and elevates the sunflower above its vegetal anonymity. At the time, Ludwig Hevesi thought that this appeared to be "like an enamored fairy whose greenish-grey robe flows downwards, passionately shivering."[12] The super elevation on the one hand and the vegetal isolation on the other, suggests a certain unattainability. It is still lonely, selfcontained and admired by all. One is tempted to see Emilie Flöge in the anthropomorphic contours of the sunflower.

The relationship between Klimt and Flöge was most intense precisely at the time this picture was painted in 1907. A comparison between *The Sunflower* and photographs possibly taken by Gustav Klimt of Emilie Flöge in front of a farmhouse garden in Litzlberg on Attersee, is not without interest (fig. 15). There actually does appear to be a formal relationship between the silhouettes with some internal forms.

The same phenomenon can be seen in a comparison between *The Sunflower* and Klimt's monumental icon *The Kiss* (fig. 5, page 18). There is a picture-filling ornamental wall behind the protagonists which, in both works, is surmounted by a small, vegetal elevation with flowers. The contour at the lower border of the lovers corresponds with that of the sunflower. Hevesi correctly noted that new things happen "in nature, as soon as Klimt appears on the scene."[13] Klimt's inspiration and direction developed a particular, almost hierarchical, system for nature which protected it from all external influences. Not unjustly, one thinks of human characteristics and is reminded of the statement Peter Altenberg made in 1909 that Klimt treated the landscape like a woman: "It has been elevated to its own romantic peaks!"[14]

The term 'vegetalization' which characterizes this phenomenon of transformation can already be observed in Klimt's early academic works and describes the ornamentation created by vegetal elements in the artist's paintings, which reaches its crowning point in the complete identification of the flower and woman. In this sense, the landscape paintings cannot be regarded as an

11

**Children with Flowers, 1896**

Oil on canvas,

whereabouts unknown

12

**Sketch of Landscape, c. 1904**

Pencil,

Belvedere, Vienna

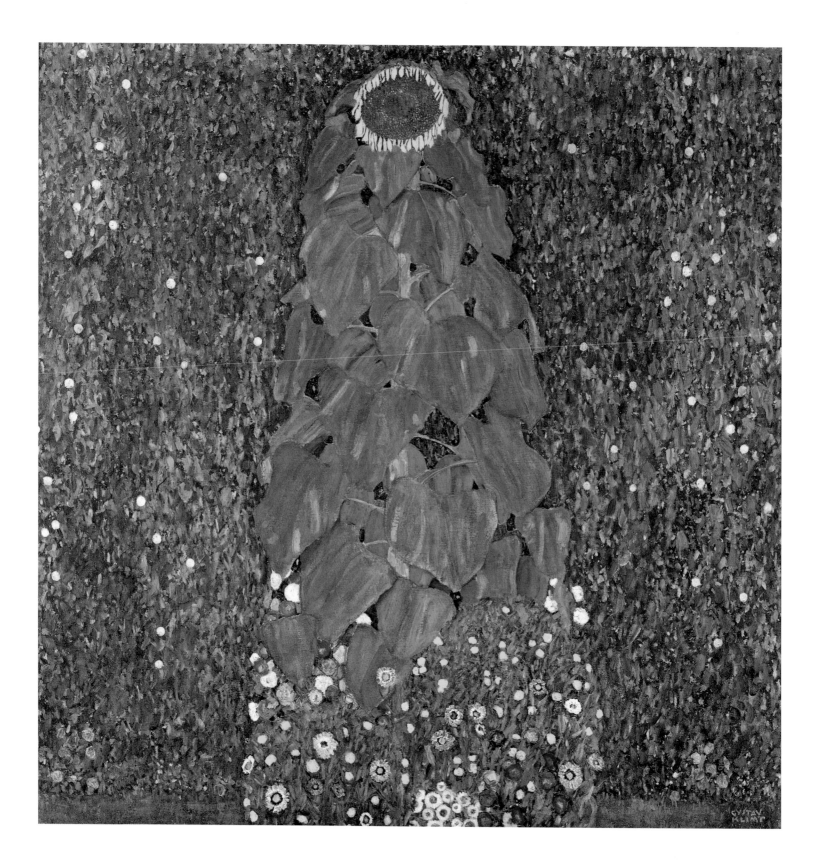

13

**The Sunflower, 1907**

Oil on canvas, 110 x 110 cm,

private collection

**14**
**Roses under Trees, 1904**
Oil on canvas, 110 x 110 cm,
Musée d'Orsay, Paris

**15**

**Emilie Flöge in Litzlberg on Attersee, c. 1907**

Photograph, private collection

**16**

**Poem by Gustav Klimt, 10 July 1917**

Private collection

individual genre but provide a completely new insight into these paintings which are – often, falsely – described as being 'lifeless' as can be corroborated through Klimt's informative correspondence. On the contrary, they are extremely lively and atmospheric and depict either exceptionally intense impressionistic scenes or cerebral materializations.

In a poem (fig. 16), penned on 10 May, 1917, a few months before his death, the artist gives us one final indication of this phenomenon: "The water lily grows in the lake. It is blossoming. In its soul, it grieves over a handsome man."[15]

\* This text was originally published under the title "Symbolismus in den Land- schaftsbildern" (Symbolism in the Landscape Pictures) in the publication: Alfred Weidinger (ed.), *Klimt*, (Munich: 2007), pp. 177-189. Translated by Ishbel Flett, Edinburgh.

1 Hermann Bahr, *Rede über Klimt*, (Vienna: 1901), p.16
2 The commission to paint the intercolumniations and spandrels of the staircase was granted to the *Compagnie* consisting of Gustav Klimt, Ernst Klimt and Franz Matsch. Matsch painted the south side, Ernst Klimt the east, Gustav Klimt the north, and the west side was jointly executed by all three.
3 Hans Koppel, "Gustav Klimt", in *Die Zeit*, 15.11.1903
4 *Das Werk Gustav Klimts*, (Vienna: Verlag H. O. Miethke, 1914), p. 287 ff.
5 In a letter to Hofrat Ritter von Eitelberger, dated 2 February, 1884, Gustav Klimt, his brother Ernst (1864–92) and Franz Matsch (1861–1942) described their joint venture as the "Compagnie" (Bibliothek der Stadt Wien, inv. no. 22439). The *Compagnie* was founded in 1880 and dissolved following Ernst Klimt's death in 1892, although Gustav Klimt and Matsch carried out joint commissions until around 1900.
6 Thomas Zaunschirm, *Gustav Klimt. Margarethe Stonborough-Wittgenstein. Ein österreichisches Schicksal*, (Frankfurt/Main: 1987)
7 Alice Strobl, *Gustav Klimt – Die Zeichnungen*, Vol. IV, (Salzburg: 1989), p. 98
8 Op. cit., p. 16, note 1
9 Ibid.
10 Oskar Kokoschka, *Die Träumenden Knaben*, (Vienna: 1908)
11 Egon Schiele, after 23 May 1911, cited from the first transcription of one of his poems in his own handwriting, in Christian M. Nebehay, *Egon Schiele 1890–1918. Leben, Briefe, Gedichte*, (Salzburg: 1979), p.175
12 Ludwig Hevesi, *Altkunst – Neukunst*, (Vienna: 1909), p. 319
13 Ibid.
14 Peter Altenberg, "Kunstschau 1908" in E. Reiß, *Bilderbögen des kleinen Lebens*, (Berlin: 1909), p.115
15 Gustav Klimt, 10 July 1917, facsimile, Klimt Archives, Vienna

**Houses at Unterach on the Attersee, 1915/16**

Oil on canvas, 110 x 110 cm,

private collection

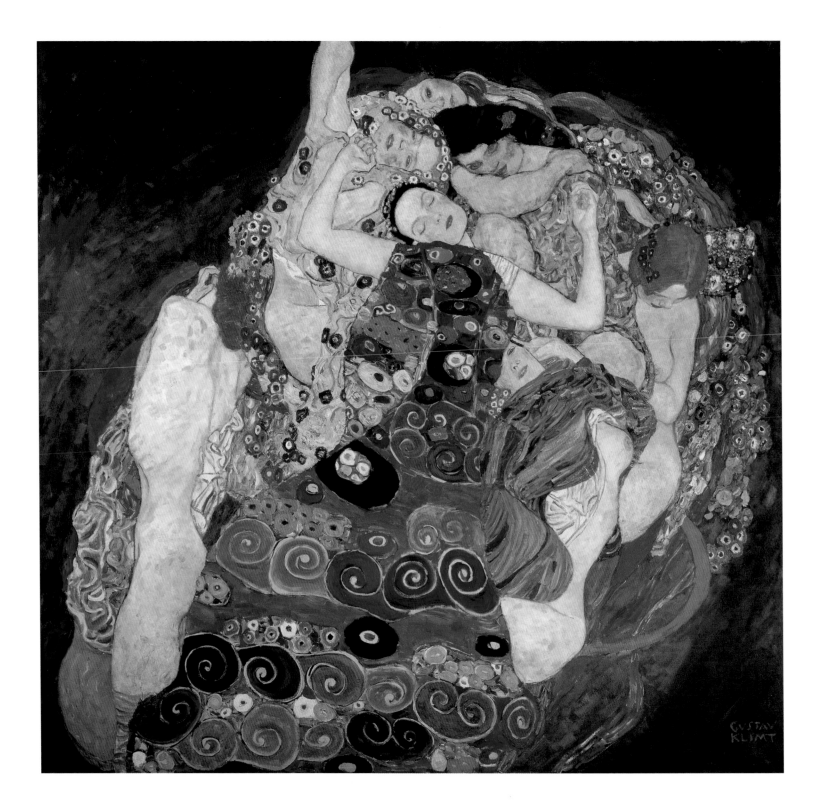

1

**The Virgin, 1913**

Oil on canvas, 190 x 200 cm,

Národní Galerie, Prague

# ON THE DRAWINGS OF GUSTAV KLIMT BY MARIAN BISANZ-PRAKKEN

Gustav Klimt's drawings occupy a unique position in Austria as well as in the spectrum of international modernism around 1900. Due to their linear aesthetic and their often explicit eroticism, the works have enjoyed a constantly growing popularity particularly in recent years. It is commonly overlooked, however, that these studies contain the key to understanding the mindset and the modes of operation of the artist – especially with regard to the evolution of his paintings. To properly appreciate the phenomenon of Klimt in its entirety, an examination of his graphic works is crucial.[1]

The drawings also indicate the fact that Klimt always took up new challenges in order to forge the right path for himself and find his balance in the prevailing situation at any given time. For all the fundamental changes he experienced, he maintained his unmistakable identity to the end. Hence, an early study for the Historicist decoration of the Burgtheater is just as typically "Klimt" as a later, casually drawn work done for *The Bride*. Throughout all of the stages of his development, the same high quality level is maintained in his drawings.

Klimt virtually never commented on his own work – neither on his paintings nor on his drawings. The creative act of drawing was of such an intimate and personal nature for him, that neither the society ladies who were to be portrayed nor any of his numerous models were allowed a glimpse of the work. His friend and close colleague, Carl Moll wrote: "Several models were available daily; if they were not needed for the continuation of paintings, then nude studies were drawn, always in relation to these paintings."[2]

The fact that Klimt was actually working on most of these figurative studies with his painting projects in mind has been impressively confirmed by Alice Strobl in her catalog raisonné comprising approx. 3800 works. The four volumes appeared between 1980 and 1989 as scientific publications of the Albertina.[3] The drawings which have newly appeared since 1989 – several hundred, and with the numbers continually growing – will be edited by myself as Alice Strobl's successor, in a supplemental volume, likewise a publication of the Albertina.

The sketches shown in this exhibition illuminate different stages in the development of the draftsman Gustav Klimt. The earliest of the selected works are two meticulous detail studies for Romeo and Juliet in the tableau *Shakespeare's Theater* (plates 34 and 35), which was painted as part of the ceiling decorations for the staircase of the Vienna Burgtheater. At the time of the creation of these studies, Klimt was at the height of his career as a painter in the Historicist tradition of the Ringstrasse. Both of the drawings were executed using live models and were rendered with photographic sharpness. Extremely confident and subtle contour lines are already the great specialty of the artist in this phase. But particularly the study for the dead Juliet goes far beyond the realistic manner of representation. The suggestive contrasting effects

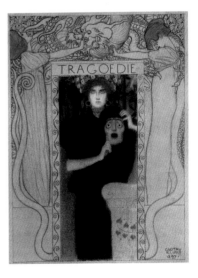

2

**Tragedy, 1897**

Black crayon, graphite and wash
with gold, published as no. 66 in:
"Allegorien, Neue Folge",
Wien Museum, Vienna

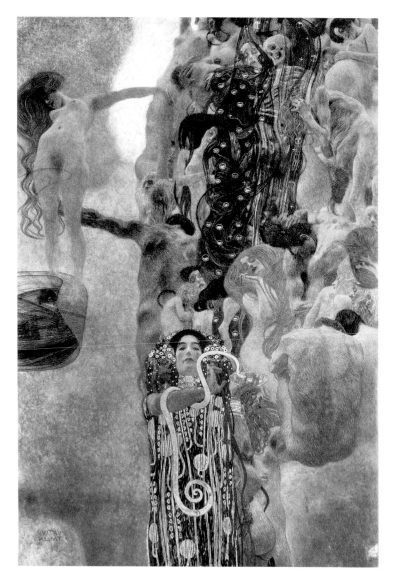

3

**Medicine, 1900–07**

Oil on canvas, 430 x 300 cm; signed, lower right;

ceiling painting for the Auditorium at the University of Vienna.

Destroyed by fire at Schloss Immendorf, 1945

most indebted to Ferdinand Laufberger as the one "who was able to teach him the most in the craft."[4] It was no coincidence that it was Laufberger in particular who always attached such special importance to drawing as an indispensable basis for painting.

And indeed, Klimt internalized the three main pillars of his multi-faceted education at the School for Applied Arts like no other artist: technical perfection; profound insight into the great epochs of the past; and a thorough knowledge of anatomy and the movement of the human body – nude and clothed. Drawing formed the lower rung of a predefined hierarchy in Historicism: a study served as allegorically or historically designated decoration, while a painted composition in turn served a programmatically conditioned architecture. Hence, the artist always had to keep in mind the architectural function as well as the higher theoretical context while drawing the positions and gestures. Despite the subordinate role of drawing, the young Klimt developed like no other contemporary the study of the human figure – particularly that of the female – and its details into a highly cultivated art form, on a par with that of painting. In drawing, Klimt quickly left his colleagues far behind, and in the aforementioned studies for the Burgtheater he was already head and shoulders above the rest. Soon thereafter, his extremely conventional career was a thing of the past.

In the 1890s, under the influence of international Symbolism, his dramatic turn to Modernism took place. Klimt became the leader of the Secession, founded in 1897, and was elected its first president. Klimt's allegories *Junius* (1896), *Sculpture* (1896) and *Tragedy* (1897) (fig. 2) were created to be reproduced in Martin Gerlach's publication "Allegories. New Series" (*Allegorien. Neue Folge*) under the immediate influence of the highly optimistic, almost sacral spirit prevailing during the founding period. The historic significance of this successful series lay in the new, autonomous role of works on paper. Die "Allegorien," which were to symbolize modern life in the publisher's terms, were an ideal platform for many young and established artists from Germany and Austria for the circulation of new artistic techniques, style concepts and ideas. It was within this framework that Klimt also openly acknowledged Symbolism with his allegory drawings.

His most modern and radical contribution was undoubtedly the sheet *Tragedy*, created in the founding year of the Secession (1897); this archaizing depiction of the Muse of Tragedy marks the beginning of Klimt's new monumental style. Seen front-view, the main figure, its hypnotizing gaze intensified by the mask, contrasts emphatically with the resigned figures in profile, whose eyes are either closed or covered. These are accompanied by decorative contrasts which emphasize the subject: the dark central section stands in marked opposition to the bright frame; the static and rigid central figure is in expressive contrast to the lin-

of the deep black chalk and the transparent white heightening create the impression that the girl, as if touched by the hand of death, is already departing from the world of the living. In this subtle rendering of the intangible and mysterious, it would seem that Klimt is already distancing himself emotionally from the rational outlook of Historicism.

Although he would break the mold and depart from this tradition soon thereafter, he never denied his fundamental training at the Kunstgewerbeschule (School of Applied Arts) in Vienna. On the contrary: on the occasion of his fiftieth birthday (1912), Klimt emphasized – at the beginning of his late creative period – that, of all the teachers at the School for Applied Arts, he was still

ear movement of the detailed figures of mourning. A new role is played by the magic of gestures, which – as if dictated by a secret force – integrate themselves right up to the fingertips of the tectonics of their environs. Klimt was inspired in this phase to a considerable extent by the Belgian artist Fernand Khnopff – with regard to the mysterious female typology and the delicate use of chalk – as well as by the Dutch artist Jan Toorop, who would play a central role for Klimt with his Symbolist linear compositions.[5] The threatening-looking dragon in the upper part of the image sets a novel Far Eastern accent. The preliminary study for *Tragedy* shown here (plate 40) is still characterized by the linear dynamics of the draft phase, which precedes the highly sophisticated character of the completed drawing.

*Tragedy*, a work of great significance with regard to Klimt's artistic development, is a characteristic work of transition from the old to the new. The pseudo-architectural framework of the composition and the didactic overtones of the allegory point to the historical roots of the entire serial publication. At the same time Klimt uses a traditional approach to convey modern, metaphysical topics and to put new compositional means to the test.

These would soon manifest themselves monumentally in the paintings *Philosophy* (1900; fig. 2, page 16) and *Medicine* (1901; fig. 3) for the University of Vienna. The commission awarded to Franz Matsch and Gustav Klimt in 1894 to adorn the ceiling of the university auditorium with allegorical paintings of the different sciences was, however, beset by major problems. Having turned to Symbolism, it had become impossible for Klimt to deal with the subjects assigned to him, *Philosophy*, *Medicine* and *Jurisprudence* (fig. 3, page 16), in a traditional positivistic manner. The project ended in disaster: the paintings would never reach their destination. For Klimt the artist, however, the work on the faculty paintings was of pivotal importance. He was grappling, for the first time, with vital issues that would continually engage him from then on.

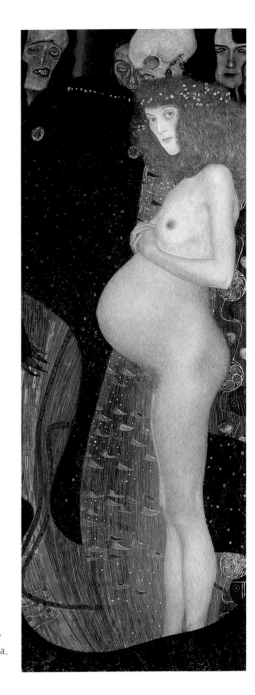

**4**

**Hope I, 1903/04**

Oil on canvas, 181 x 67 cm,

National Gallery of Canada,

Ottawa

For Klimt's drawing, this reorientation as regards content would have extensive consequences. With renewed intensity and an attitude that differed essentially from his Historicist origins, he addressed the study of the nude. The individual studies of the nude models – women and men, children, pregnant women and old people – testify to the artist's search for the most accurate possible position in each case and the appropriate gesture for a particular mood. Particular significance is attached to the contours, carefully drawn in black chalk: they describe the psychological boundaries between the emotional world of Man and the empty outside world. The state of nudity and the expression of abandoned helplessness are united here for the first time in these works. Klimt's figurative drawings still serve a specific purpose; however, the figures are now no longer subject to the programmatic goals of Histori-

cism, but to the invisible forces of fate. Time and again, Klimt emphasizes the trance-like state of his figures, whose eyes are always closed. The search for the expression of weightless floating is particularly evident in the studies for the female hovering in space in *Medicine* (plates 37–39). It cannot be emphasized enough that Klimt's nude studies for *Philosophy* and *Medicine* represent a pioneering act for the new psychological approach to the representation of the human form in Viennese Modernism which was to continue until the Expressionism of Egon Schiele.

Without the preliminary drawings for the faculty paintings *Philosophy* and *Medicine*, the studies for the *Beethoven Frieze* (1902; plates 20 and 21) would not have been imaginable. The experience of

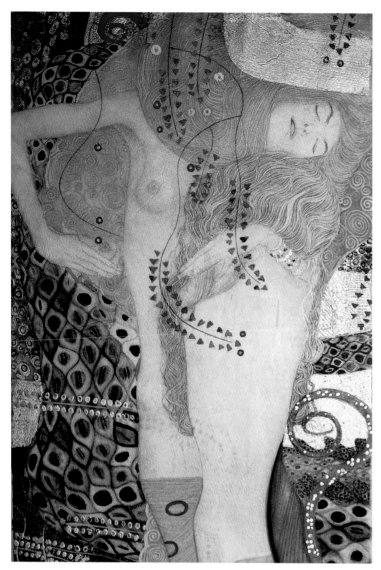

5

Water Serpents I, Detail, 1904/07

Detail, pencil, watercolor and oil on parchment

with silver and gold ornamentation, 50 x 20 cm,

Belvedere, Vienna

the hovering forms in *Longing for Happiness*, or the *Arts* (plate 46). As is explicitly demonstrated by the nude study for the supine floating figure shown here, the new, streamlined corporeal ideal is united with these immaterial figures (plate 47).

Following the Faculty Paintings and the *Beethoven Frieze*, Klimt's graphic work correlated to a substantial extent with these monumental painting projects. For his allegories of life, he would consistently return to individual motifs from the faculty paintings *Philosophy* and *Medicine*. Accordingly, his paintings from the "Golden Period" (c. 1904-1909) are tersely labeled with titles such as *Hope*, *The Three Ages*, *Expectation*, *Fulfillment*. In the process Klimt grappled in his drawing with the "primal states" of Man with utmost discipline.[6]

In his studies, the supra-individual relationship of the single figure to the higher principles – self-evident to the artist – is internalized anew with each work. The way Klimt captures the positions and gestures of his models in the "primal states" of standing, walking, lying, sitting or metaphysical floating testifies to his incessant search for the ideal balance between spiritual expression and a higher order. Most notably after 1902 – with the dramatic experience of working on the *Beethoven Frieze* – every study has the character of the necessary and definitive. Appropriately, the edges of the sheet of the virtually constant paper format constitute the constraining border between interior and exterior; they become the defining factor in the dynamic process of planar arrangement, which takes place with a natural ease. Klimt's attitude toward this essentially subordinate "space-oriented art" would remain unchanged to the end of his life. What did change over and over again, however, was his creative handling of these principles.

Like his nude studies, the sketches for portrait paintings could also be described as "primal states" of sitting or standing; the primary accent in these works is on the reproduction of the clothing. In the numerous studies for the portrait of *Adele Bloch-Bauer I*, (fig. 7, page 19) which were produced shortly after the *Beethoven Frieze*, Klimt's art of drawing even becomes "space-oriented art" (plate 60). In every sketch, Klimt affixes the sitting figure to the surface by allowing the paper's edges to cut across or touch her pleated garments and her forehead. He only accentuates certain parts of the face itself, the highly stylized, sensuous mouth forming the center of attraction. The work on display very aptly shows the principle of the superimposed spatial layers in a subtle interplay of flowing line and angular, geometric accents. In this complex of reciprocal dependencies and dynamic tensions, negative space – the non-form – also plays an active role. The principles of Viennese planar art have achieved their greatest perfection here. In the 1904 studies for the portrait of *Fritza Riedler* (completed in

working directly on the wall surface in a congenial architectural surrounding – with new materials – raised the artist's awareness of the tension present between planar and linear elements. In terms of the then current ideals of "space-oriented art" (*Raumkunst*), Klimt strove to subject the positions and gestures of his figures to geometric principles of order: the frontal and profile positions and the horizontal and vertical main axes dominate. The contour thus acquires a vital significance as an expressive element. The body contours and the masses of hair of the beguiling *Three Gorgons* are thus characterized by sensually curving lines with an almost complete lack of drawn detail within the outlines (plates 44, 45 and 49). These "femmes fatales" stand in marked contrast to the programmatically "good" figures in the *Beethoven Frieze* – for example

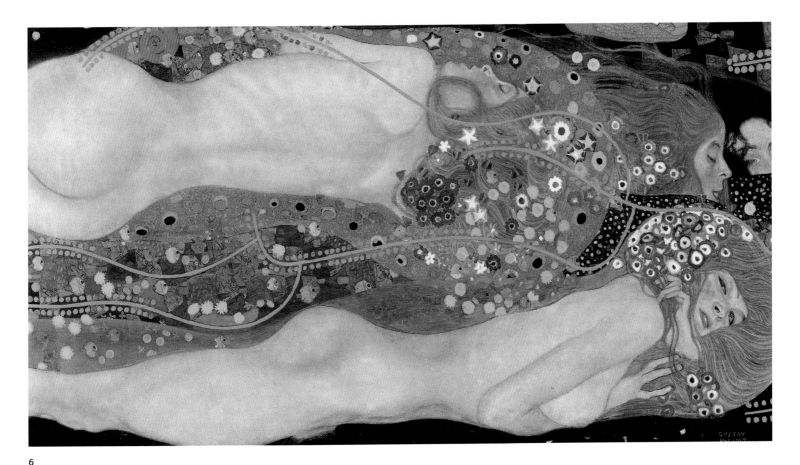

6

Water Serpents II ,1904

Oil on canvas, 80 x 145 cm, private collection

1905) (fig. 1, page 20), the geometric discipline of the imminent "Golden Period" is already dominant (plate 50).

Just as in the Bloch-Bauer studies, the connection between monumental bracing in the surface and sweeping lines is apparent in those created in 1903 for the painting *Hope I*. In this image, Klimt applies himself with religious sobriety to the taboo subject of pregnancy – not without the fatalistic allusion to menacing forces (fig. 4). The sketches in which the male partner joins the pregnant main figure express a particular intimacy (plate 43); a central motif of these sheets is the swelling contours of the heavily pregnant profile figure, whose belly as focal point simultaneously presents a decorative element and an outstanding symbol for the hope of new life.[7]

A very important "primal state" for Klimt is floating, or being horizontally or vertically propelled – for example the women being carried by the waves in the painting *Moving Water* (plate 17), the hovering woman in *Medicine* or the floating figures in *Longing for Happiness* in the *Beethoven Frieze*. After Klimt turned to a geometrically emphasized manner of composition around 1904, the energetic motion of floating mutates into the static state of the prostrate. Owing to

their predominately sectional rendering and by virtue of the dynamic course of their contours, the figures, arranged parallel to the picture's surface, seem nonetheless to be integrated in an infinite horizontal movement. The impression of flowing is further reinforced by the robes, which swirl about the naked bodies like water. The result of this large group of studies (plates 52 and 53), in which Klimt addresses the taboo subjects of masturbation and lesbian love for the first time, are the playfully erotic paintings *Water Snakes I* and *Water Snakes II*, both created 1904-07 (fig. 5 and 6).

The objectives of the mosaic frieze for the Palais Stoclet in Brussels were *Expectation* and *Fulfillment* (figs. 14 and 15, page 29) – as a variation on the dominant dialectic of struggle and conquest in the *Beethoven Frieze*. Klimt's active interest in modern expressive dance is evidenced in the numerous studies produced in preparation for *Expectation*. Appearances by celebrities such as Loïe Fuller, Elisabeth Duncan and Ruth St. Denis in Vienna had drawn great attention to the dance form.[8] The sheets on display (around 1907; plates 54 and 55) are impressive examples of one of the most interesting phases of the drawing work of Gustav Klimt, who – just before the famous *Kunstschau* (1908) – was at the height of his "Golden Style." The female figures shown here seem to be rising from the

7

**The Bride, 1917**

Oil on canvas, 165 x 191 cm,

private collection

(On loan in the Belvedere, Vienna)

earth's surface despite being in mid-stride. The balance between strict surface fixation and linear detachment, between formal discipline and inner agitation has an especially persuasive effect here. The angular gestures and the languorous facial expressions of the figures manifest – apart from the Egyptian components – the influence of the Dutch Symbolist Jan Toorop and the Belgian sculptor George Minne, who played an important role for Klimt and the Viennese avant-garde, especially prior to 1900.[9] Closely related to the studies for *Expectation*, is the equally enchanting study of a dancer which correlates to the group of studies for the painting *Salome* (1909; plate 61).

After returning from his travels to Spain and Paris (1909-10), Klimt turned his back on his "Golden Style." His paintings are no longer reminiscent of friezes, frescoes or gold mosaics; he uses bright, luminous colors, and the flatness of his compositions gives way to a new spatiality. In his drawing, Klimt devoted himself with greater intensity to the female eros, focusing on two important projects: *Virgin* (1913; fig. 1) and *The Bride* (1917/18, unfinished; fig. 7). His models appear natural and unselfconscious, conveying various stages of reverie or erotic ecstasy (plates 70–73, 76, 77 and 87). At the same

time, Klimt is always latently present as observer or director; he is the invisible, stable male antithesis to the volatile female psychological state. His studies present a differentiated typology of femininity, which – as could recently be demonstrated – exhibit striking outer and inner parallels to contemporary nude photography.[10]

The question as to why Klimt devoted himself to the subject of eroticism with such great obsession is to a certain degree answered by the works themselves. Time and again, he seems to focus on that moment of reverie when the subject is being directly touched by the mystery of life, which is conveyed by their eyes, which are usually closed, and their trance-like actions and movements. The Japanese woodcuts, of which Klimt was an avid collector, no doubt influenced him significantly. Alice Strobl pointed out the particular importance of sexuality as mysterious life principle.[11] With almost sacred earnestness, Klimt focuses again and again on the openly presented female sex, which alludes to the beginnings of human life and simultaneously forms the central point of sexual arousal. His endeavors to fixate the moments of ecstasy as precisely as possible are augmented by his efforts to subject the depicted figures to a higher geometric order or specific system of movement.

This often results in complicated, expansive positions, in which the form-revealing textiles play a highly dramatic role.

The later studies (1916/17) for *The Bride* exhibit great extremes, typologically speaking. The area of tension between bodily presence and immateriality, between erotic ecstasy and a connectedness to cosmic wholeness seems even more intense here than in *Virgin*. Just before the end of his life, Klimt reached astounding artistic peaks, as in the virtuoso study for the haggard figure of a girl, who, on the right side of the picture, – as was recently exposed – is quietly being led away by the figure of Death, prepared with strokes of chalk but never completed.[12] With extremely loose and at the same time astoundingly sure lines, referring back to influences from the contemporary Expressionism, Klimt captures this gauntly stylized dream figure, lifting off half in dance (plate 87). A remarkable aspect of this study, in which the principles of surface fixation are still in force, is the unusual union of eroticism and metaphysics. With the gaunt body ideal and the right-angled position of the left arm, Klimt is drawing on inspiration from Jan Toorop on ideals of corporeal form that influenced his figures particularly during the Secession and the "Golden Period."[13]

During the last decade of the artist's life, the production of portrait paintings increased substantially. Klimt's preparatory drawings were primarily concerned with the various manners of dress, whereas he often accommodated his models' character with subtle means; of the exhibited portrait studies, several examples are emphasized here. The studies, begun in 1912, for the portrait of *Mäda Primavesi* – Klimt's only official commission for a child's portrait – are a playful balancing act between the cursory characterization of this lively girl and the discipline of decoration (plates 68 and 69). Less ingenuous are his studies for the portraits of ladies from high society. An extremely forceful, vital pencil stroke characterizes the studies for the portrait of *Friederike Beer-Monti* (fig. 10, page 57 and plates 78 and 79), whose round face with its distinctive, symmetrical facial features he emphasized again and again. In the study of the seated figure shown here, Klimt concentrates on the frontal, hypnotizing countenance, framed as if by an aureole by the back of the armchair; he reduces the forms of the body to a minimum. In the animate oscillation between bright and dark gray lines, he achieves the greatest density in the shining pencil matter around the chin area. Klimt's particular attraction to mask-like round facial types during these years can also be seen in the vivaciously executed portrait drawing of little Trude Flöge. The girl was the daughter of Hermann Flöge, the brother of Klimt's lifelong companion Emilie. (plate 80).

The fact that the unfinished likeness of *Ria Munk III* was a posthumous portrait commission – the young woman took her own life in 1911 – may have played a role in the immaterial character of the preparatory studies (plates 83 and 84).[14] These drawings were created using various models, who are all sheathed like mummies, as it were, in a kimono.[15]

It is notable in this context that Klimt subdued the corporeal in the drawings as well as in the unfinished picture more than in all the other portrait depictions. One of the examples exhibited here shows the figure anchored column-like in the surface, the head and foot areas overlapped by the edge of the paper, so that the figure seems to persist in infinity. In changing rhythms, the constantly turning pencil describes the kimono-figure, resulting in a multitude of abstract patterns. Fragile transparency and strict tectonics maintain the balance; in this late phase of extensive linear abstraction as well, the principle of integration constitutes the prerequisite for the evolvement of graphic energy.

As modern as Klimt was, he submitted to the end to the principles of the *Gesamtkunstwerk* or "total work of art" and devoted himself to the subordinate role of the drawing.

1 The basis for this article is my paper "Gustav Klimt's Drawings", in: Colin B. Bailey and John Collins, *Gustav Klimt – Modernism in the Making*, (exhibit. cat. National Gallery of Canada: Ottawa 2001), pp. 143–161. Relevant new insights have been additionally taken into account here.

2 Carl Moll, "Meine Erinnerungen an Klimt. Aus dem Leben und Schaffen des Meisters der Secession", *Neues Wiener Tageblatt*, 1.24.1943, quoted in: Christian M. Nebehay, *Gustav Klimt Dokumentation* (Vienna: 1969), p. 54, note 7b

3 Alice Strobl, *Gustav Klimt: The Drawings*, vol. 1–4 (Salzburg: 1980–89)

4 Arpad Weixlgärtner, "Gustav Klimt", in: *Die Graphischen Künste* 35, 1912, p. 51

5 For Khnopff, Toorop and Vienna, see: Marian Bisanz-Prakken, ed., with contributions by Hans Janssen and Gerard van Wezel, *Toorop/Klimt. Toorop in Wenen: Inspiratie voor Klimt* (exhib. cat. Haags Gemeentemuseum: Den Haag 2006–07), with a summary of the previous publications on this subject.

6 Klimt's grappling with the "primal states" of human life, also in terms of contemporary monumental art, first discussed in: Marian Bisanz-Prakken, op. cit. note 1, p. 150 ff

7 On the subject of pregnancy and its associated symbolism, Klimt was frequently inspired in both his painting and his drawing by the allegory *The Three Brides* (1892) by Jan Toorop. See: Marian Bisanz-Prakken, "Die fernliegenden Sphären des Allweiblichen", Jan Toorop und Gustav Klimt", in: *Belvedere* 7, 2001, pp. 34–47; same in: exhib. cat. Den Haag (see note 5), pp. 212–220

8 cf: Alice Strobl, op. cit. note 3, vol. 2, p. 143

9 Marian Bisanz-Prakken, op. cit. note 5, pp. 205–06

10 Marian Bisanz-Prakken, "Gustav Klimt: The Late Work. New Light on The Virgin and The Bride," in: Renée Price, ed., *Gustav Klimt. The Ronald S. Lauder und Serge Sabarsky Collections* (exhib. cat. Neue Galerie: New York), p. 105–121

11 Alice Strobl, op. cit. note 3, vol. 3, p. 12

12 ibid., pp. 122–127

13 Marian Bisanz-Prakken, "Gustav Klimt und die 'Stilkunst' Jan Toorops," in: *Mitteilungen der Österreichischen Galerie, Klimt-Studien*, 22/23, 1978-79, 66/67, pp. 208–09 and following publications on this subject.

14 The hitherto generally accepted thesis, argued in depth by Alice Strobl, that this painting is the third posthumous portrait of Ria Munk, has been supported by Sophie Lillie in several commentaries, but remains disputed by Alfred Weidinger. See: Alice Strobl, op. cit. note 3, vol. 3, pp. 111–116; the group of studies for the standing figure: Nos. 2607–2617. Alfred Weidinger, *Gustav Klimt* (Munich: 2007), cat. no. 246. The discussions concerning this are as yet not concluded.

15 On the mummy-like, ethereal character of the drawings and their possible connotations within the posthumous subject matter : Marian Bisanz-Prakken, op. cit. note 1, p. 158

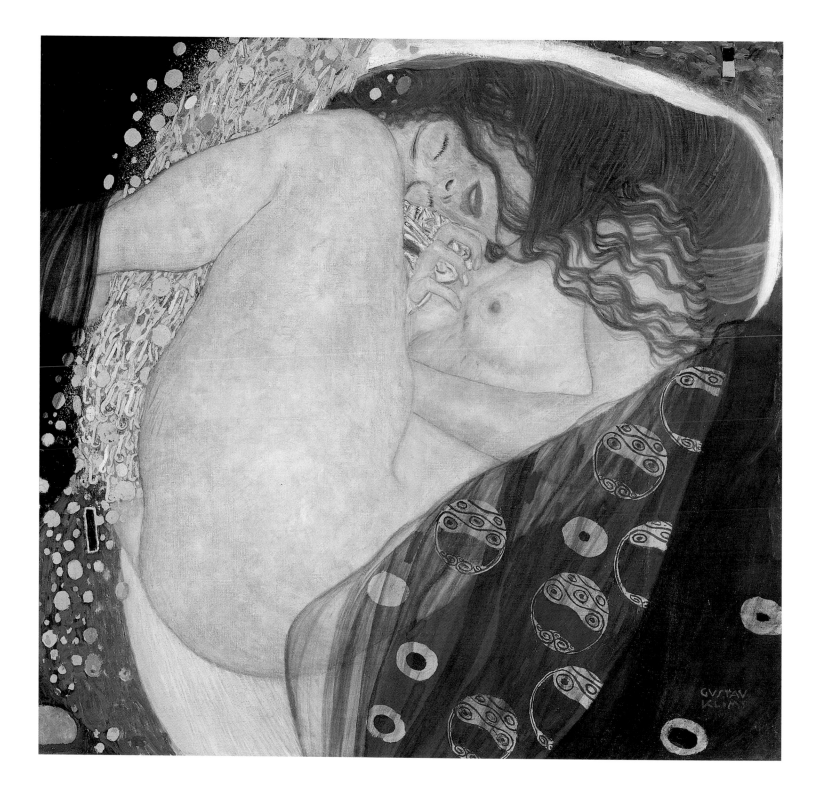

1

**Danae. 1907/08**

Oil on canvas, 77 x 83 cm,

private collection

# GUSTAV KLIMT AND THE ART OF EAST ASIA BY JOHANNES WIENINGER

In 1913, the Japanese artist and journalist Kijiro Ohta visited Vienna with the objective of writing an article on Gustav Klimt for the art journal *Bijutsu-shinpo* ("News from the Art World"). In its objectivity and detail, this report is something of a genre picture of the art scene in Vienna after 1900. Almost dispassionately, Ohta gives an account of his efforts to establish contact with Gustav Klimt. Procuring a letter of introduction with the greatest of difficulty, he follows up even the tiniest rumors, picking up rumors of indiscretion and offering in this manner overall an accurate picture of the "artist prince."[1]

In the end, however, Ohta did succeed in making the arduous journey into the suburb, several kilometers to the west of Schönbrunn, where Klimt had maintained a studio since 1911. Ohta was sitting in the garden, when Klimt suddenly stormed past him and then, only recognizing him at second glance, remembered the announced visitor from faraway Japan and devoted a few minutes to the distant traveler. Klimt showed him several drawings and sketches as well as unfinished paintings displayed on easels, and then he finally broke the silence of their non-verbal communication with a single word: "Japon."

This was exactly the word that the stranger was waiting for and that he could now take home with him as a sort of confirmation. But this verbal affirmation would not have been necessary. One glimpse of the studio would have sufficed: a display case with all sorts of little objects documented the interest in things foreign, and then there was the cabinet with kimonos and Chinese fabrics and robes. And above all, visible for every visitor – the great studio wall, with the image of the god Guandi (fig. 2) and his attendants (from China or Korea) in the middle, framed by *ukiyo-e*, Japanese woodcuts. All of this could pass for "Japanese." People were not so meticulous at the time – what was most important was the fact that it was interesting and novel. It was not the con-

tent but the composition that mattered: all of these lines, colors and surfaces contradicting the accustomed and studied rules, seemingly without space and hence also without time, this mix of art and ornament, the freedom and lightness with which an artist was able – and permitted! – to express himself.

Klimt's work reflects the transition from the 19th to the 20th century; in fact, he himself was a driving force of this development in the Viennese scene. With the founding of the Vienna Secession in 1897, a group of innovative artists abandoned the traditions of Historicism and began to experiment with compositions, subjects, techniques, and colors. Not only did Klimt join this group of creative artists; he was, in fact, the outstanding personality among them.

The art scene in Vienna did not form part of the European avant-garde. For decades, the world had been looking to Paris and London, where traditional panel painting had long since been under-

2

**View of Gustav Klimt's studio**

Vestibule of the studio in the Feldmühlgasse. Image of the god Guandi, surrounded by Japanese color wood

**3 and 3a**

**Ogata Kôrin (1658–1716), Red and White Plum Blossoms**

A pair of two-section partition screens, paint and gold on paper,

each 156 x 172,2 cm, Japan, Edo Period, beginning of the 18th century,

MOA Museum of Art, Atami

going a renewal. The cultural climate in these two centers was by far more open than in other European capitals. Paris saw itself as the cultural capital. Artists flocked here in great numbers; many new ideas were pursued here, and Paris was also the departure point for many new ideas which spread into the rest of Europe. And one of the sources of these new ideas was Japanese art, which was welcomed and received with enthusiasm in Paris.

Western European countries established diplomatic and economic ties with East Asian countries well before Austria-Hungary. Furthermore, an aesthetic interest in the "new art" was aroused elsewhere earlier and, in the years around and shortly after 1870, had led to a so-called "exotic Japonisme." The term "Japonisme" was coined around 1870 in Paris by Philippe Burty (1830-1890) and was used to refer to works which chiefly dealt with Japanese woodcut color prints (*ukiyo-e*). Just as everything from the Far East was termed "Indian" in the 17th century and "chinoiserie" in the 18th century, so in the 19th century, works from China and Korea were subsumed under the broad term "Japonisme" despite the fact that geographic knowledge had become more precise in the meantime.

By the time Ando Hiroshige (1797-1858) produced his series *One Hundred Famous Views of Edo* just before his death, color woodcut

prints were also available for purchase in London and Paris. They were small, light, and easy to transport. With them, an entire culture could be placed in a portfolio and carried about. Katsushika Hokusai's (1760–1849) little sketch books – from *Manga* to *One Hundred Views of Mount Fuji* – generally served the function of a guidebook. In the late 1870s, these printed pictures could be purchased in the first Orient shops, and there was surely not a single artist left who did not own something from East Asia.

A year after the founding of the Vienna Secession, the exhibition hall at the edge of the Karlsplatz was opened. And two years later in 1900, the never-to-be repeated exhibition of Japanese art from the private collection of Adolf Fischer took place. Only a short time later in 1901, the Imperial and Royal Austrian Museum of Art and Industry (today's MAK – Austrian Museum of Applied Arts/Contemporary Art in Vienna) mounted a monographic exhibit of the works of Katsushika Hokusai.

The great significance attributed to Far Eastern art as a prerequisite for an artist's own creative work was evident in the Secession's 16th exhibition in the year 1903, which bore the title *Development of Impressionism in Painting and Sculpture*. Jointly with the great Impressionists of France, woodcuts by Kiyonaga, Eishi, Toyokuni, Utamaro, Hokusai and Hiroshige were also shown

here. But not only public collections and exhibitions showed Far Eastern art; many private people began to collect orientalia as well, decorating their dwellings with the objects.

Far Eastern art lent itself readily in the search for sources of inspiration. Japan was the last undiscovered culture, as the Viennese architect Adolph Loos ironically remarked.[2] Therefore, when searching for "Japanese elements" in Gustav Klimt's oeuvre, our sights must be set on works from two creative periods: on works from the so-called "Golden Phase" 1907/08 and the *Stoclet Frieze*, as well as on a succession of portraits after 1912.

## : DANAE

This subject from ancient mythology has a long tradition in the art history of Europe, which is why Klimt's work is often, and probably justifiably, compared with the painting of the same name by the Venetian painter Titian (1485–1576). Upon regarding it more closely, however, we can observe elements which are not explicable solely with reference to European painting history. The young lady is forced into a curious diagonal composition which is formed using bright and luminous surfaces – in particular, her thigh and the laburnum – as well as the dark, gold-adorned veil (fig. 1). The image is lacking spatial depth: the two-dimensional composition is defined by large and harmonious curvatures. The surfaces are placed next to each other – color placed next to color.

One does not need long to discover that these seemingly unusual compositions have an – indeed not coincidental – parallel to a work of Ogata Korins (1658–1716): the two-piece screen *Red and White Plum Blossom* by Ogata Korin (figs. 3 and 3a). Here the *Red Plum Blossom* is also divided by a large curved line running through the entire picture; creating a dark surface – the course of the river – and a bright, luminous one – the golden zone with the blossoming tree. Both Klimt's *Danae* (77 x 83 cm) as well as Korin's landscape (156 x 172,2 cm) are entered into more or less square formats, and if we transfer the division of the Japanese room screen onto Klimt's picture, then we are able to see that the balance and tension of the two halves of the image, the relationship between empty space and painted area, resemble each other.

But there is also a great difference: Klimt mirrored Korin's composition. He most probably knew that images were read from right to left in the Far East, but that the viewing habits in Europe would cause the eye to glide from left to right. In both pictures, the bright side is to be read first: Korin attracts our attention to the blossoms, Klimt to the laburnum.

## : ADELE BLOCH-BAUER I

At the same time, Gustav Klimt created one of his most noted portraits, the golden portrait of *Adele Bloch-Bauer I* (fig. 4).

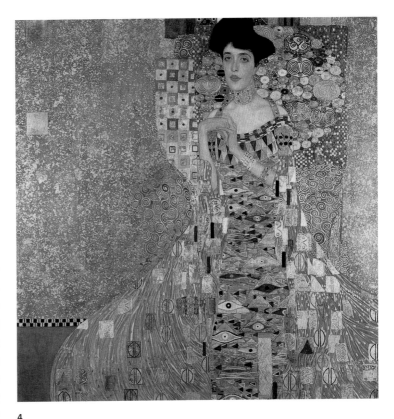

4

**Adele Bloch-Bauer I, 1907**

Oil, silver, and gold on canvas, 138 x 138 cm,

Neue Galerie New York. This acquisition made available in part through the generosity of the heirs of the Estates of Ferdinand and Adele Bloch-Bauer

Sitting elegantly in an armchair, Adele Bloch-Bauer's sumptuous robes and her body are completely dissolved in ornament. She is enveloped in a veil, which falls in broad curves from her shoulders. But this is not all: it seems to melt harmoniously into the background, which frames and accentuates her face. The figure itself is displaced from the center, the veil only interrupts the golden void in the bottom part of the left half of the picture, emphasizing once again the asymmetric composition.

Gustav Klimt was obviously so fascinated by Korin's pair of screens that he now followed up with the composition of its second piece, the *White Plum Blossoms* (fig. 3a). Again, one can imagine this square picture (138 x 138 cm), divided vertically in two, and perceive just how much Klimt modeled the composition on Korin's.

One of the main characteristics of the so-called Rimpa school is the asymmetry in surprising two-dimensional composition. A balance between eccentricity and harmony resides in these usually large-scale works. There is no clash between the generous vacancy and implications of plenty; they fold into each other in curves and waves – can we not claim the same of the works of Gustav Klimt mentioned here?

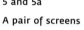

**A pair of screens**

Black-and-white book illustrations after an (unknown) original by

Ogata Korin, from: Hoitsu Sakai and Ohashi Shintaro, *Korin Hyakuzu:*

*100 paintings by Korin*, 2 vol., Tokyo, 1895

Of course, we already find this principle in rudimentary form in Klimt's *Sonja Knips* from 1898 (fig. 1, page 20). This was the very time in which he began to occupy himself with Japanese art, at first only in regards to motif, as we can also see in the bordure of the chalk drawing *Tragedy* (fig. 2, page 43) from 1897. As early as 1891, the border of the portrait of the young Emilie Flöge, with cherry blossoms on a golden background, first shows Japanese motifs. If we review his portraits of seated ladies – all of them square or nearly square – we can witness a development in the direction of ornamentalization and flattening, from the portrait of Sonja Knips (1898) to the likeness of Marie Henneberg (1901/02), and the likeness of Fritza Riedler (1906; fig. 1, page 20) up to the portrait of Adele Bloch Bauer I (fig. 4).

Art history not infrequently refers to James McNeill Whistler (1834–1903) as well as to other Western European artists as "models" for Klimt's portrait painting. Such comments should not be neglected: on the contrary – they were among the first to set their sights on Japan. And it is also typical for the way Japonisme evolved in Europe. London and Paris were home to the vanguard as it were; German-speaking artists looked to the West – and discovered the East! The indirect approach led to a direct examination of the art of East Asia.

Gustav Klimt, who never visited Japan himself, had gained his knowledge on the one hand from the many collections around him, from exhibitions and also, of course, from secondary literature. Klimt himself reports that he would retire to the study of "his Japanese books." Which books specifically he owned is unfortunately unknown, since the library was dispersed, but one work can be cited that he was sure to have known well: *Korinha gashu – Picture Collection of the Korin School* in five volumes, which also appeared in an English language edition.[3]

Indeed, this five-volume publication belonged to those works of the day that offered the most detailed and delicate illustrations. Not only the quality of the colors, but the reproduction of gold and silver as well are extraordinary. In addition to the color woodcuts, this work offered the chance to become acquainted with and appreciate the colors and composition of the works of the Rimpa school. During these years, Japonsime reached its peak within Klimt's oeuvre thanks to the possibility of studying directly Rimpa arts (figs. 5 and 5a) and, above all, through the works of Korin. The secondary Japonisme, which he got to know through the works of other artists, mutated by means of better sources to an independent decorative style. These observations provide us with another opportunity to discuss Klimt's "golden background." To put it simply, the question is: Byzantium/Ravenna or Japan?

In Japanese interior design and decorative painting, the traditional use of gold reaches back into the 16th century. Particularly in screen painting, narrative subject matter is presented before a golden foil. Beginning in the 17th century however, the artists of the Rimpa school no longer used gold merely as a background, but also as a sort of counterbalance to the simplified depiction of landscapes. In the mosaic tradition of Byzantium/Ravenna, gold was used as a background, in front of which the figures were portrayed. In this respect, Klimt tends to be on the Japanese side, designing the golden surfaces as part of the composition and not just as a foil. Gustav Klimt visited Ravenna in 1905 and was thus able to study the mosaics directly. This was just before his "Golden Phase," which is why it stands to reason that these personal art experiences are connected with the following period of work.

As previously discussed in relation to picture compositions, neither the one nor the other should be excluded here: the golden mosaics surely inspired Klimt to deal intensively with the complex of problems presented by "gold in the image." And in the art of Rimpa, he must have found his ideal.

## :STOCLET FRIEZE – 1908 TO 1911

This mosaic frieze brings fine arts and applied arts together (see fig.6). The two long mosaic friezes adorn the dining room of the Palais Stoclet, mounted across from each other on the longitu-

6

**The Stoclet Frieze, Right Wall: Fulfillment (Embrace), 1909–11**

Mixed technique, 200 x 738 cm,

Palais Stoclet, Brussels

dinal walls – like a matching pair of multiple-part screens. Each side has more than six parts; the rhythmization shows, apart from all other technical arguments, a parallel to the screen painting system of East Asia.

Upon entering the dining room, the first thing one notices is the figures which correspond to each other and then, afterwards, the two rose bushes. The composition is very calm. A large tree in the center of the mosaic stretches its stylized boughs and branches over all parts of the images, its gold spirals spread across the walls, replacing the gold surfaces of the "golden epoch." This tree only serves to unify two other, larger motifs: the people – the solitary girl and, opposite, the embracing couple – and the rose bushes. The mosaic friezes are decorative, they are calm, but they are not dull – the small number of motifs provide the composition with enough tension. The idea to interrupt a quiet composition with just a few motifs again shows parallels with Rimpa art. The representation of a continuous meadow serves as a foundation for the pictures: the bushes and trees stand rootless and as if upon flowing waves.

The dissolving of the bodies in surface ornament and their melding with each other gives us the opportunity to look back and compare the year 1902. The so-called *Beethoven Frieze* (plates 20, 20a and 21) was perhaps another conceptual formulation – public and not private, temporary, conceived as an ephemeral work for an exhibition and following a set subject matter. But, compared to the *Stoclet Frieze*, the execution of the "Japanese" elements is interesting. The *Beethoven Frieze* displays many ornamental references whose roots lie in the Far East. The often directly adopted samples were printed patterns and armorials or *katagamis*, Japanese coloring stencils, which had a strong influence on applied

arts and decoration in Vienna around 1900. The driving forces were Koloman Moser and Josef Hoffmann, so that Klimt had enough examples to make use of. Their use is, however, strictly motivistic.

In the portrait of *Adele Bloch-Bauer I* (fig. 4), *The Kiss* (fig. 5, page 18) and finally *Fulfillment* in the *Stoclet Frieze* (fig. 6), there is not only a rounding of individual motifs, but the Japanese origin of the patterns is only just discernible. Klimt's interest in the conception in its entirety concerned him more than the detail, which would seemingly represent a departure, but was moreover an arrival at a much more profound accord.

## : PORTRAITS – 1912 TO 1916

A final group of portraits of women was produced in Klimt's new studio in Hietzing, where, as described in the opening, he received his unexpected Japanese guest, Ohta, in 1913. The latter must have been well-informed concerning Klimt's art and was duly expecting to see golden pictures, but he was, as he notes in his aforementioned essay, disappointed: "...I reported that he uses gold and silver only sparingly, and that he paints entirely differently from the way one would presume. ..."

It would seem that indeed a certain change of style did take place parallel to the relocation of his studio to Hietzing. Klimt painted more openly but, at the same time, a realism remained in his portraits; the ornamental fusions and layering, as for example in the *Stoclet Frieze*, gave way to a unified conception of figure and background, as if he wanted to interpret the subject matter additionally through the décor. And, to this end, Japan was evidently no longer sufficient. The décor tended toward the figural.

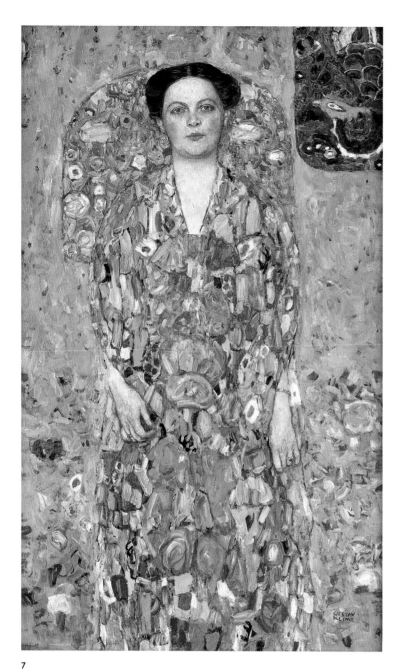

7

**Eugenia (Mäda) Primavesi, 1914**

Oil on canvas, 140 x 84 cm,

Toyota Municipal Museum of Art, Toyota City

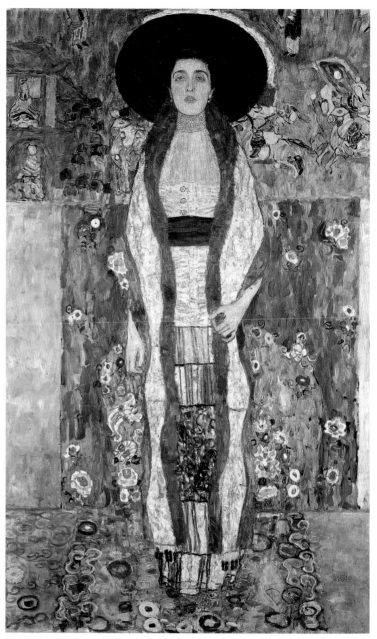

8

**Adele Bloch-Bauer II, 1912**

Oil on canvas, 190 x 120 cm,

private collection

Until 1910, Klimt suffused his portraits with more dynamics by using a more or less pronounced lateral view – the subjects regard us slightly askew, slightly asymmetrically. In the portraits produced after 1912 however he maintains a frontal view. The subjects sit and stand looking straight ahead and frontally; one could almost describe the likenesses as rigid (figs. 7 and 8).

Diverse ornaments and color fields take the depth from every space. The figures stand without shadowing; their bodies, clad in the heavily geometric but softly falling waves of their robes, are highly ornamentalized. The soft curves of the garments define the body in contrast to the surfaces which are delimited by line and color. These are, on the one hand, floral in design and, on the other, one can distinguish apparently Chinese equestrian or theater scenes. Conjecture that Klimt was using variations of decorations from porcelain vases, can probably not be verified. However, we are reminded more of textiles and silk hangings, which were embroidered and painted, like the ones Klimt must have owned. Motifs from "dragon robes" can be discerned.

**9**

Portrait of the Qianlong Kaiser, attributed to Giuseppe Castglioni, 1736

Palace Museum, Beijing.

**10**

Friederike Maria Beer-Monti, 1916

Oil on canvas, 168 x 130 cm, Mizne Blomental Collection, Tel Aviv Museum of Art

Is it only coincidence that Klimt combined his frontal portraits with Chinese décor? Probably not. Ancestral and sovereign portraits (fig. 9), but depictions of important deities as well – such as Klimt had in front of him at his studio in Hietzing daily – have a long tradition in East Asia and are always frontal, this being considered the ideal and truest form of portrayal for a person. Sumptuously ornamented robes and the wood carvings of the throne form an "ornamental plinth" in Chinese portrait painting similar to that aspired to by Klimt. This dense ornamentation spreads across the entire picture in Klimt's works, to the point of "horror vacui" in the Beer-Monti likeness from 1916 (fig. 10).

Gustav Klimt was an avid reader and seeker. Fascinated by works of art history, he took over material and changed it to suit his purposes. He remained true to European traditions with regard to content; the subjects that he took up were familiar to Europeans. But as regards composition and design, he was open to new ideas and did not attempt to make a secret of his "love" for the Far East. In his oeuvre, we can trace a constant development from an adoption of motifs, to independent variations with elements of style from the so-called Rimpa school, to a turning toward Chinese portrait art and the figural ornament as he had discovered it in Chinese textile art.

1  Kijiro Ohta and Gustav Klimt, *Zu Besuch bei Klimt in Wien. Das Atelier in Unter St. Veit in Wien* (Vienna: 2005)

2  Peter Pantzer and Johannes Wieninger (ed.), *Verborgene Impressionen. Hidden Impressions. Japonismus in Wien. Japonisme in Vienna. 1870–1930* (exhibit. cat. Österreichisches Museum für angewandte Kunst: Vienna 1990)

3  *Korinha Gashu, Picture Collection of the Korin School*, 5 volumes, Tokyo, 1906–1909

# PLATES

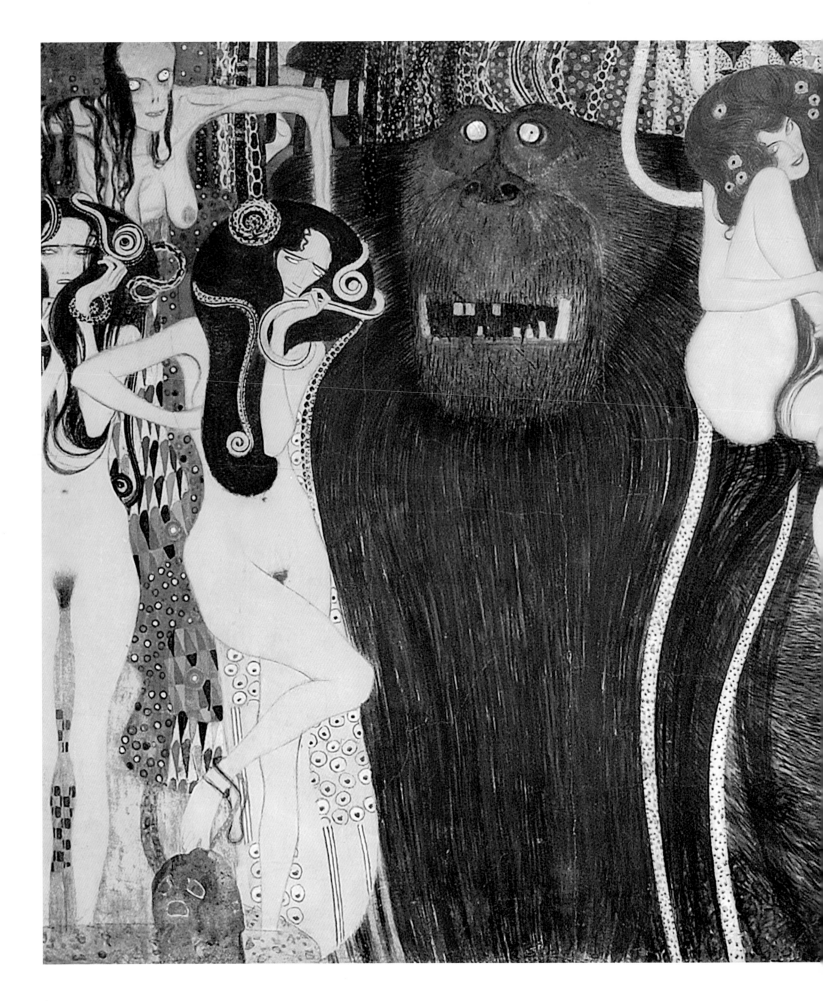

# PAINTINGS
# BY GUSTAV KLIMT

1

**Study of a Girl's Head, 1880**

Oil on canvas, 43 x 30 cm,

private collection

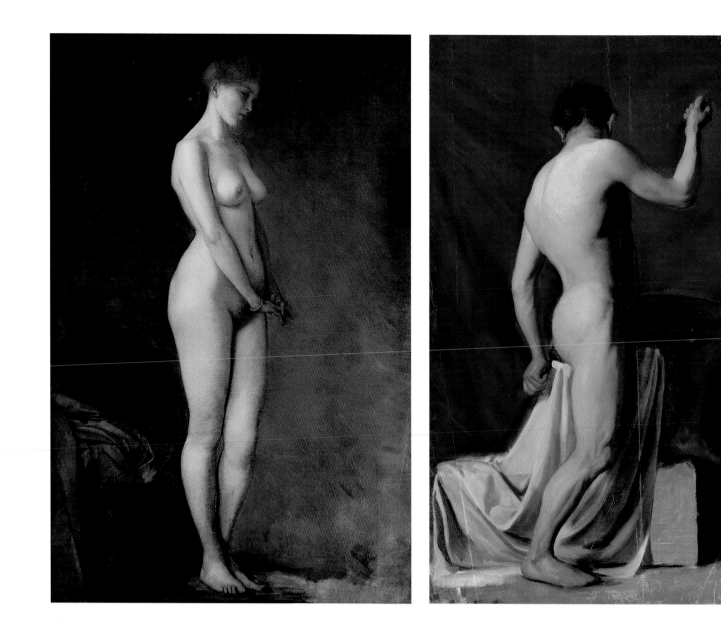

3

**Study of a Female Nude, c. 1883**

Oil on canvas, 86,5 x 42,5 cm,

private collection

4

**Male Nude Facing Right, c. 1883**

Oil on canvas, 75 x 48,5 cm

private collection, courtesy

Galerie St. Etienne, New York

**5**
**Savoyard Boy, c. 1882**
Oil on canvas, 39,5 x 25 cm
private collection

6

**Portrait of a Child with Flowers, c. 1883**

Miniature on ivory, diam. 3,5 cm

private collection

**Portrait of a Child on Brown
Background, c. 1883**
Miniature on ivory, diam. 3,5 cm,
private collection

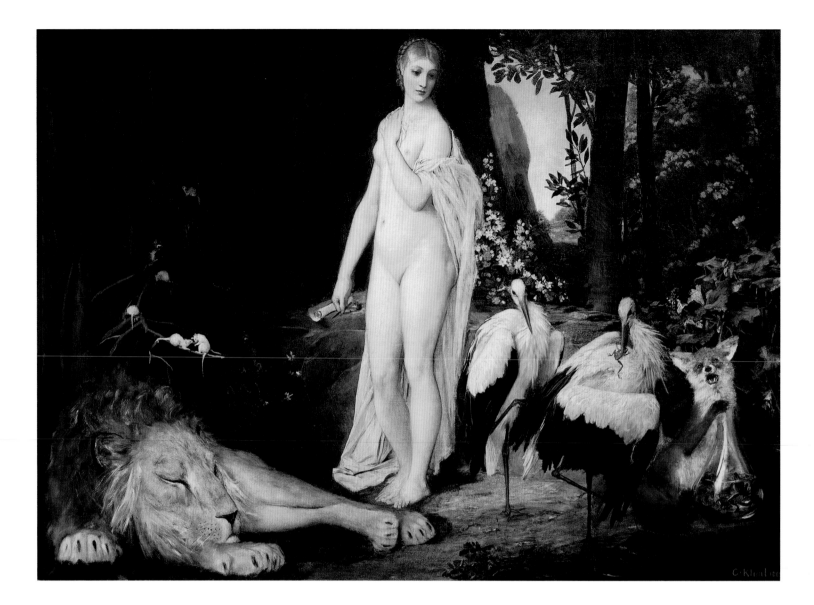

**8**

**Fable, 1883**

Oil on canvas, 84,5 x 117 cm,

Wien Museum, Vienna

(Not in exhibition)

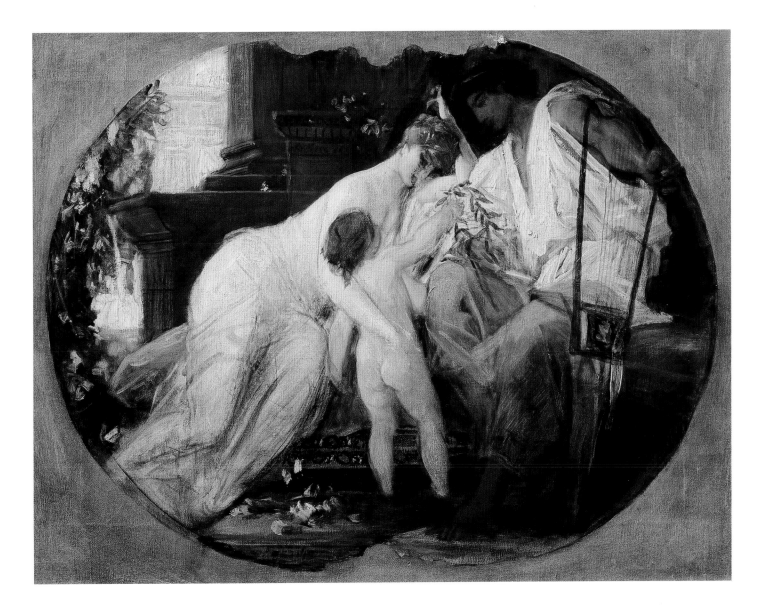

**Mythological Scene: Amor Giving a
Laurel Wreath to a Singer, 1885**
Oil on canvas, 35,5 x 49,8 cm,
Muzeul National de Arta al României

10

**Poster Design for the "International Exhibition
of Music and Theatrical Art", 1892**

Oil on canvas, 84 x 56 cm,

Wien Museum, Vienna

**11**
**Marie Breunig, c. 1894**
Oil on canvas, 155 x 75 cm,
private collection

**12**

**Love, 1895**

Oil on canvas, 60 x 44 cm,

Wien Museum, Vienna

(Not in exhibition)

**Schubert at the Piano (Study for**
**the painting of the same title), 1896**

Oil on canvas, 30 x 39 cm,

private collection

**14**

**Woman with Fur Collar, 1897/98**

Oil on cardboard, mounted on wood,

36 x 19,7 cm,

private collection, courtesy

Galerie St. Etienne, New York

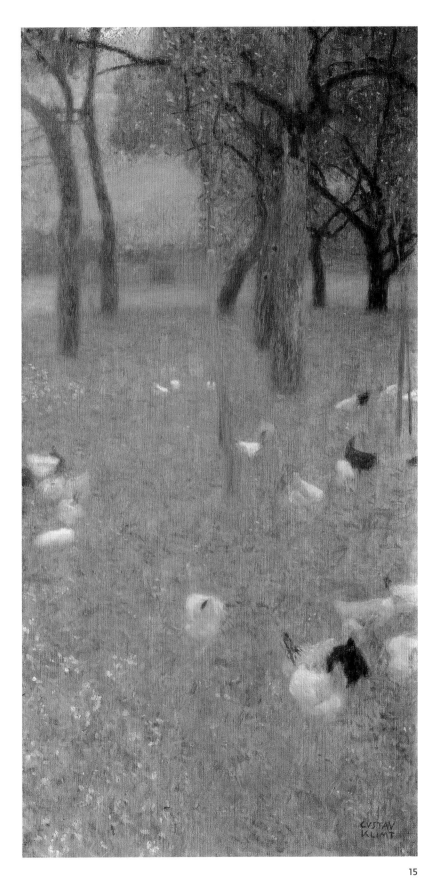

15

**After the Rain (Garden with
Chickens in St. Agatha), 1898**

Oil on canvas, 80 x 40 cm,

Belvedere, Vienna

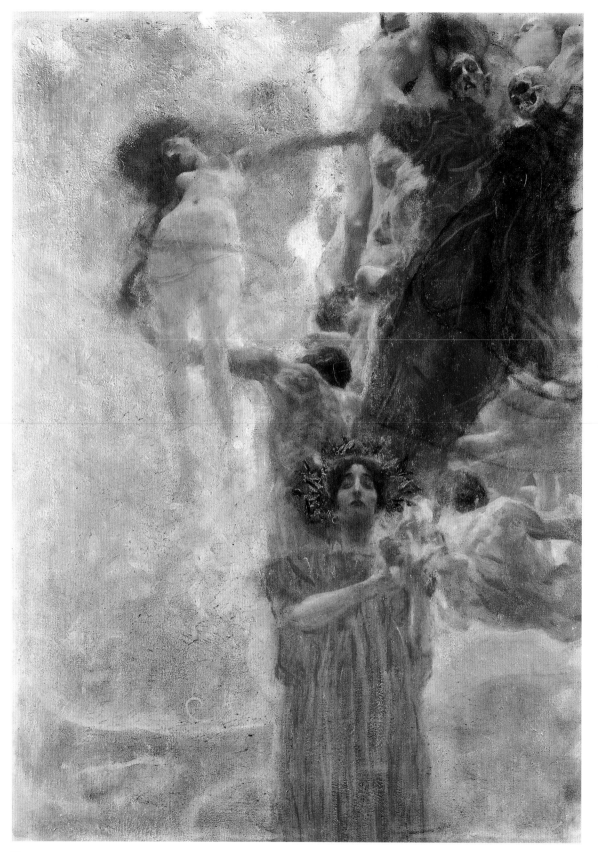

**16**

**Medicine (Composition Study for
the painting of the same title), 1898**

Oil on canvas, 72 x 55 cm,

private collection

**17**

**Moving Water, 1898**

Oil on canvas, 53 x 66,4 cm,

private collection, courtesy

Galerie St. Etienne, New York

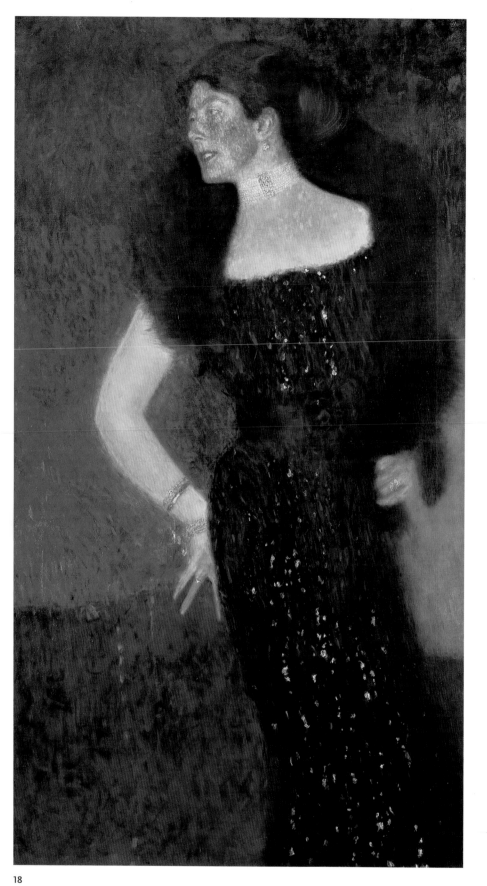

**18**

**Rose von Rosthorn-Friedmann, 1900/01**

Oil on canvas, 140 x 80 cm,

private collection, Vienna (Not in exhibition)

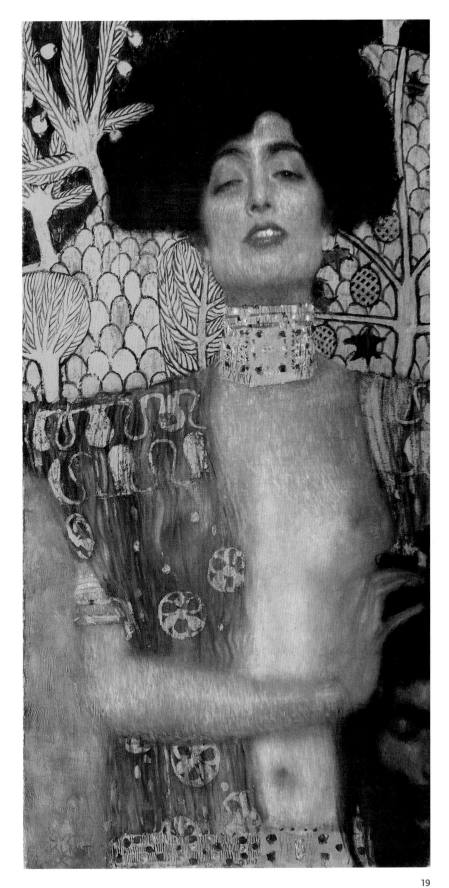

**Judith I, 1901**

Oil on canvas, 84 x 42 cm,

Belvedere, Vienna

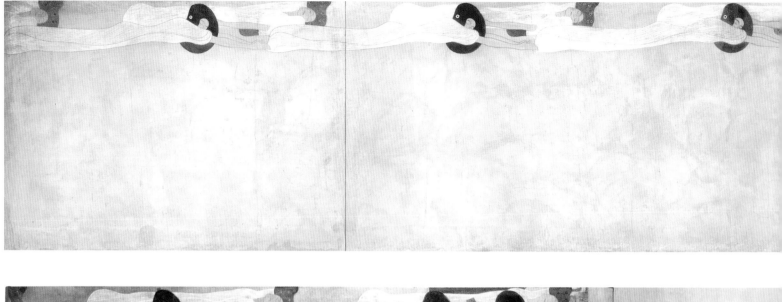

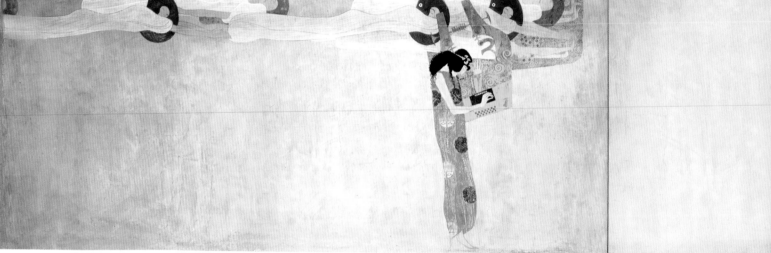

**20 and 20a**

**Beethoven Frieze – Reconstruction of the 1903 Installation at**

**the Vienna Secession (Comprising Seven Panels), 1901–02**

Above: left wall, below: right wall

Casein, gold pigment, black and colored chalk, graphite, stucco

and various materials (glass, mother of pearl, gold) on plaster,

full length: 34,14 m (13,92 x 6,30 m), height: 2,15 m,

Belvedere, Vienna

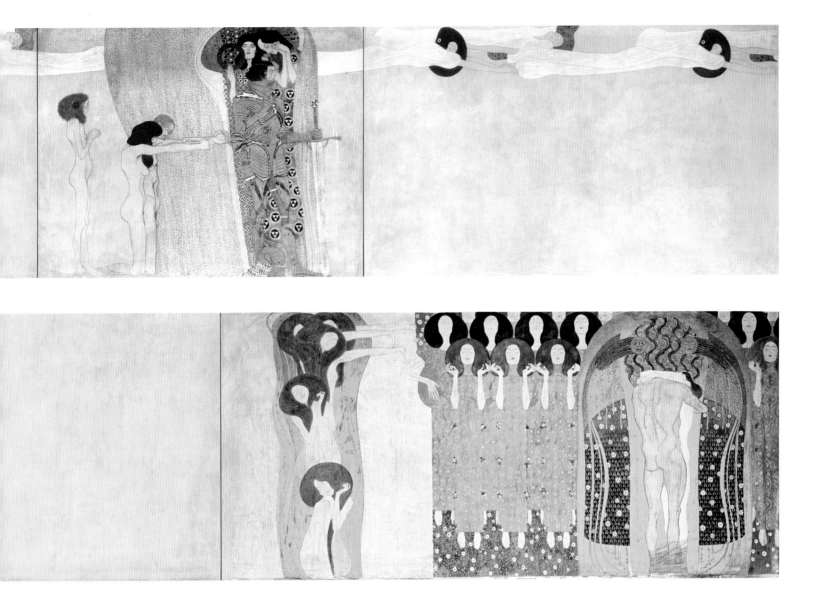

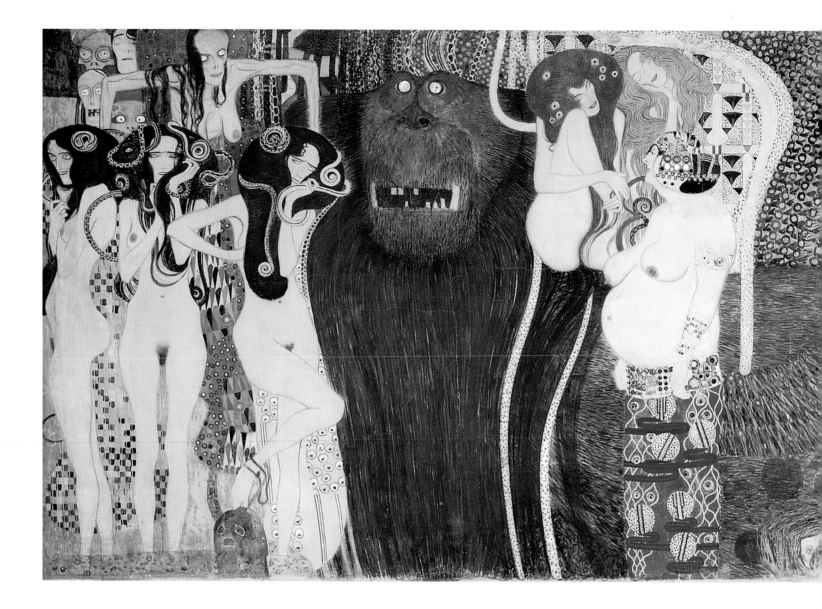

21

**Beethoven Frieze – Reconstruction of the 1903 Installation at the Vienna Secession (Comprising Seven Panels), 1901–02**
Middle wall
Casein, gold pigment, black and colored chalk, graphite, stucco
and various materials (glass, mother of pearl, gold) on plaster,
full length: 34,14 m (13,92 x 6,30 m), height: 2,15 m,
Belvedere, Vienna

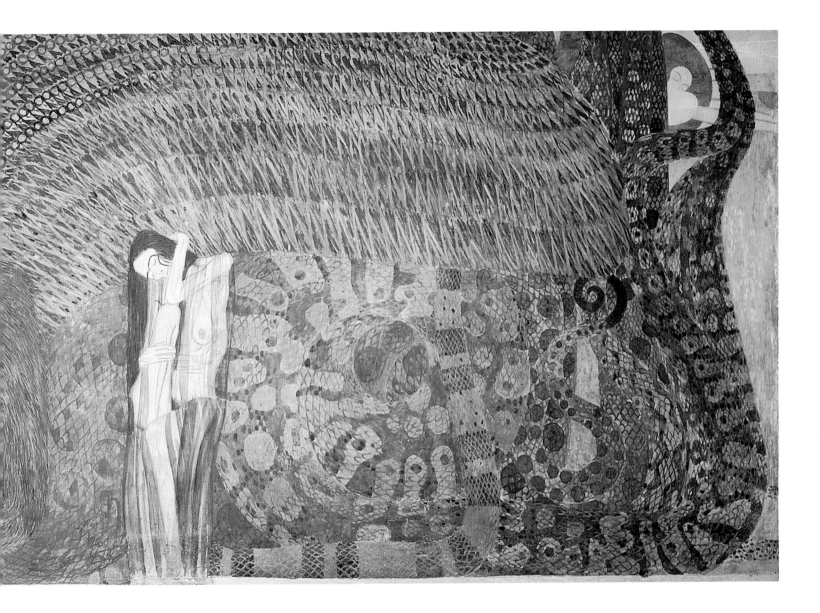

22

**Gustav Zimmermann**

**(Son of Gustav Klimt), 1902**

Oil on canvas,

private collection

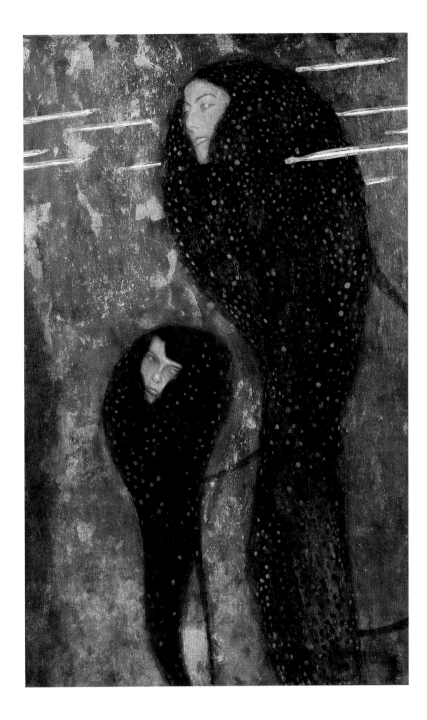

**Silverfish (Water Nymphs), 1901/02**

Oil on canvas, 60 x 44 cm,

Kunstsammlung Bank Austria, Vienna

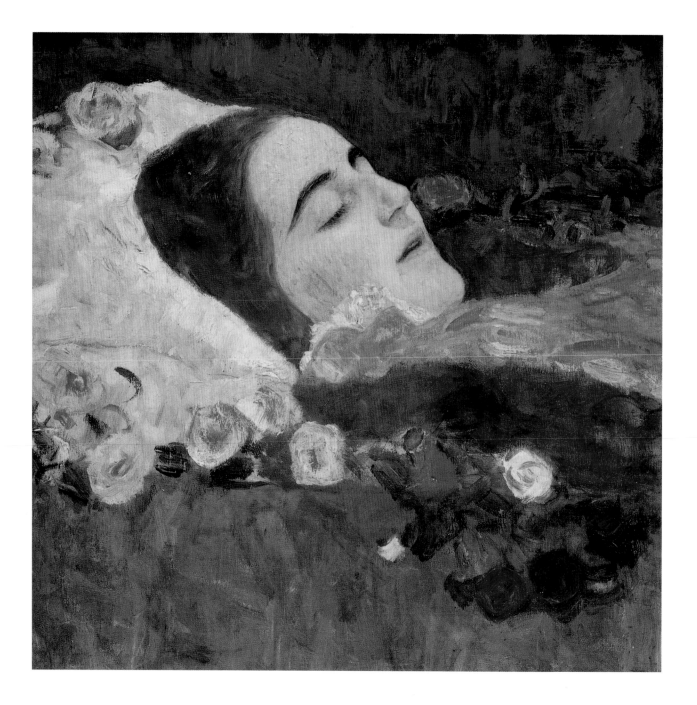

**24**

**Maria (Ria) Munk, 1912**

Oil on canvas, 50 x 50,5 cm,

private collection, courtesy

Richard Nagy Ltd., London

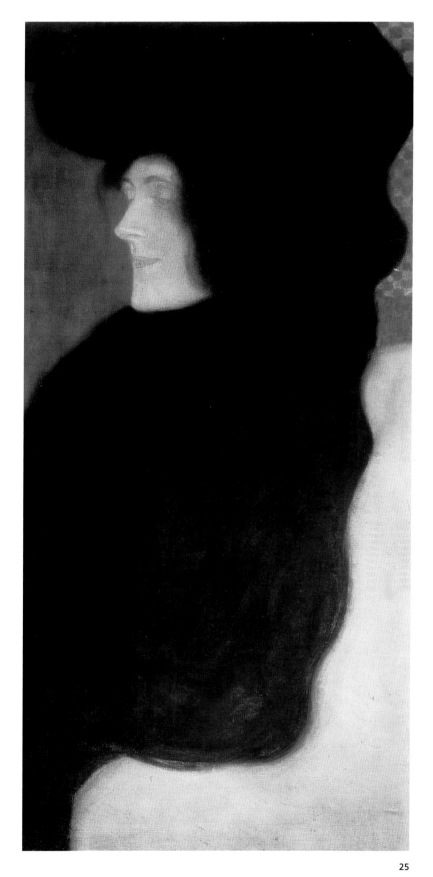

**25**
**Pale Face, 1903, revised 1904/05**
Oil on canvas, 80 x 40 cm,
private collection, courtesy
Neue Galerie New York

87

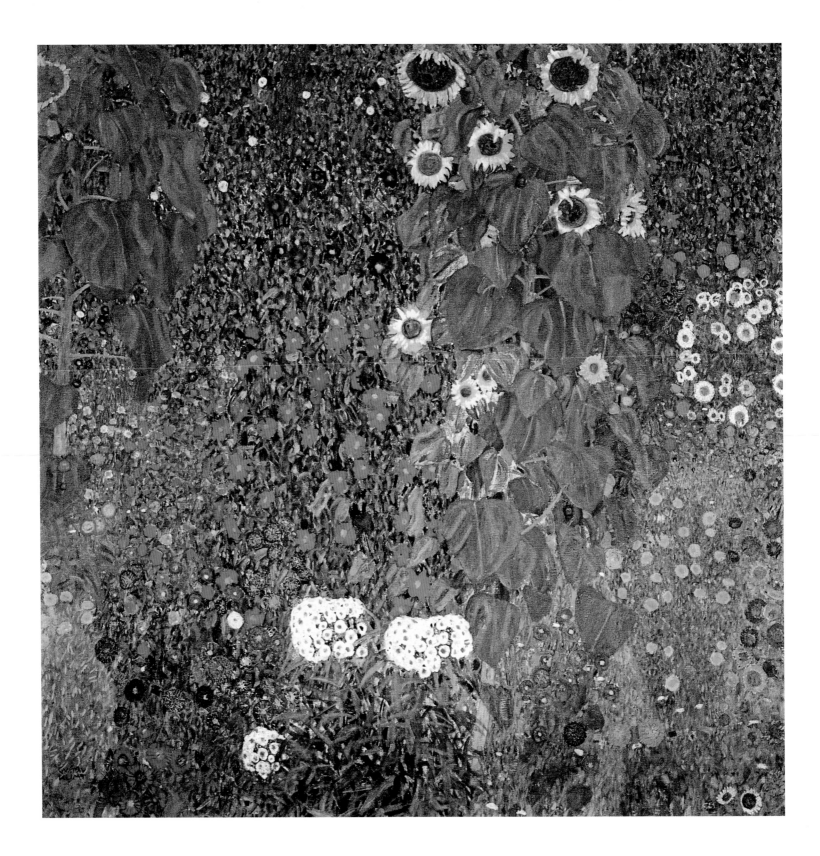

**26**

**Farm Garden with Sunflowers, 1908**

Oil on canvas, 110 x 110 cm,

Belvedere, Vienna

(Not in exhibition)

**Promenade in Schloss
Kammer Park, 1912**
Oil on canvas, 110 x 110 cm,
Belvedere, Vienna

28

**Italian Garden Landscape, 1913**

Oil on canvas, 110 x 110 cm,

Kunsthaus Zug, Stiftung Sammlung Kamm

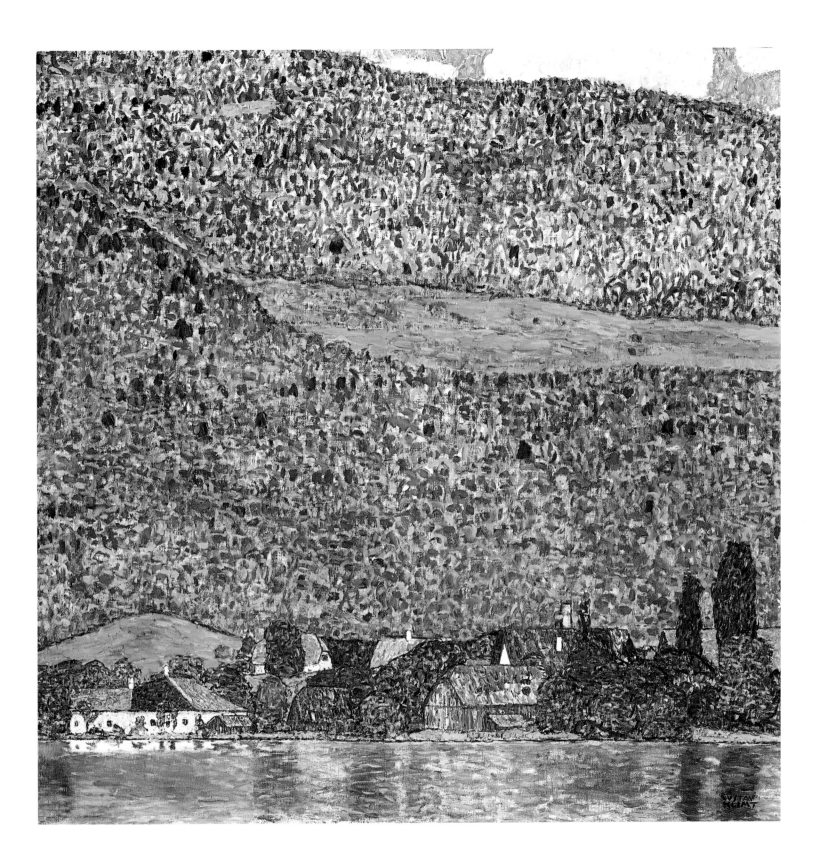

**Litzlberg on the Attersee, 1914**

Oil on canvas, 110 x 110 cm,

Museum der Moderne Rupertinum, Salzburg

**30**

**Johanna Staude, 1917**

Oil on canvas, 70 x 50 cm,

Belvedere, Vienna

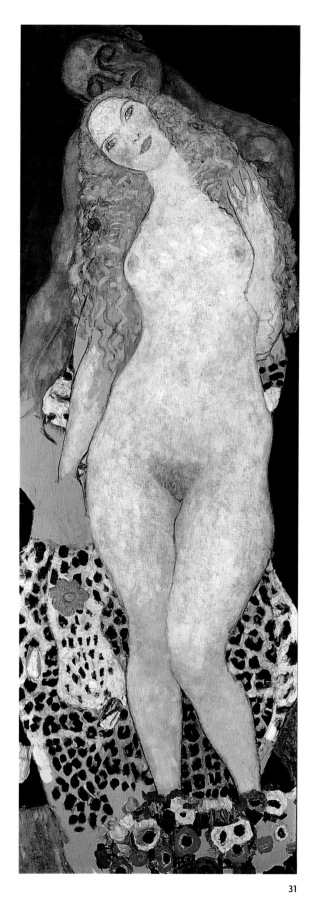

**31**

**Adam and Eve, 1917**

Oil on canvas, 173 x 60 cm,

Belvedere, Vienna

**32**
**Amalie Zuckerkandl,**
**1917 (unfinished)**
Oil on canvas, 128 x 128 cm,
Belvedere, Vienna

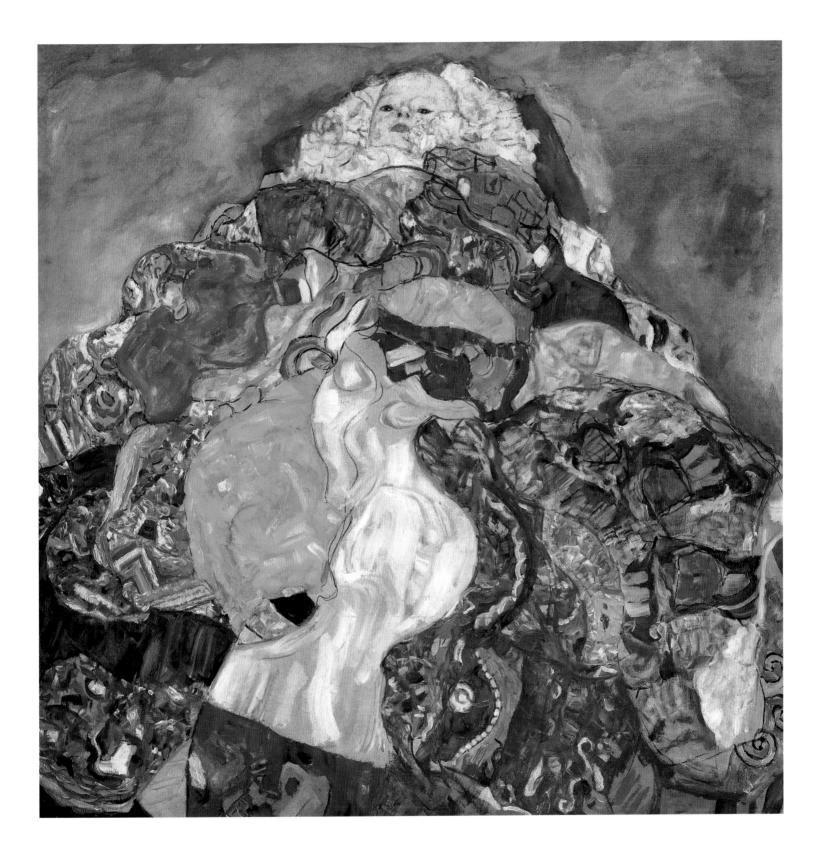

**33**

**Baby (Cradle), 1917**

Oil on canvas, 110 x 110 cm,

National Gallery of Art, Washington; Gift from Otto and Franziska Kallir

with the support of the Carol and Edwin Gaines Fullinwider Fund 1978

# DRAWINGS
# BY GUSTAV KLIMT

**34**

**Head of a Young Man, Reclining**

**(Study for "Shakespeare's Theater" in the Burgtheater), ca. 1887**

Black crayon and pencil with white highlights on paper, 44,8 x 31,4 cm,

Albertina, Vienna

**35**
**Head of a Girl, Reclining**
**(Study for "Shakespeare's Theater" in the Burgtheater), c. 1887**
Black crayon and pencil with white highlights on paper, 27,3 x 42,2 cm,
Albertina, Vienna

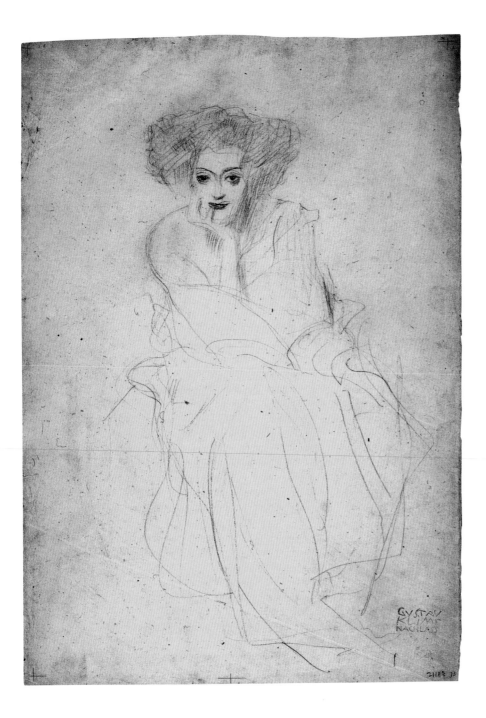

**36**

**Seated Woman, Chin Resting in Right Hand**

**(Study for "Music II"), c. 1897**

Black crayon on paper, 44,5 x 31,7 cm,

private collection, courtesy

Galerie St. Etienne, New York

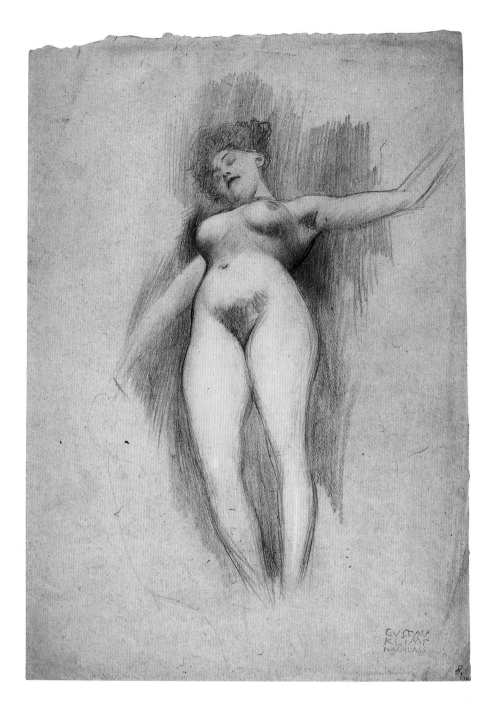

**Floating Female Nude in Front of Dark Background
(Study for "Medicine"), c. 1896**
Pencil with white highlights on paper, 45,1 x 32 cm,
private collection, courtesy
Galerie St. Etienne, New York

**38**

**Standing Female Nude**

**(Study for "Medicine"), c. 1897**

Black crayon on paper, 47,8 x 31,4 cm,

Albertina, Vienna

**39**

**Floating Woman with Raised Left Arm
(Study for "Medicine"), 1897/98**

Black crayon on paper, 45,7 x 31,9 cm,

Albertina, Vienna

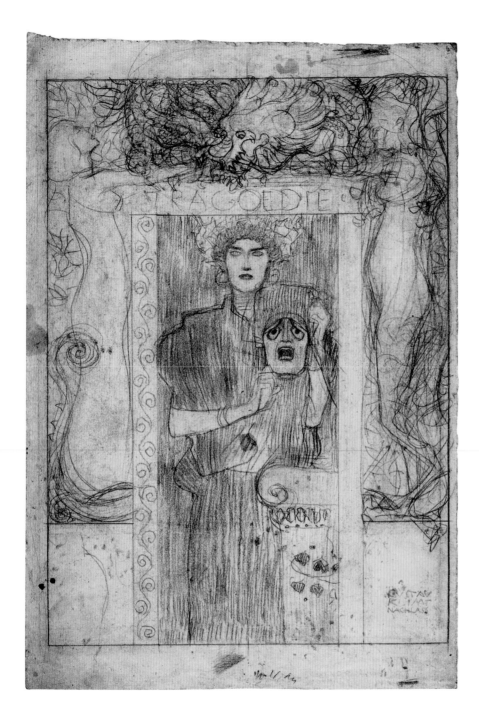

**40**
**Study for "Tragedy", 1897**
Pencil and black crayon on paper, 45,7 x 31,5 cm,
private collection, courtesy
Galerie St. Etienne, New York

**Study of a Man's Head in Profile**

**(Illustration for "Ver Sacrum"), 1897/98**

Ink, with corrections in white gouache, 9 x 9,1 cm,

Albertina, Vienna

**42**

**Standing Girl in Profile,**

**Facing Left (Torso), 1898**

Red and blue  pencil on paper, 45 x 31,6 cm,

Wien Museum, Vienna

**43**
**Pregnant Woman with Man, Facing Left**
**(Study for "Hope I"), 1902/1903**
Blue and orange pencil on paper, 44,8 x 30,5 cm,
private collection, courtesy
Galerie St. Etienne, New York

**44**

**Study for the "Beethoven Frieze"**

**(Gorgon to the Left), 1901–02**

Black crayon on paper, 45,1 x 31,3 cm,

Albertina, Vienna

**45**
**Study for the "Beethoven Frieze"**
**(Gorgon to the Right), 1901–02**
Black crayon on paper, 44,4 x 31,8 cm,
Albertina, Vienna

**46**

**Seated Female Nude (Study for the**
**"Beethoven Frieze": The Arts), 1901–02**

Black chalk on paper, 44,5 x 29,8 cm,

private collection, courtesy

Galerie St. Etienne, New York

Reclining Nude Girl, Right Hand Visible
Above Head (Study for the "Beethoven
Frieze": Longing for Happiness), 1901–02
Charcoal on paper, 37,2 x 56,5 cm,
private collection, courtesy
Neue Galerie New York

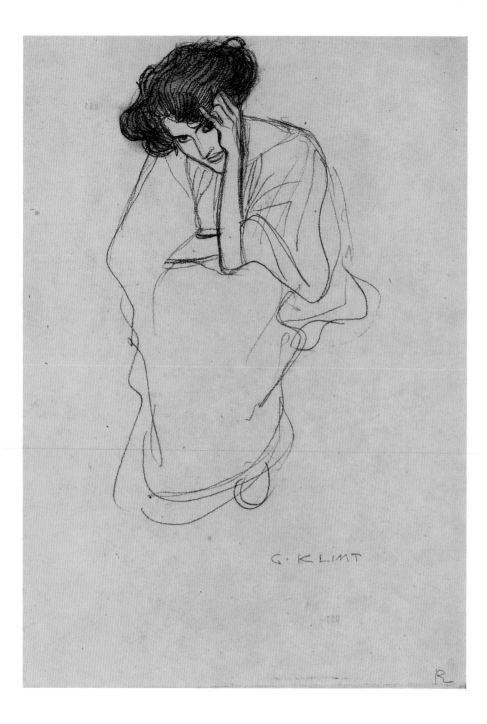

**48**

**Seated Woman, Resting, 1901–02**

Charcoal on paper, 44,5 x 31,8 cm,

private collection, courtesy

Neue Galerie New York

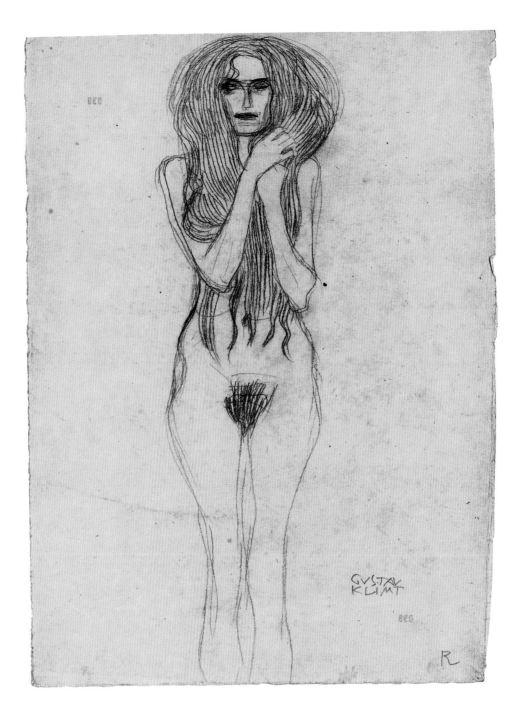

**49**
**Female Nude, Facing Front**
**(Study for the "Beethoven Frieze":**
**Gorgon in the Middle), 1901–02**
Charcoal on paper, 44,8 x 32,7 cm,
private collection, courtesy
Neue Galerie New York

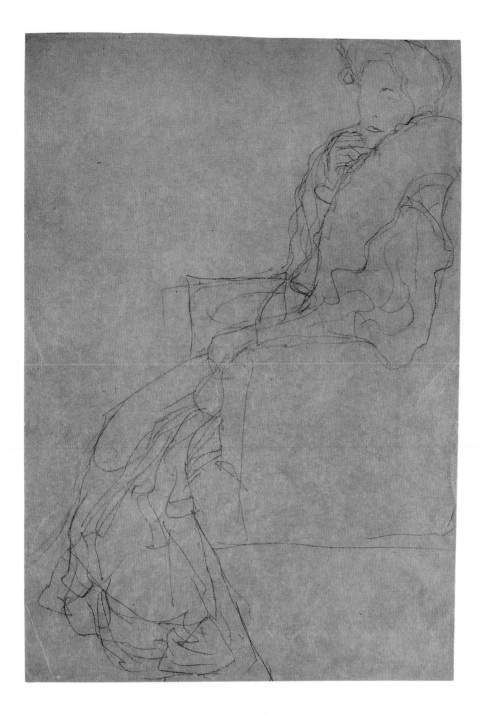

**50**

**Fritza Riedler, Seated, Facing Left**

**(Study for the painting of the same subject), c. 1905**

Black crayon on paper, 45,6 x 31,3 cm ,

Wien Museum, Vienna

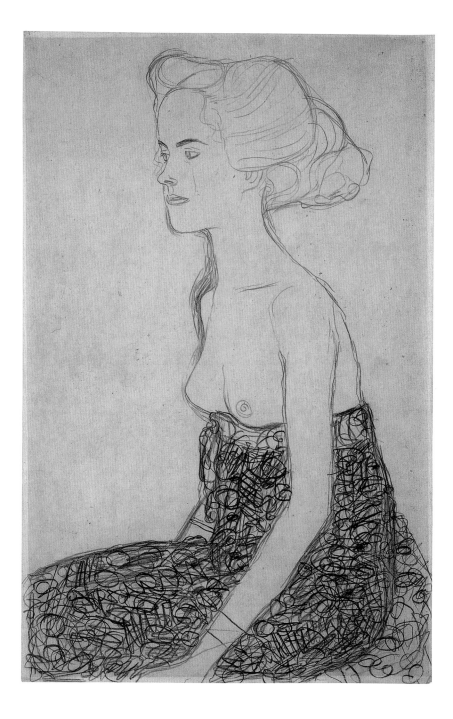

**Seated Semi-Nude, Facing Left, 1904/05**

Pencil on paper, 56 x 37 cm,

Kunsthaus Zug, Stiftung

Sammlung Kamm, Switzerland

**52**

**Reclining Female Nude with**

**Bent Right Leg , 1905/06**

Blue pencil on paper, 36,4 x 56 cm,

Wien Museum, Vienna

**54**

**Standing Female Dancer with Raised Forearm**

**(Study for "Expectation"), c. 1907**

Pencil on paper, 55,9 x 37 cm,

Wien Museum, Vienna

**Two Studies of a Standing Female Dancer with Raised Forearm**

**(Study for "Expectation"), c. 1907**

Pencil on paper, 55,9 x 37,1 cm,

Wien Museum, Vienna

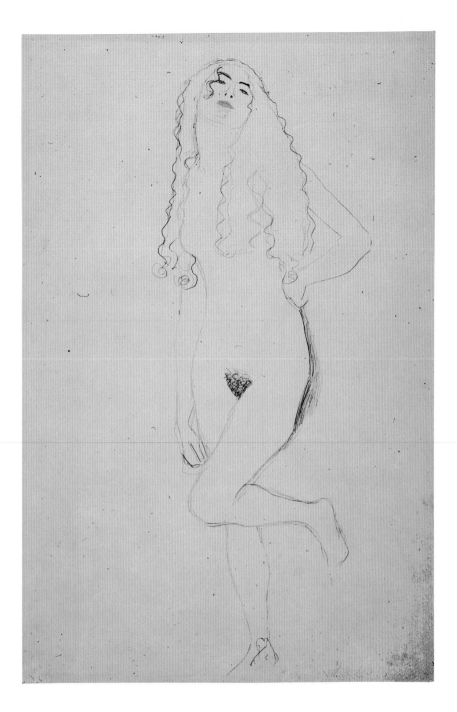

**56**
**Standing Female Nude with Long Hair**
**and Raised Left Leg, 1906/07**
Pencil and red pencil on paper, 55,8 x 37,2 cm,
private collection, courtesy
Galerie St. Etienne, New York

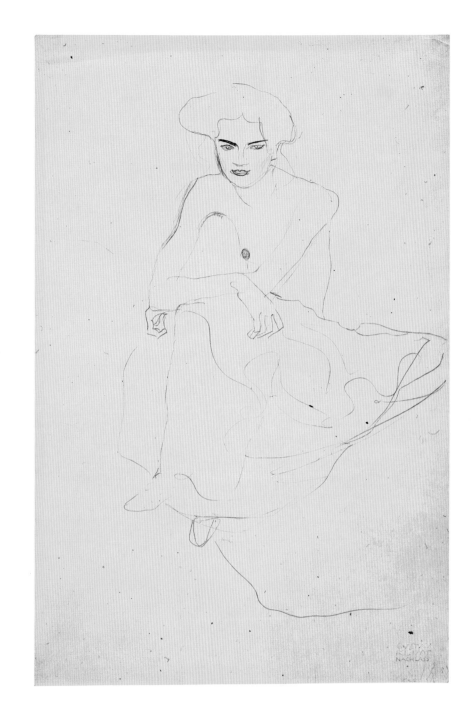

**57**

**Seated Female Semi-Nude,**

**Facing Front, c. 1907**

Pencil with red and blue pencil highlights on paper, 56.1 x 37.2 cm,

private collection, courtesy

Galerie St. Etienne, New York

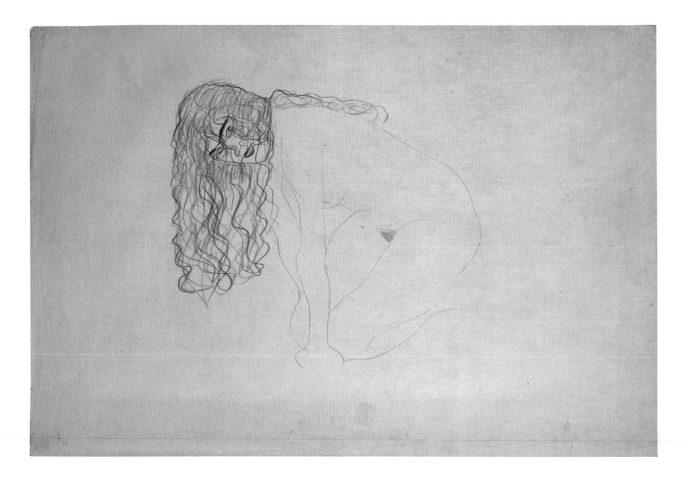

**58**
**Crouching Female Nude with**
**Hair Over Face, c. 1907**
Blue pencil on paper, 37,2 x 56 cm,
Wien Museum, Vienna

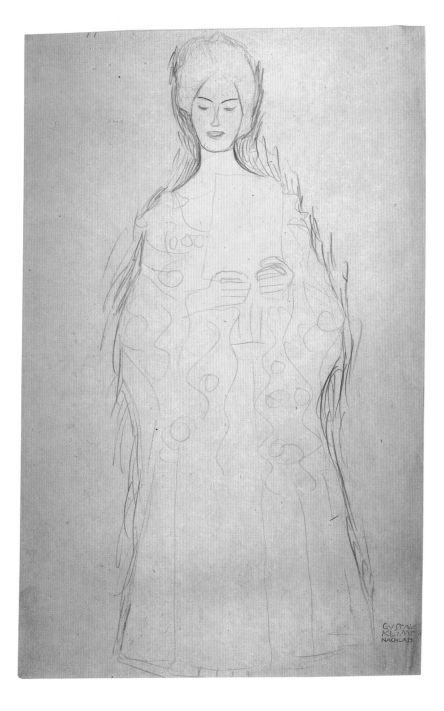

59
"Reading" or "Singing" Woman,
Facing Front, c. 1907
Red and blue pencil on paper, 55,9 x 36,8 cm,
private collection, courtesy
Neue Galerie New York

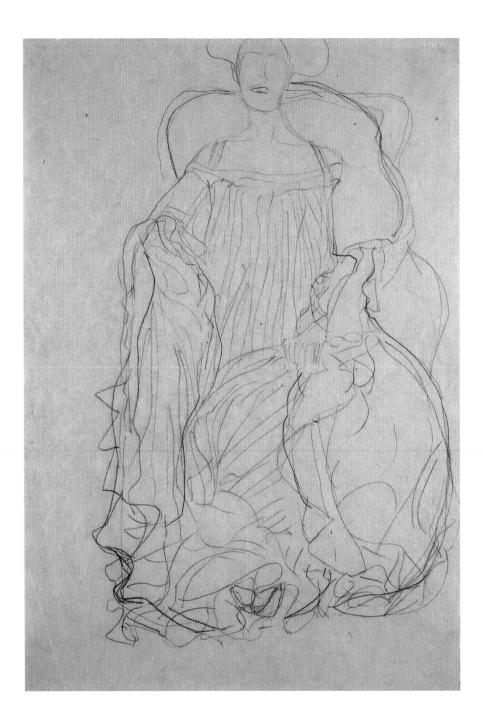

**60**

**Adele Bloch-Bauer with Boa Over Left Shoulder, Seated, Facing Front**

**(Study for the painting of the same subject), 1903–04**

Black crayon on paper, 45,1 x 31,4 cm,

private collection, courtesy Neue Galerie New York

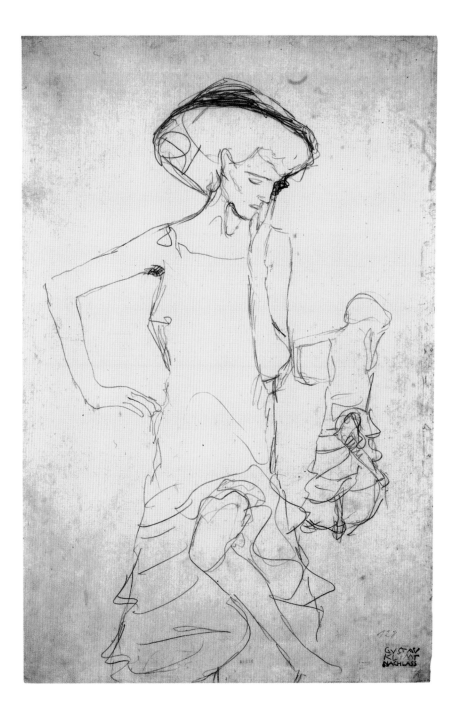

**61**
**Female Dancer with**
**Raised Leg, 1907/08**
Pencil on paper, 56,2 x 36,8 cm,
Albertina, Vienna

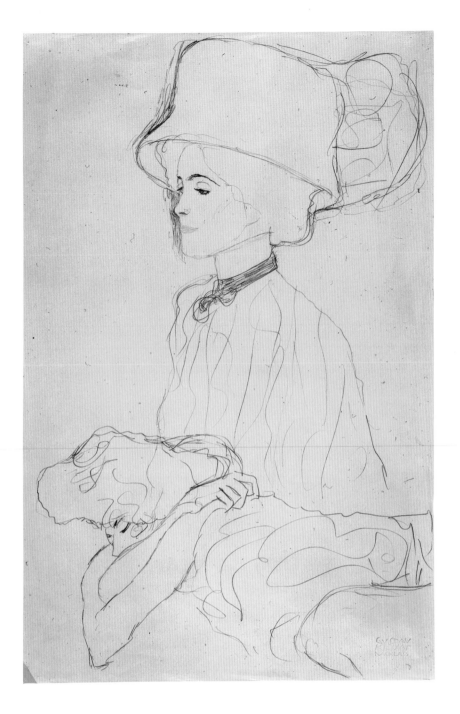

**62**

**Portrait of a Woman in a Tall Hat**

**and Reclining Woman, 1907/08**

Pencil and red pencil on paper, 55,9 x 37,1 cm,

private collection, courtesy

Galerie St. Etienne, New York

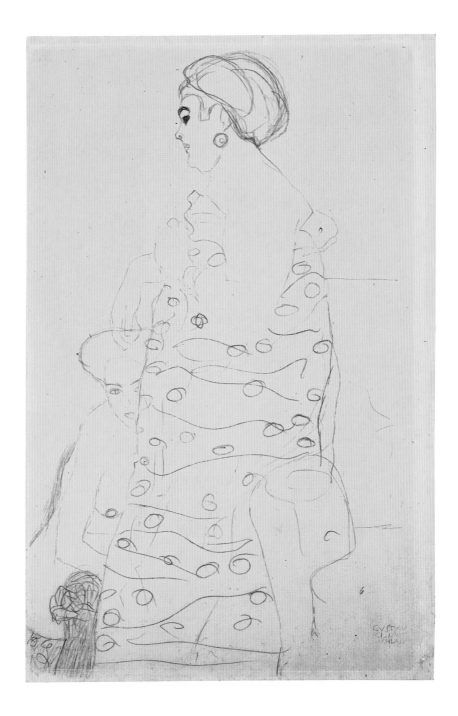

63
**Heavy Clothed Woman with**
**Female Nude Half-Hidden at Her Feet, 1908**
Blue pencil on paper, 56,2 x 37,1 cm,
private collection, courtesy
Galerie St. Etienne, New York

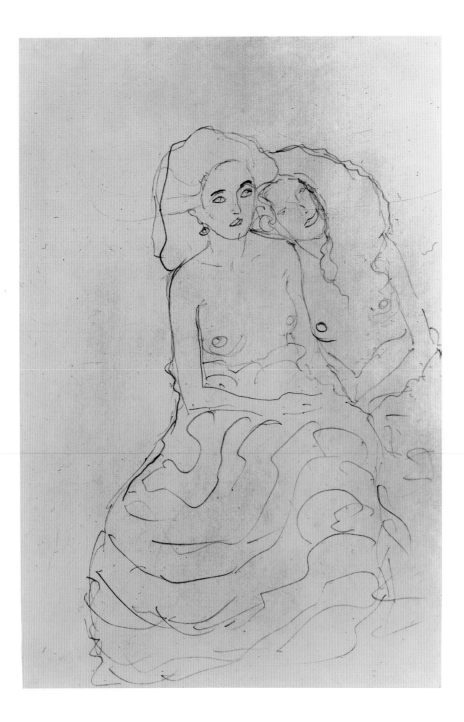

**64**
**Two Seated Girlfriends,**
**Facing Right, 1910**
Pencil on paper, 56 x 37,4 cm,
Wien Museum, Vienna

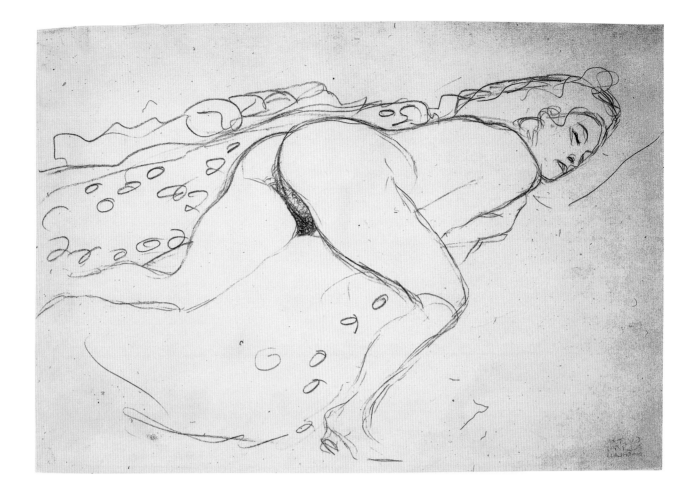

**65**
**Reclining Woman Lying on Stomach,**
**Facing Right, 1910**
Blue pencil on paper, 36,5 x 53,3 cm,
private collection, courtesy
Galerie St. Etienne, New York

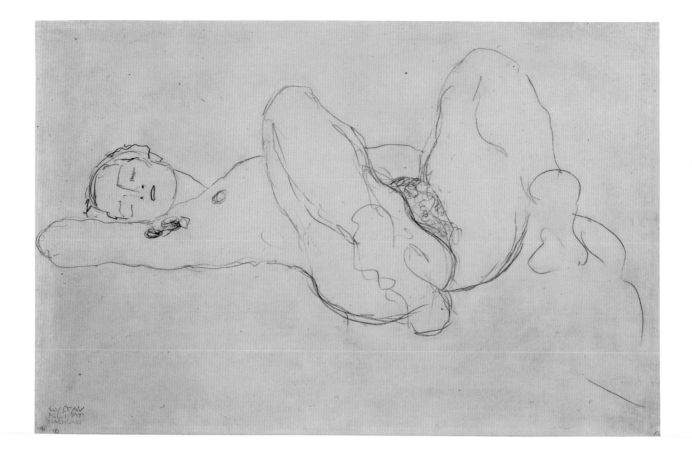

**66**

**Reclining Nude with Raised Legs,**
**Facing Left, c. 1912/13**

Pencil on paper, 36,2 x 56,3 cm,

private collection, courtesy

Galerie St. Etienne, New York

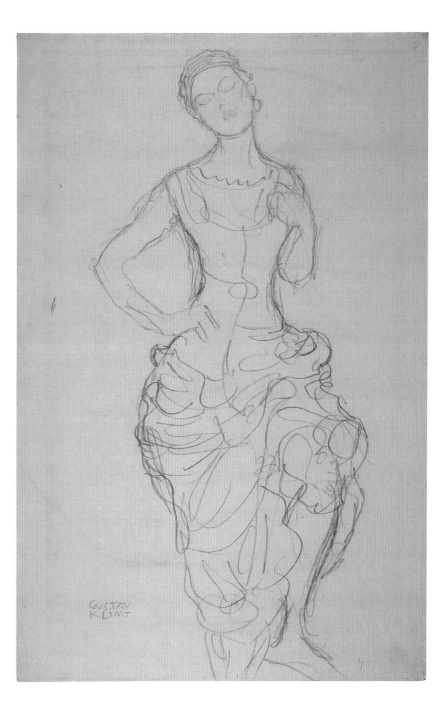

**67**

**Girl with Bunched-Up Skirt**

**(Study for "The Virgin"), 1912/13**

Pencil on paper, 54 x 32,5 cm,

Albertina, Vienna

**68**

**Standing Girl with Hands on Hips**

**(Study for the "Portrait of Mäda Primavesi"), 1912/13**

Pencil on paper, 56,7 x 37 cm,

Albertina, Vienna

**Seated Girl (Study for the "Portrait
of Mäda Primavesi"), 1912/13**
Pencil on paper, 55,9 x 36,7 cm,
Albertina, Vienna

**70**

**Recumbent Seated Semi-Nude, 1913**

Pencil on paper, 55,9 x 37,1 cm,

Wien Museum, Vienna

**Seated Semi-Nude with**

**Closed Eyes, 1913**

Pencil on paper, 56,7 x 36,9 cm,

Wien Museum, Vienna

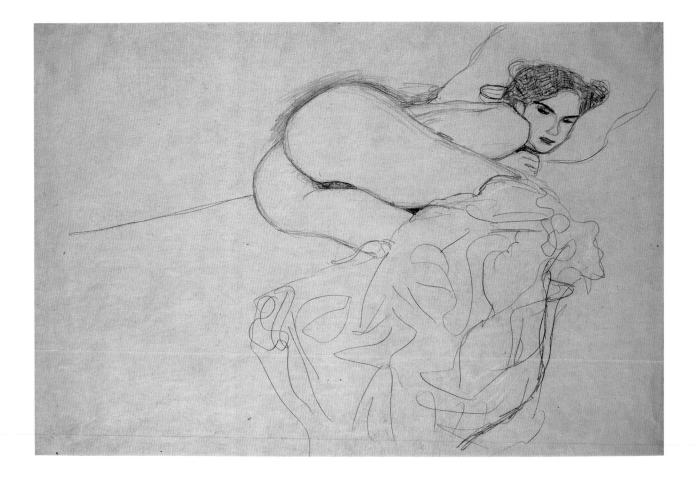

**72**

**Reclining Nude with Bent Knees,**

**Facing Right, 1913**

Pencil, blue and red pencil with white crayon on paper, 37 x 55,8 cm,

Wien Museum, Vienna

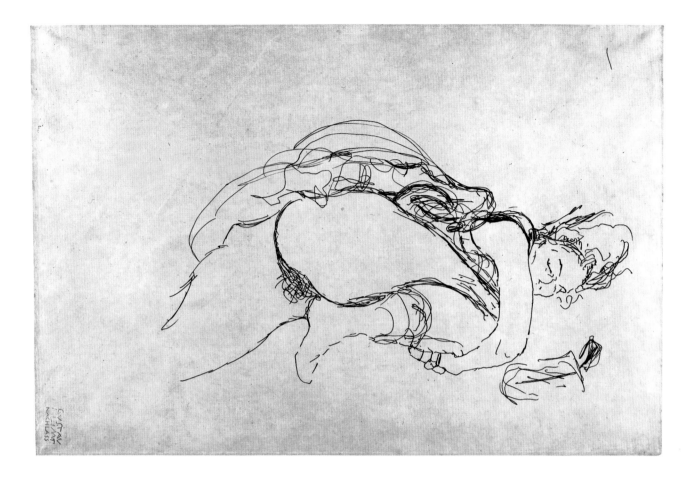

**Crouching Semi-Nude,**
**Facing Right, 1913**
Ink on paper, 37,2 x 56,5 cm,
Wien Museum, Vienna

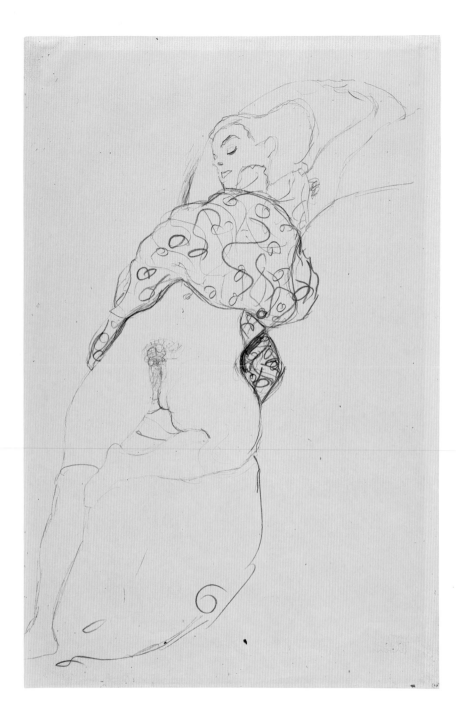

**74**

**Seated Semi-Nude, 1913**

Pencil on paper, 54,5 x 35,5 cm,

private collection, courtesy

Galerie St. Etienne, New York

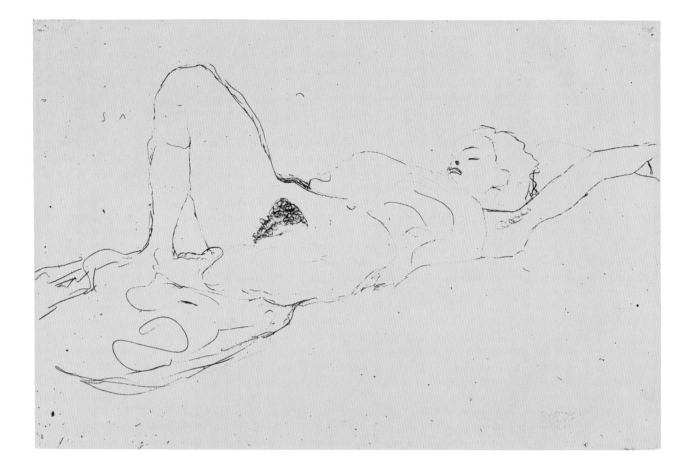

Reclining Female Semi-Nude with
Raised Right Leg, ca. 1913
Pencil on paper, 37,2 x 56,2 cm,
private collection, courtesy
Galerie St. Etienne, New York

**76**
**Reclining Female Nude,**
**Facing Left, 1914/15**
Pencil on paper, 37,2 x 57 cm,
Wien Museum, Vienna

**78**

**Study for the "Portrait of Friederike Beer-Monti"**

**(Seated, Front View), 1915/16**

Pencil on paper, 57 x 37,4 cm,

Albertina, Vienna

Seated Woman, Front View
(Study for the "Portrait of Friederike Beer-Monti"), 1915/16
Pencil on paper, 57 x 37,3 cm,
Albertina, Vienna

gezeichnet v. Gustav Klimt          Fridl Flöge

**80**

**Gertrude Flöge, Facing Front, c. 1915**

Pencil on paper, 55,9 x 36,8 cm,

private collection, courtesy

Galerie St. Etienne, New York

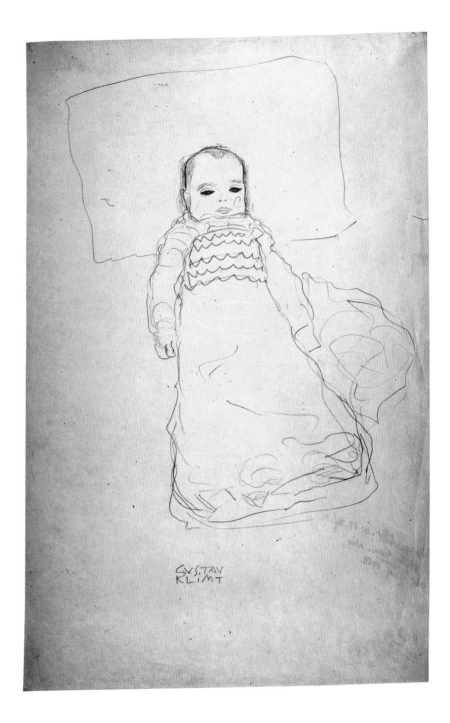

**81**
**Baby (Study for the painting**
**of the same subject), c. 1917**
Red and blue pencil on paper, 57,2 x 37,2 cm,
private collection, courtesy
Neue Galerie New York

**82**

**Standing Female Dancer with Head Turned**

**(Study for "The Dancer"), c. 1917**

Pencil on paper, 49,7 x 32,3 cm,

Albertina, Vienna

**Lady in Kimono, 1917/18**

Pencil on paper, 50 x 32,5 cm,

Albertina, Vienna

**84**

**Lady in a Kimono, Baring**

**Right Shoulder, 1917/18**

Pencil on paper, 50,1 x 32,4 cm,

private collection, courtesy

Galerie St. Etienne, New York

**85**
**Seated Woman,**
**Facing Front, 1917/18**
Pencil on paper, 56 x 37 cm,
private collection, courtesy
Galerie St. Etienne, New York

**86**

**Johanna Staude, Facing Front (Study for**

**the painting of the same subject), 1917/18**

Pencil on paper, 50,1 x 32,5 cm,

private collection, courtesy

Galerie St. Etienne, New York

Reclining Female Nude with Spread Legs
(Study for "The Bride"), 1917/18
Pencil on paper, 50 x 32,5 cm,
Kunsthaus Zug, Stiftung
Sammlung Kamm, Switzerland

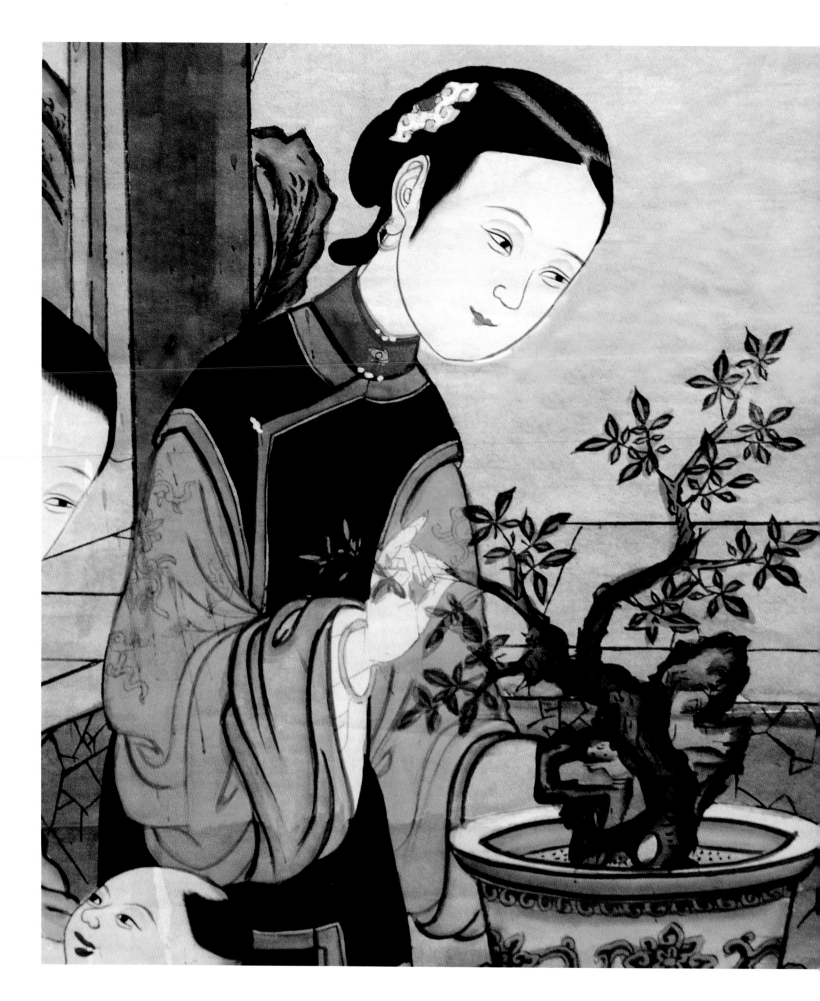

# KLIMT'S PERSONAL BELONGINGS

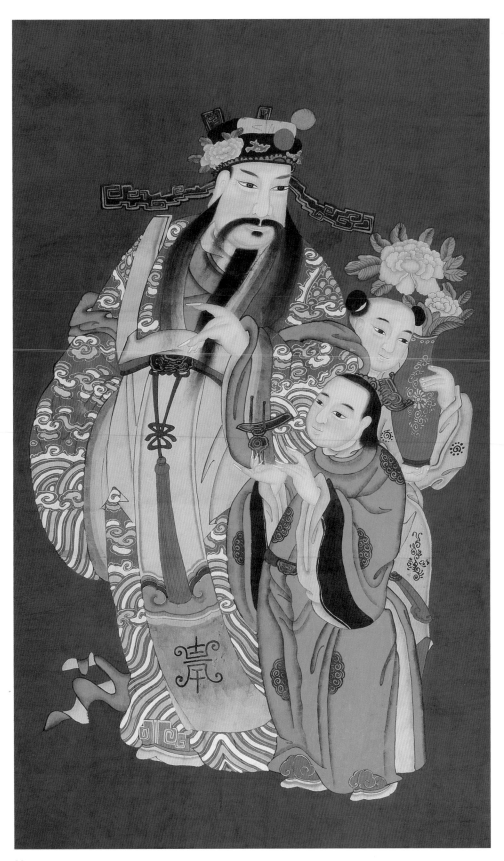

**88**

**Tien Guan, the Good of Good Fortune,**

**Qing Dynasty, end of 19th century**

Watercolor and gouache on paper, 170 x 91 cm,

private collection (Estate of Gustav Klimt)

89

**Guandi, the God of Wealth, with Guan Ping and Zhon Cang,
Qing Dynasty, end of 19th century**

Watercolor and gouache on paper, 170 x 91 cm,
private collection (Estate of Gustav Klimt)

**90**

**Josef Hoffmann:**

**Cookie Tin with Ivory Handle, 1912**

Presented by the Wiener Werkstätte to Gustav Klimt to mark his 50th birthday.

Chased rolled silver, gilded, height: 18,5 cm,

private collection (Estate of Gustav Klimt)

**Lung with Chu, Qing Dynasty, 18th/19th century**
Gift from Gustav Klimt to Emilie Flöge.
Gold embroidery on silk, 130 x 80 cm,
private collection (Estate of Emilie Flöge)

**92 and 92a**

**Josef Hoffmann:**

**Wallet (left), c. 1905**

Snakeskin, 15,5 x 10 cm,

manufactured by the Wiener Werkstätte,

private collection (Estate of Gustav Klimt)

**Wallet (right), c. 1905**

Red leather, 14,5 x 10 cm,

manufactured by the Wiener Werkstätte,

private collection (Estate of Gustav Klimt)

93

**Josef Hoffmann:**

**Cigarette Case (left), c. 1905**

Leather with gold embossing, 11,3 x 9,2 cm,
manufactured by the Wiener Werkstätte,
private collection (Estate of Gustav Klimt)

**Wallet (right), c. 1905**

Leather with gold embossing, 10,5 x 15 cm,
manufactured by the Wiener Werkstätte,
private collection (Estate of Gustav Klimt)

**Gustav Klimt's personal coffee service, c. 1908**
Cup, saucer, coffee pot, milk jug, sugar bowl,
manufactured by the Porzellanhaus Ernst Wahliss, Vienna
private collection (Estate of Gustav Klimt)

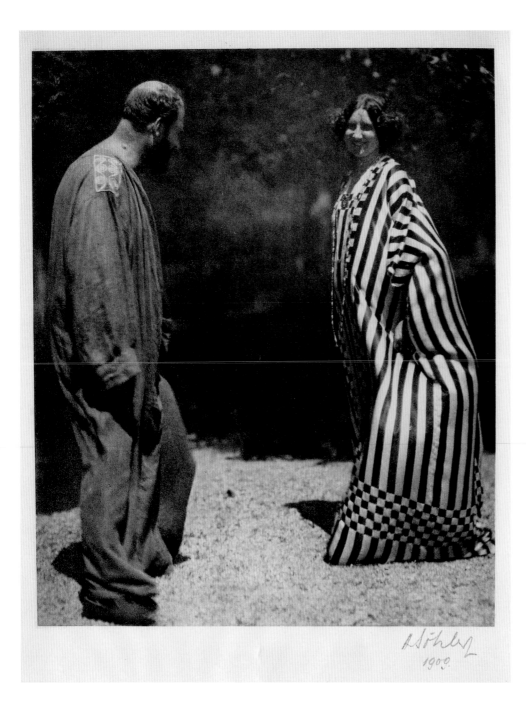

**95**

**Gustav Klimt and Emilie Flöge in the Garden**

**of the Josefstädterstrasse Studio, 1909**

Photogravure by Hans Böhler, 28,6 x 24,2 cm,

Lentos Kunstmuseum Linz

**96**
**The Painter's Smock Owned by Klimt, c.1903**
Indigo blue Linen with white embroidery,
at shoulders 143 cm long,
Wien Museum, Vienna

# KLIMT AND THE "TOTAL ARTWORK"

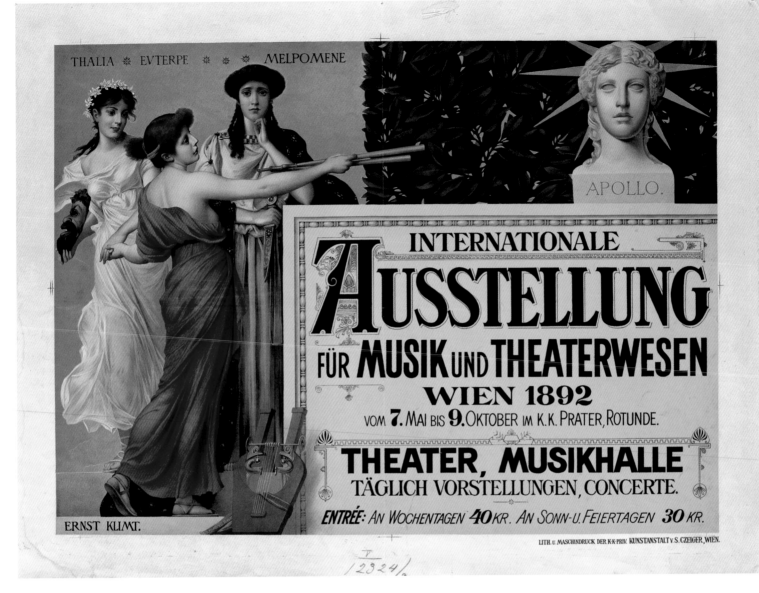

97

**Ernst Klimt:**

**Poster for a Music and Theater Exhibition**

**at the k.k. Prater, Vienna**

Lithograph, printed by S. Czeiger, Vienna, 64 x 86 cm,

MAK – Austrian Museum of Applied Arts/Contemporary Art, Vienna

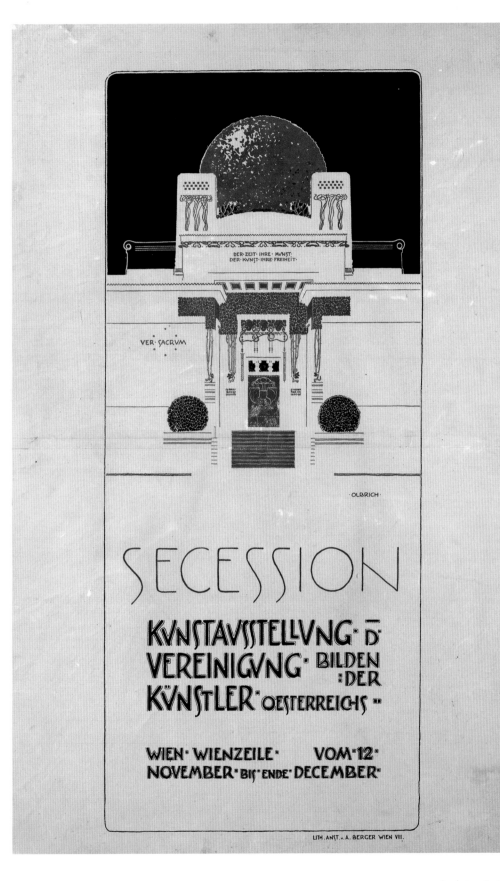

98

Josef Maria Olbrich:

Poster for the First Exhibition of the Vienna Secession, 1898

Lithograph, printed by A. Berger, Vienna, 81,4 x 51 cm,

MAK – Austrian Museum of Applied Arts/Contemporary Art, Vienna

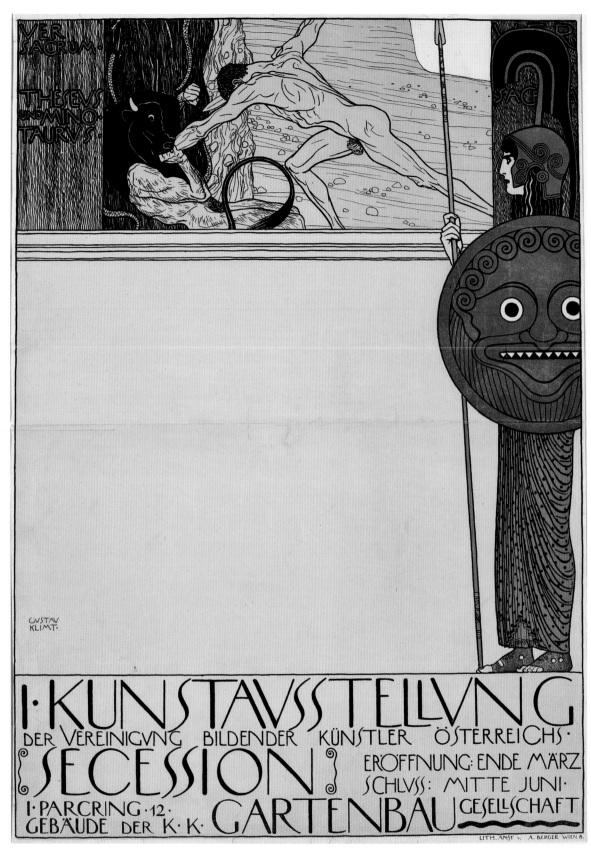

**99**

**Poster for the First Exhibition of the Vienna Secession**

**(Uncensored Version), 1898**

Lithograph, printed by A. Berger, Vienna, 64 x 46,5 cm,

MAK – Austrian Museum of Applied Arts/Contemporary Art, Vienna

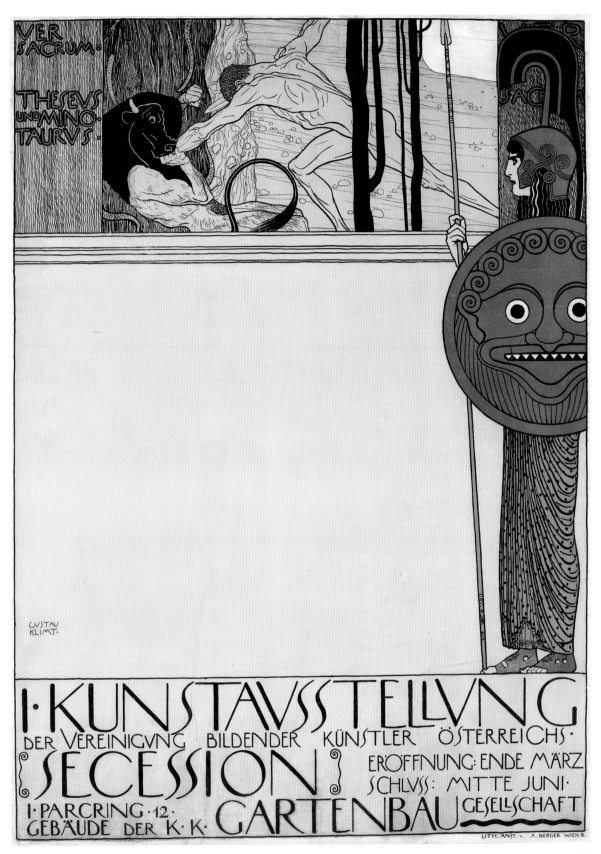

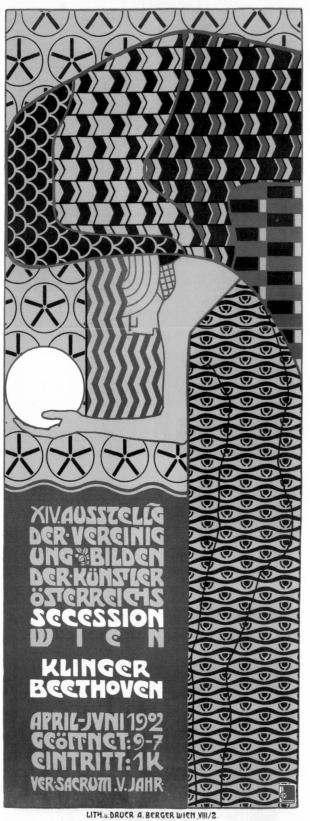

**101**

**Alfred Roller:**

**Poster for the 14th Exhibition of the Vienna Secession (Beethoven), 1902**

Lithograph, printed by A. Berger, Vienna, 99,5 x 62,5 cm,

MAK – Austrian Museum of Applied Arts/Contemporary Art, Vienna

**102**

**Poster for the 18th Exhibition of the Vienna Secession
(Gustav Klimt), 1903**

Lithograph, printed by A. Berger, Vienna, 93,1 x 29 cm,

MAK – Austrian Museum of Applied Arts/Contemporary Art, Vienna

**103**

**The Wiener Werkstätte Room**

Reconstruction of the Installation at the "Kunstschau 1908."

Belvedere, Vienna, 2008/09

**103a**

**The Wiener Werkstätte Room, as originally**

**installed at the "Kunstschau 1908"**

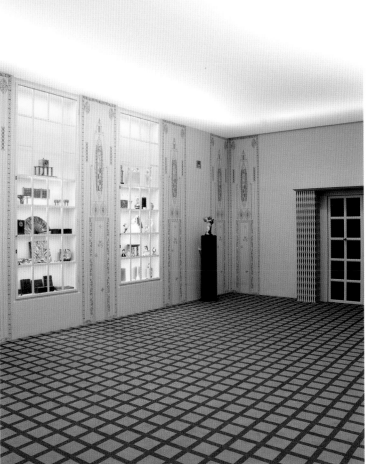

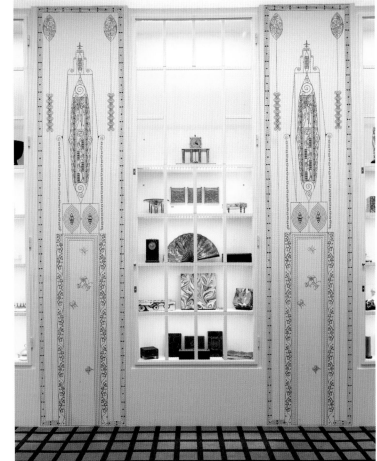

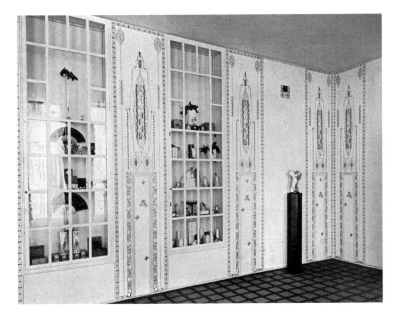

104a

The Wiener Werkstätte Room, as originally
installed at the "Kunstschau 1908"

104

The Wiener Werkstätte Room

Reconstruction of the Installation at the "Kunstschau 1908."

Belvedere, Vienna, 2008/09

105

**Carl Otto Czeschka:**

**Leather Jewelbox with Intarsia, 1908**

Ernst Ploil, Vienna

106
Carl Otto Czeschka:
Hammered and Gilded Copper Panels for the Skoda Vitrine, 1906
Ernst Ploil, Vienna

**107a and 107b**

**Josef Hoffmann:**

**Two Blue Glasses with Polished Surface**

Ernst Ploil, Vienna

**107c and 107d**

**Josef Hoffmann:**

**Two Blue Glasses with Polished Surface**

Ernst Ploil, Vienna

**108**

Josef Hoffmann:

**Marbled Cardboard Box for the woodcut series**

**"Beethovenhouses" by Carl Moll, 1902**

Ernst Ploil, Vienna

110 a–d

Josef Hoffmann:

Six-Piece Table Setting for the "Fledermaus" Café, 1907

(only four pieces are illustrated)

Ernst Ploil, Vienna

110 and 111a
**Josef Hoffmann:**
**Box for Playing Cards, 1906**
Crocodile skin,
Ernst Ploil, Vienna

112
**Josef Hoffmann:**
**Album, 1907**
Snakeskin,
Ernst Ploil, Vienna

113
Josef Hoffmann:
"The Revelation of St. John", c. 1906
Frogskin,
Ernst Ploil, Vienna

**114 a–d**

**Josef Hoffmann:**

**Four "Gitterwerk" Vessels, 1905–07**

White lacquered tin,

Ernst Ploil, Vienna

114e and 114f
**Josef Hoffmann:**
**Two "Gitterwerk" Vessels, 1905–07**
White lacquered tin,
Ernst Ploil, Vienna

116 a–c

**Bertold Löffler:**

**Three Tubular Vases, Design c. 1903, Execution c. 1905**

Ernst Ploil, Vienna

117 and 117a
**Bertold Löffler:**
**Two Vases, c. 1906**
Ernst Ploil, Vienna

**118 and 118a**

**Koloman Moser:**

**Two Small Boxes, 1905-06**

Ernst Ploil, Vienna

**119 and 119a**
**Otto Prutscher:**
**Glass Vase and Glass Bowl, 1908**
Crystal glass with gold paint
Ernst Ploil, Vienna

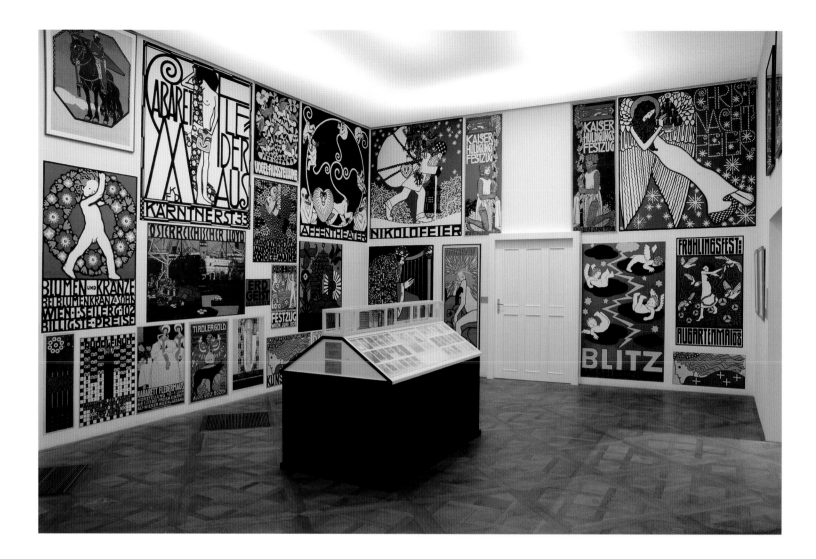

**120**

**Poster Room**

Reconstruction of the Installation at the "Kunstschau 1908."

Belvedere, Vienna 2008/09

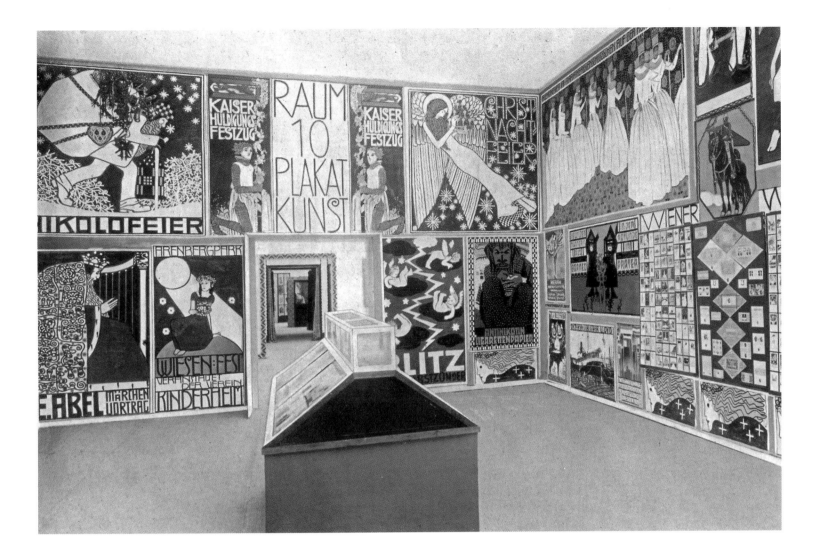

120a
Poster Room, as orignally installed
at the "Kunstschau 1908"

197

**121a**

**Emil Hoppe: Erdberg – Wöllischgasse, 1908**

Postcard of the Wiener Werkstätte No. 22, color lithography, 8,5 x 13,5 cm,

Detlef Hilmer, Munich

**121b**

**Emil Hoppe: Chapel Nußdorferstraße, 1908**

Postcard of the Wiener Werkstätte No. 46, color lithography, 13,5 x 8,5 cm,

Detlef Hilmer, Munich

**121c**

**Moriz Jung: Conversation between an Editor and a Statesman, 1908**

Postcard of the Wiener Werkstätte No. 58, 13,5 x 8,5 cm, color lithography,

Detlef Hilmer, Munich

**121d**

**Moriz Jung: Conversation between Mutes, 1908**

Postcard of the Wiener Werkstätte No. 62, color lithography, 13,5 x 8,5 cm,

Detlef Hilmer, Munich

199

**122a**

**Oskar Kokoschka: The Three Kings, 1907**

Postcard of the Wiener Werkstätte No. 155, color lithography, 13,5 x 8,5 cm,

Detlef Hilmer, Munich

**122b**

**Oskar Kokoschka: Mother with three Children, 1907**

Postcard of the Wiener Werkstätte No. 117, color lithography, 13,5 x 8,5 cm,

Detlef Hilmer, Munich

**122c**

**Oskar Kokoschka: Girl with Lamb Threatened by Bandits, 1907**

Postcard of the Wiener Werkstätte No. 77, color lithography, 13,5 x 8,5 cm,

Detlef Hilmer, Munich

**122d**

**Oskar Kokoschka: Musicians at Night, 1907**

Postcard of the Wiener Werkstätte No. 78, color lithography, 13,5 x 8,5 cm,

Detlef Hilmer, Munich

**123a**

**Rudolf Kalvach: Humorous Scene, 1908**

Postcard of the Wiener Werkstätte, color lithography, 13,5 x 8,5 cm,

Detlef Hilmer, Munich

**123b**

**Rudolf Kalvach: Humorous Scene, 1908**

Postcard of the Wiener Werkstätte, color lithography, 13,5 x 8,5 cm,

Detlef Hilmer, Munich

**123c**

**Rudolf Kalvach: Veni Vidi Vici, 1908**

Postcard of the Wiener Werkstätte No. 85, color lithography, 13,5 x 8,5 cm,

Detlef Hilmer, Munich

**123d**

**Rudolf Kalvach: The Lutenist, 1908**

Postcard of the Wiener Werkstätte No. 95, color lithography, 13,5 x 8,5 cm,

Detlef Hilmer, Munich

**124a**

**Urban Janke: Vienna, Palais Schwarzenberg – Hochstrahlbrunnen, 1908**

Postcard of the Wiener Werkstätte No. 139, color lithography, 13,5 x 8,5 cm,

Detlef Hilmer, Munich

**124b**

**Urban Janke: Vienna, From Schönbrunn, 1908**

Postcard of the Wiener Werkstätte No. 133, color lithography, 8,5 x 13,5 cm,

Detlef Hilmer, Munich

**124c**

**Urban Janke: Biedermeier Fashion, 1908**

Postcard of the Wiener Werkstätte, color lithography, 13,5 x 8,5 cm,

Detlef Hilmer, Munich

**124d**

**Urban Janke: Biedermeier Fashion, 1908**

Postcard of the Wiener Werkstätte, color lithography, 13,5 x 8,5 cm,

Detlef Hilmer, Munich

205

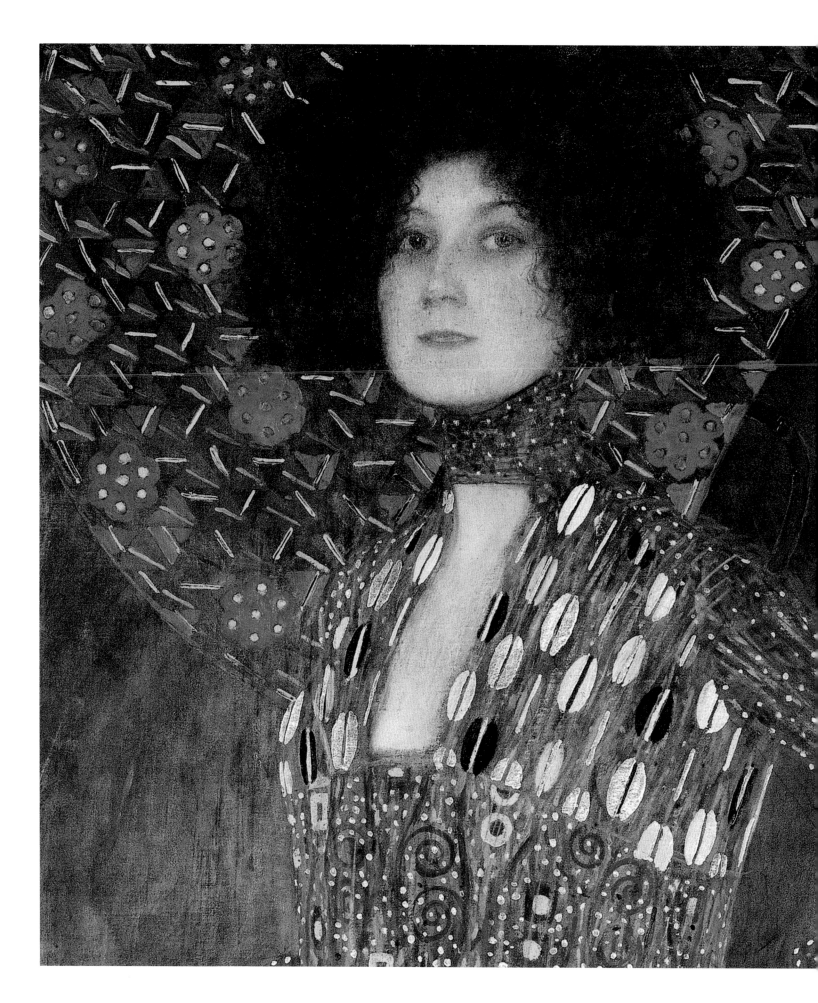

# KLIMT'S INFLUENCE ON HIS CONTEMPORARIES

125

**Richard Gerstl:**

**Portrait of Mathilde Schönberg, Before the Summer 1907**

Tempera on canvas, 95 x 75 cm,

Belvedere, Vienna

126

Maximilian Kurzweil:
**Female Nude in front of a Mirror, 1907**
Oil on canvas, 88 x 69,5 cm,
Schütz Kunst & Antiquitäten, Vienna

**127**

**Karola Nahowska:**

**Portrait of a Woman, 1909**

Oil on canvas, 50 x 50 cm,

Belvedere, Vienna

128
Koloman Moser:
**Portrait of a Woman in Profile, c. 1910**
Oil on canvas, 50 x 50 cm,
Belvedere, Vienna

129

**Maximilian Oppenheimer:**

**Half-length Portrait of Ernst Koessler, 1910**

Oil on canvas, 86,5 x 75 cm,

Belvedere, Vienna

130

**Egon Schiele:**

**Mother and Child, 1909/10**

Oil on canvas, 57,7 x 50,7 cm,

courtesy Kunsthandel

Wienerroither & Kohlbacher, Vienna

131

**Koloman Moser:**

**Blooming Sapling, c. 1913**

Oil on canvas, 50 x 50 cm,

Belvedere, Vienna

**132**
**Egon Schiele:**
**Trieste Fishing Boat, 1912**
Oil and pencil on canvas, 75 x 75 cm,
private collection, courtesy
Galerie St. Etienne, New York

133

**Koloman Moser:**

**The Bathers, c. 1913–1914**

Oil on canvas, 76 x 76 cm, monogrammed bottom right,

Estate of Koloman Moser, Schütz Kunst & Antiquitäten, Vienna

134
Koloman Moser:
**Self-Portrait with Mermaid, 1914**
Oil on canvas, 37,6 x 50,5 cm,
Schütz Kunst & Antiquitäten, Vienna

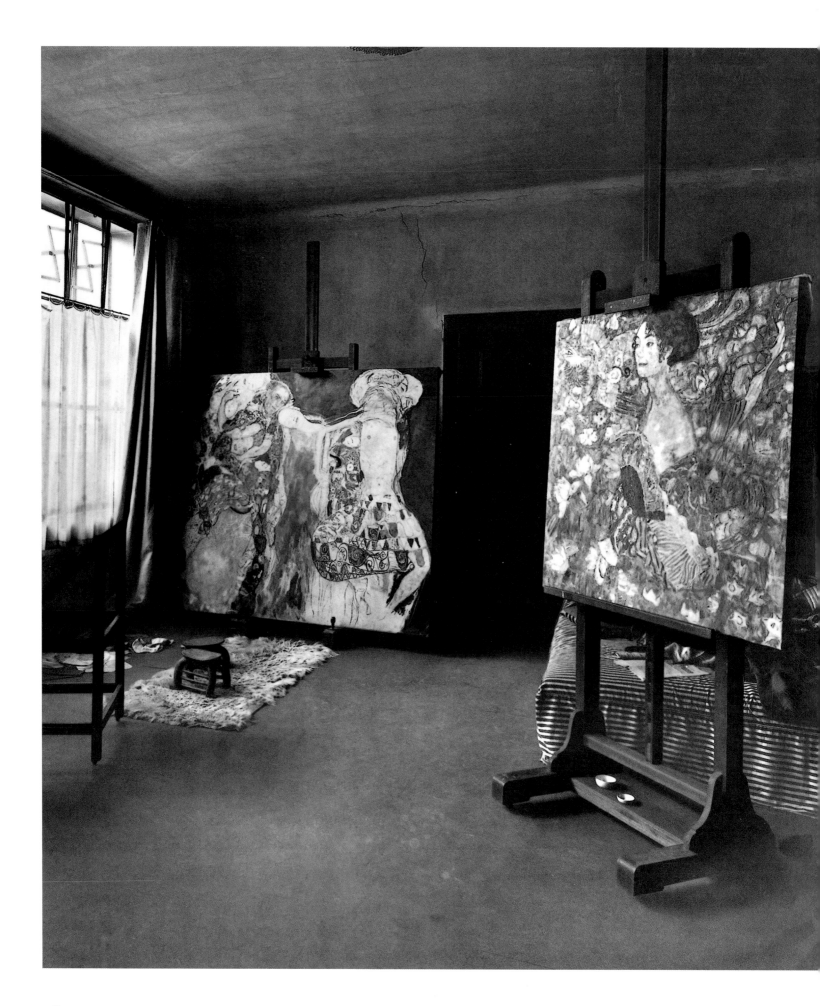

# PHOTOGRAPHS

135

Maria Zimmermann with her
son Gustav, c. 1903

136
Page 218:
Inside Gustav Klimt's studio at
Feldmühlgasse, 1917/18

Gustav Klimt with a telescope on the dock
at the Villa Paulick in Seewalchen at Attersee, 1904

photograph, private collection

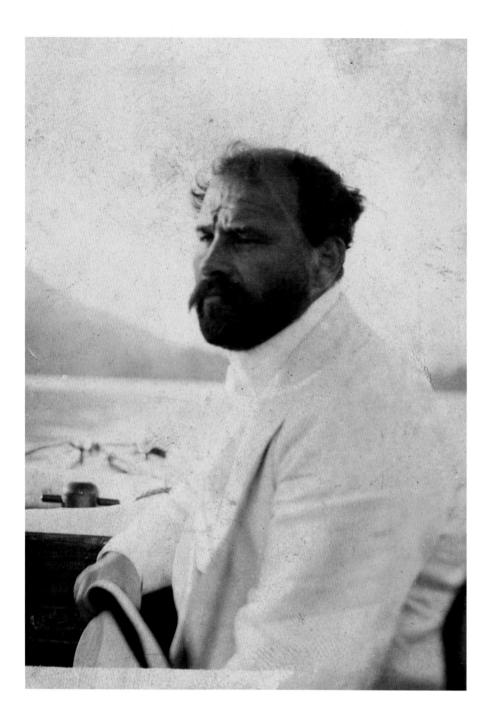

138
Gustav Klimt in a motorboat
on the Attersee, 1904

Emilie Flöge in a motorboat on the
northside of the Attersee, 1904

140
Gustav Klimt and Gertrude Flöge on the jetty of the
Villa Paulick in Seewalchen on the Attersee, Easter

224

141
Gustav Klimt and Gertrude Flöge on the jetty
of the Villa Paulick in Seewalchen, Easter 1912

142

Gustav Klimt and Friederike Beer-Monti

in Weissenbach on the Attersee, 1916

Gustav Klimt in the garden of
his Josefstädterstrasse studio

Joseph Maria Olbrich,
unknown person, Koloman
Moser and Gustav Klimt in Fritz
Waerndorfer's garden, 1902

# GUSTAV KLIMT
# BIOGRAPHICAL CHRONOLOGY

**:1862**

Gustav Klimt, son of a poor Bohemian metal engraver, is born on July 14 in the tenement suburb of Baumgarten, on the outskirts of Vienna.

**:1876**

Klimt receives a scholarship to the Vienna Kunstgewerbeschule, a progressive school of the applied arts. His younger brother Ernst joins him there in 1877.

**:1880**

Gustav and Ernst Klimt, together with fellow Kunstgewerbeschule student Franz Matsch, begin to receive independent mural commissions.

**:1883**

The *Künstler-Compagnie* of Matsch and the two Klimt brothers opens its own studio. The trio will spend the next years traveling around Austria painting curtains and murals for provincial theaters.

**:1886**

The *Künstler-Compagnie* receives its first major commission in the Viennese capital: the staircase decorations for the new Burgtheater. Gustav Klimt also paints a large gouache documenting the old Burgtheater before it is demolished.

**:1888**

The *Künstler-Compagnie* receives the Gold Service Cross from the Emperor Franz Joseph for its Burgtheater murals.

**:1890**

Klimt receives the Emperor's Prize for his gouache of the old Burgtheater. *The Künstler-Compagnie* is commissioned to paint the spandrels above the staircase in Vienna's Kunsthistorisches Museum.

**:1892**

Klimt's father dies in the summer, his brother Ernst in December. The artist enters a protracted period of depression and withdrawal.

**:1896**

Though Klimt is no longer actively partnering with Franz Matsch, the two receive a final joint commission: the ceiling paintings for the auditorium at the University of Vienna.

Some members of the Secession in the main hall of the Beethoven
Exhibition before the opening, 1902 (Photo: Moritz Nähr)

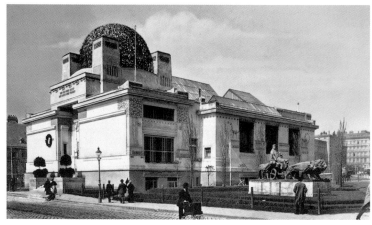

Secession building in Vienna, c. 1902

:1897

Klimt's break with the conservative tradition exemplified by the
*Künstler-Compagnie* is confirmed by his leadership role in the foun-
ding of the Vienna Secession.

:1898

The Vienna Secession launches its exhibition program in a new
"art temple" designed by Josef Maria Olbrich. Klimt's poster for
the opening depicts Theseus battling the Minotaur, representing
the struggle between young artists and the perceived Philisti-
nism of their elders.

:1900

The first of Klimt's University paintings, *Philosophy*, is exhibited
at the Secession and triggers a huge controversy due to its explicit
nudity and lack of a traditional allegorical context.

:1901

The exhibition of Klimt's second University painting, *Medicine*,
occasions further protests.

:1902

The Secession mounts its most complete realization of the *Gesamt-
kunstwerk*, an exhibition devoted to Beethoven, for which Klimt
designs a monumental frieze.

:1903

Josef Hoffmann and Koloman Moser, with backing from Fritz
Waerndorfer, found the Wiener Werkstätte design collective
of visual artists. The controversy over the University paintings
continues with the exhibition of Klimt's third and final canvas,
*Jurisprudence*.

:1905

Friction within the Secession between the conventional easel
painters and Klimt's group, which favors the integration of the
fine and applied arts in a *Gesamtkunstwerk*, prompts the latter fac-
tion to resign. Klimt also renounces the University commission.
Henceforth, he will largely recede from the public sphere, devo-
ting most of his time to private clients.

:1906

The Wiener Werkstätte commissions Klimt to design a frieze
for the dining room of the Belgian industrialist Adolph Stoclet.
Klimt will work intermittently in the ensuing years on the car-
toons for this project, which is executed in mosaics by the studio
of Leopold Forstner between 1910 and 1911.

:1908

Klimt and his colleagues at the Wiener Werkstätte help orche-
strate a massive "Kunstschau," an art exhibition to mark the 60th
anniversary of the Emperor Franz Joseph's reign. This is the first
major exhibition of the Austrian avant-garde since the Secession
split, and an entire room is devoted to Klimt's paintings. Also in-
cluded is the work of the young Oskar Kokoschka, who represents
the nascent shift toward an Expressionistic aesthetic.

:1909

A second "Kunstschau," more international in focus, marks the
debut of the Expressionist Egon Schiele.

:1918

Klimt suffers a stroke in January and succumbs to pneumonia on
February 6.

At the School for Applied Arts in Vienna – Ernst Klimt in front with a cup in his hand, Franz Matsch behind him, and Gustav Klimt behind Matsch to the right

# 1. PAINTINGS BY GUSTAV KLIMT

**1**

**STUDY OF A GIRL'S HEAD** 1880
Oil on canvas, 43 x 30 cm,
(Weidinger 3), private collection

**2**

**PORTRAIT OF KLARA KLIMT** C. 1880
Oil on canvas, 29 x 20,5 cm,
(Weidinger 6), private collection

**3**

**STUDY OF A FEMALE NUDE** C. 1883
Oil on canvas, 86,5 x 42,5 cm,
(Weidinger 17), private collection

**4**

**MALE NUDE, FACING RIGHT** C. 1883
Oil on canvas, 75 x 48,5 cm,
(Weidinger 16), private collection;
courtesy Galerie St. Etienne, NY

**5**

**SAVOYARD BOY** C.1882
Oil on canvas, 39,5 x 25 cm
(Weidinger 13), private collection

**6**

**PORTRAIT OF A CHILD WITH
FLOWERS** C. 1883
Miniature on ivory, diam. 3,5 cm,
(Weidinger 25c), private collection

**7**

**PORTRAIT OF A CHILD ON BROWN
BACKGROUND** C. 1883
Miniature on ivory, diam. 3,5 cm,
(Weidinger 25d), private collection

**8**

**FABLE** 1883
Oil on canvas, 84,5 x 117 cm,
(Weidinger 28), Wien Museum, Vienna
*Not in exhibition*

**9**

**MYTHOLOGICAL SCENE** 1885
Oil on canvas, 35,5 x 49,8 cm,
(Weidinger 46), Muzeul Naţional
de Artă al României

**10**

**POSTER DESIGN FOR THE
„INTERNATIONAL EXHIBITION OF
MUSIC AND THEATRICAL ART"** 1892
Oil on canvas, 84 x 56 cm,
(Weidinger 84), Wien Museum,
Vienna

**11**

**PORTRAIT OF MARIE BREUNIG** C.1894
Oil on canvas, 155 x 75 cm,
(Weidinger 91), private collection

**12**

**LOVE** 1895
Oil on canvas, 60 x 44 cm,
(Weidinger 93), Wien Museum, Vienna
*Not in exhibition*

**13**

**SCHUBERT AT THE PIANO
(STUDY FOR THE PAINTING OF THE
SAME TITLE)** 1896
Oil on canvas, 30 x 39 cm,
(Weidinger 95), private collection

**14**

**WOMAN WITH FUR COLLAR** 1897/98
Oil on cardboard, mounted
on wood, 36 x 19,7 cm,
(Weidinger 112), private collection;
courtesy Galerie St. Etienne, NY

**15**

**AFTER THE RAIN (GARDEN WITH
CHICKENS IN ST. AGATHA)** 1898
Oil on canvas, 80 x 40 cm,
(Weidinger 124), Belvedere, Vienna

**16**

**MEDICINE (COMPOSITION
STUDY FOR THE PAINTING OF
THE SAME TITLE)** 1898
Oil on canvas, 72 x 55 cm,
(Weidinger 118), private collection

**17**

**MOVING WATER** 1898
Oil on canvas, 53 x 66,4 cm,
(Weidinger 128), private collection;
courtesy Galerie St. Etienne, NY

**18**

**PORTRAIT OF ROSE VON
ROSTHORN-FRIEDMANN** 1900/01
Oil on canvas, 140 x 80 cm,
(Weidinger 145), private collection
*Not in exhibition*

**19**

**JUDITH I** 1901
Oil on canvas, 84 x 42 cm,
(Weidinger 147), Belvedere, Vienna

**20, 20A AND 21**

**BEETHOVEN FRIEZE –
RECONSTRUCTION OF THE 1903
INSTALLATION AT THE VIENNA
SECESSION (COMPRISING SEVEN
PANELS)** 1901/02
Casein, gold pigment, black and
colored chalk, graphite, stucco
and various materials (glass, mother
of pearl, gold) on plaster,
full length: 34,14 m (13,92 x 6,30 m),
height: 2,15 m,
(Weidinger 153), Belvedere, Vienna

**22**

**PORTRAIT OF GUSTAV ZIMMERMANN (SON OF GUSTAV KLIMT)** 1902
Oil on canvas,
(Weidinger 158), private collection

**23**

**SILVERFISH (WATER NYMPHS)** 1901/02
Oil on canvas, 82 x 52 cm,
(Weidinger 146), Kunstsammlung
Bank Austria, Vienna

**24**

**PORTRAIT OF MARIA (RIA) MUNK** 1912
Oil on canvas, 50 x 50,5 cm,
(Weidinger 207), private collection;
courtesy Richard Nagy Ltd., London

**25**

**PALE FACE** 1903, revised 1904/05
Oil on canvas, 80 x 40 cm,
(Weidinger 170), private collection,
courtesy Neue Galerie New York

**26**

**FARM GARDEN WITH SUNFLOWERS** 1908
Oil on canvas, 110 x 110 cm,
(Weidinger 190), Belvedere, Vienna
*Not in exhibition*

**27**

**PROMENADE IN SCHLOSS KAMMER PARK** 1912
Oil on canvas, 110 x 110 cm,
(Weidinger 212), Belvedere, Vienna

**28**

**ITALIAN GARDEN LANDSCAPE** 1913
Oil on canvas, 110 x 110 cm,
(Weidinger 215), Kunsthaus Zug,
Stiftung Sammlung Kamm,
Switzerland

**29**

**LITZLBERG ON THE ATTERSEE** 1914
Oil on canvas, 110 x 110 cm,
(Weidinger 221), Museum der
Moderne Rupertinum, Salzburg

**30**

**PORTRAIT OF JOHANNA STAUDE** 1917
Oil on canvas, 70 x 50 cm,
(Weidinger 248), Belvedere, Vienna

**31**

**ADAM AND EVE** 1917
Oil on canvas, 173 x 60 cm,
(Weidinger 251), Belvedere, Vienna

**32**

**PORTRAIT OF AMALIE ZUCKERKANDL (UNFINISHED)** 1917
Oil on canvas, 128 x 128 cm,
(Weidinger 250), Belvedere, Vienna

**33**

**BABY (CRADLE)** 1917
Oil on canvas, 110 x 110 cm,
(Weidinger 253), National Gallery of
Art, Washington, D.C.; Gift from
Otto and Franziska Kallir with the
support of the Carol and Edwin
Gaines Fullinwider Fund 1978

# 2. DRAWINGS BY GUSTAV KLIMT

**34**

HEAD OF A YOUNG MAN, RECLINING (STUDY FOR "SHAKESPEARE'S THEATER" IN THE BURGTHEATER) c.1887
Black crayon and pencil with white highlights on paper, 44,8 x 31,4 cm, (Strobl 143), Albertina, Vienna

**35**

HEAD OF A GIRL, RECLINING (STUDY FOR "SHAKESPEARE'S THEATER" IN THE BURGTHEATER) c.1887
Black crayon and pencil with white highlights on paper, 27,3 x 42,2cm, (Strobl 142), Albertina, Vienna

**36**

SEATED WOMAN, CHIN RESTING IN RIGHT HAND (STUDY FOR "MUSIC II") c. 1897
Black crayon on paper, 44,5 x 31,7 cm, (Strobl 297), private collection; courtesy Galerie St. Etienne, NY

**37**

FLOATING FEMALE NUDE IN FRONT OF DARK BACKGROUND (STUDY FOR "MEDICINE") c. 1896
Pencil with white highlights on paper, 45,1 x 32 cm, (Strobl 530), private collection; courtesy Galerie St. Etienne, NY

**38**

STANDING FEMALE NUDE (STUDY FOR "MEDICINE") c.1897
Black crayon on paper, 47,8 x 31,4 cm, (Strobl 527), Albertina, Vienna

**39**

FLOATING WOMAN WITH RAISED LEFT ARM (STUDY FOR "MEDICINE") 1897/98
Black crayon on paper, 45,7 x 31,9 cm, (Strobl 535), Albertina, Vienna

**40**

STUDY FOR "TRAGEDY" 1897
Pencil and black crayon on paper, 45,7 x 31,5 cm, (Strobl 337), private collection; courtesy Galerie St. Etienne, NY

**41**

STUDY OF A MAN'S HEAD IN PROFILE (ILLUSTRATION FOR "VER SACRUM") 1897–98
Ink, with corrections in white gouache, 9 x 9,1 cm, (Strobl 344), Albertina, Vienna

**42**

STANDING GIRL IN PROFILE, FACING LEFT (TORSO) 1898
Red and blue pencil on paper, 45 x 31,6 cm, (Strobl 430), Wien Museum, Vienna

**43**

PREGNANT WOMAN WITH MAN, FACING LEFT (STUDY FOR "HOPE I") 1902/03
Blue and orange pencil on paper, 44,8 x 30,5 cm, (Strobl 946), private collection; courtesy Galerie St. Etienne, NY

**44**

STUDY FOR THE "BEETHOVEN FRIEZE" (GORGON TO THE LEFT) 1901–1902
Black crayon on paper, 45,1 x 31,3 cm, (Strobl 787), Albertina, Vienna

**45**

STUDY FOR THE "BEETHOVEN FRIEZE" (GORGON TO THE RIGHT) 1901–02
Black crayon on paper, 44,4 x 31,8 cm, (Strobl 806), Albertina, Vienna

**46**

SEATED FEMALE NUDE (STUDY FOR THE "BEETHOVEN FRIEZE": THE ARTS) 1901–02
Black chalk on paper, 44,5 x 29,8 cm, (Strobl 839), private collection; courtesy Galerie St. Etienne, NY

NOT ILLUSTRATED

TWO STUDIES OF A FEMALE NUDE, FACING FRONT (STUDY FOR THE "BEETHOVEN FRIEZE": GORGON IN THE MIDDLE) 1902

Charcoal on brownish paper; estate stamp, verso, 45,2 x 31,6 cm, (Strobl 800), private collection; courtesy Galerie St. Etienne, NY

**47**

RECLINING NUDE GIRL, RIGHT HAND VISIBLE ABOVE HEAD (STUDY FOR THE "BEETHOVEN FRIEZE": LONGING FOR HAPPINESS) 1901–02
Charcoal on paper, 37,2 x 56,5 cm, (Strobl 746), private collection; courtesy Neue Galerie New York

**48**

SEATED WOMAN, RESTING 1901–02
Charcoal on paper, 44,5 x 31,8 cm, (Strobl 828), private collection; courtesy Neue Galerie New York

**49**

FEMALE NUDE, FACING FRONT (STUDY FOR THE "BEETHOVEN FRIEZE": GORGON IN THE MIDDLE) 1901–02
Charcoal on paper, 44,8 x 32,7 cm, (Strobl 797), private collection; courtesy Neue Galerie New York

**50**

FRITZA RIEDLER, SEATED, FACING LEFT (STUDY FOR THE PAINTING OF THE SAME SUBJECT) c. 1905
Black crayon on paper, 45,6 x 31,3 cm, (Strobl 1231), Wien Museum, Vienna

**51**

SEATED SEMI-NUDE, FACING
LEFT 1904/1905
Pencil on paper, 56 x 37 cm,
(Strobl 1292), Kunsthaus Zug, Stiftung
Sammlung Kamm, Switzerland

**52**

RECLINING FEMALE NUDE WITH
BENT RIGHT LEG 1905/06
Blue pencil on paper, 36,4 x 56 cm,
(Strobl 1495), Wien Museum, Vienna

**53**

RECLINING GIRLFRIENDS,
FACING RIGHT 1905/06
Pencil on paper, 37,2 x 56,5 cm,
(Strobl 1477), Wien Museum, Vienna

**54**

STANDING FEMALE DANCER
WITH RAISED FOREARM (STUDY
FOR "EXPECTATION") C. 1907
Pencil on paper, 55,9 x 37 cm,
(Strobl 1665), Wien Museum, Vienna

**55**

TWO STUDIES OF A STANDING
FEMALE DANCER WITH RAISED
FOREARM (STUDY FOR
"EXPECTATION") C. 1907
Pencil on paper, 55,9 x 37,1 cm,
(Strobl 1667), Wien Museum, Vienna

**56**

STANDING FEMALE NUDE WITH LONG
HAIR AND RAISED LEFT LEG 1906/07
Pencil and red pencil, 55,8 x 37,2 cm,
(Strobl 1605), private collection;
courtesy Galerie St. Etienne, NY

**57**

SEATED FEMALE SEMI-NUDE,
FACING FRONT C. 1907
Pencil with red and blue pencil
highlights on paper, 56,1 x 37,2 cm,
(Strobl 1615), private collection;
courtesy Galerie St. Etienne, NY

**58**

CROUCHING FEMALE NUDE WITH
HAIR OVER FACE C. 1907
Blue pencil on paper, 37,2 x 56 cm,
(Strobl 1636), Wien Museum, Vienna

**59**

"READING" OR "SINGING" GIRL,
FACING FRONT C. 1907
Red and blue pencil on paper,
55,9 x 36,8 cm,
(Strobl 1642), private collection;
courtesy Neue Galerie New York

**60**

ADELE BLOCH-BAUER WITH BOA OVER
LEFT SHOULDER, SEATED, FACING
FRONT (STUDY FOR THE PAINTING
OF THE SAME SUBJECT) 1903–04
Black crayon on paper, 45,1 x 31,4 cm,
(Strobl 1136), private collection;
courtesy Neue Galerie New York

**61**

FEMALE DANCER WITH
RAISED LEG 1907–08
Pencil on paper, 56,2 x 36,8 cm,
(Strobl 1701), Albertina, Vienna

**62**

PORTRAIT OF A WOMAN
IN A TALL HAT AND RECLINING
WOMAN 1907/08
Pencil and red pencil on paper,
55,9 x 37,1 cm,
(Strobl 1922), private collection;
courtesy Galerie St. Etienne, NY

**63**

HEAVY CLOTHED WOMAN, WITH
FEMALE NUDE HALF-HIDDEN AT
HER FEET C. 1908
Blue pencil on paper, 56,2 x 37,1 cm,
(Strobl 1714), private collection;
courtesy Galerie St. Etienne, NY

**64**

TWO SEATED GIRLFRIENDS,
FACING RIGHT 1910
Pencil on paper, 56 x 37,4 cm,
(Strobl 2000), Wien Museum, Vienna

**65**

RECLINING WOMAN LYING ON
STOMACH, FACING RIGHT 1910
Blue pencil on paper, 36,5 x 53,3 cm,
(Strobl 1967), private collection;
courtesy Galerie St. Etienne, NY

**66**

RECLINING NUDE WITH RAISED
LEGS, FACING LEFT C. 1912/13
Pencil on paper, 36,2 x 56,3 cm,
(Strobl 3675a), private collection;
courtesy Galerie St. Etienne, NY

**67**

GIRL WITH BUNCHED-UP SKIRT
(STUDY FOR "THE VIRGIN") 1912–13
Pencil on paper, 54 x 32,5 cm,
(Strobl 2286), Albertina, Vienna

**68**

STANDING GIRL WITH HANDS ON
HIPS (STUDY FOR THE "PORTRAIT
OF MÄDA PRIMAVESI") 1912–13
Pencil on paper, 56,7 x 37 cm,
(Strobl 2125), Albertina, Vienna

**69**

SEATED GIRL (STUDY FOR THE "PORTRAIT OF MÄDA PRIMAVESI") 1912–13
Pencil on paper, 55,9 x 36,7 cm,
(Strobl 2114), Albertina, Vienna

**70**

RECUMBENT SEATED SEMI-NUDE 1913
Pencil on paper, 55,9 x 37,1 cm,
(Strobl 2273), Wien Museum, Vienna

**71**

SEATED SEMI-NUDE WITH CLOSED EYES 1913
Pencil on paper, 56,7 x 36,9 cm,
(Strobl 2275), Wien Museum, Vienna

**72**

RECLINING NUDE WITH BENT KNEES, FACING RIGHT 1913
Pencil, blue and red pencil with white crayon on paper, 37 x 55,8 cm,
(Strobl 2317), Wien Museum, Vienna

**73**

CROUCHING SEMI-NUDE, FACING RIGHT 1913
Ink on paper, 37,2 x 56,5 cm,
(Strobl 2323), Wien Museum, Vienna

**74**

SEATED SEMI-NUDE 1913
Pencil on paper, 54,5 x 35,5 cm,
(Strobl 2280), private collection;
courtesy Galerie St. Etienne, NY

**75**

RECLINING FEMALE SEMI-NUDE WITH RAISED RIGHT LEG C. 1913
Pencil on paper, 37,2 x 56,2 cm,
(Strobl 2267), private collection;
courtesy Galerie St. Etienne, NY

**76**

RECLINING FEMALE NUDE, FACING LEFT 1914/15
Pencil on paper, 37,2 x 57 cm,
(Strobl 2436), Wien Museum, Vienna

**77**

RECLINING SEMI-NUDE, FACING RIGHT 1914/15
Blue pencil on paper, 36,9 x 56 cm,
(Strobl 2405), Wien Museum, Vienna

**78**

STUDY FOR THE "PORTRAIT OF FRIEDERIKE BEER-MONTI" (SEATED, FRONT VIEW) 1915–16
Pencil on paper, 57 x 37,4 cm,
(Strobl 2537), Albertina, Vienna

**79**

SEATED WOMAN, FRONT VIEW (STUDY FOR THE "PORTRAIT OF FRIEDERIKE BEER-MONTI") 1915–16
Pencil on paper, 57 x 37,3 cm,
(Strobl 2532), Albertina, Vienna

**80**

GERTRUDE FLÖGE, FACING FRONT C. 1915
Pencil on paper, 55,9 x 36,8 cm,
(Strobl 2630), private collection;
courtesy Galerie St. Etienne, NY

**81**

BABY (STUDY FOR THE PAINTING OF THE SAME SUBJECT) C. 1917
Red and blue pencil on paper, 57,2 x 37,1 cm,
(Strobl 3037), private collection;
courtesy Neue Galerie New York

**82**

STANDING FEMALE DANCER WITH HEAD TURNED (STUDY FOR "THE DANCER") C. 1917
Pencil on paper, 49,7 x 32,3 cm,
(Strobl 2583), Albertina, Vienna

**83**

LADY IN KIMONO 1917/18
Pencil on paper, 50 x 32,5 cm,
(Strobl 2617), Albertina, Vienna

**84**

LADY IN A KIMONO, BARING RIGHT SHOULDER 1917/18
Pencil on paper, 50,1 x 32,4 cm,
(Strobl 2616), private collection;
courtesy Galerie St. Etienne, NY

**85**

SEATED WOMAN, FACING FRONT 1917/18
Pencil on Paper, 56 x 37 cm,
(Strobl 2665), private collection;
courtesy Galerie St. Etienne, NY

**86**

JOHANNA STAUDE, FACING FRONT (STUDY FOR THE PAINTING OF THE SAME SUBJECT) 1917/18
Pencil on paper, 50,1 x 32,5 cm,
(Strobl 2726), private collection;
courtesy Galerie St. Etienne, NY

**87**

RECLINING FEMALE NUDE WITH SPREAD LEGS (STUDY FOR "THE BRIDE") 1917/1918
Pencil on paper, 50 x 32,5 cm,
(Strobl 3083), Kunsthaus Zug, Stiftung Sammlung Kamm, Switzerland

# 3. KLIMT'S PERSONAL BELONGINGS

88

TIEN GUAN, THE GOD OF
GOOD FORTUNE, QING DYNASTY,
End of 19th century
Watercolor and gouache on paper,
170 x 91 cm, private collection
(Estate of Gustav Klimt)

89

GUANDI, THE GOD OF WEALTH,
WITH GUAN PING AND ZHON CANG,
QING DYNASTY End of 19th century
Watercolor and gouache on paper,
170 x 91 cm, private collection
(Estate of Gustav Klimt)

90

JOSEF HOFFMANN
(1831 VIENNA–1904 VIENNA):
COOKIE TIN WITH IVORY
HANDLE 1912
Presented by the Wiener Werkstätte
to Gustav Klimt to mark his 50th
birthday. Chased rolled silver, gilded,
height: 18,5 cm, private collection
(Estate of Gustav Klimt)

91

LUNG WITH CHU, QING DYNASTY,
18TH/19TH CENTURY
Gift from Gustav Klimt to Emilie
Flöge. Gold embroidery on silk,
130 x 80 cm, private collection
(Estate of Emilie Flöge)

92 AND 92A (LEFT)
JOSEF HOFFMANN
(1831 VIENNA–1904 VIENNA):
WALLET C. 1905
Snakeskin, 15,5 x 10 cm,
manufactured by the Wiener
Werkstätte, private collection
(Estate of Gustav Klimt)

92 AND 92 A (RIGHT)
JOSEF HOFFMANN
(1831 VIENNA–1904 VIENNA):
WALLET C. 1905
Red leather, 14,5 x 10 cm,
manufactured by the Wiener
Werkstätte, private collection
(Estate of Gustav Klimt)

93 (LEFT)
JOSEF HOFFMANN
(1831 VIENNA–1904 VIENNA):
CIGARETTE CASE C. 1905
Leather with gold embossing,
11,3 x 9,2 cm, manufactured by the
Wiener Werkstätte, private collection
(Estate of Gustav Klimt)

93 (RIGHT)
JOSEF HOFFMANN
(1831 VIENNA–1904 VIENNA):
WALLET C. 1905
Leather with gold embossing,
10,5 x 15 cm, manufactured by the
Wiener Werkstätte, private collection
(Estate of Gustav Klimt)

94

GUSTAV KLIMT'S PERSONAL
COFFEE SERVICE C. 1908
Cup, saucer, coffee pot, milk jug,
sugar bowl, manufactured by the
Porzellanhaus Ernst Wahliss, Vienna,
private collection
(Estate of Gustav Klimt)

95

GUSTAV KLIMT AND EMILIE FLÖGE
IN THE GARDEN OF THE
JOSEFSTÄDTERSTRASSE STUDIO 1909
Photogravure by Hans Böhler,
28,6 x 24,2 cm,
Lentos Kunstmuseum Linz

96

THE PAINTER'S SMOCK OWNED BY
KLIMT C.1903
Indigo blue Linen with white
embroidery, at shoulders 143 cm long,
Wien Museum, Vienna

# 4. KLIMT AND THE "TOTAL ARTWORK"

**97**

ERNST KLIMT
(1864 WIEN–1892 WIEN): POSTER
FOR A MUSIC AND THEATER EXHIBITION
AT THE K.K. PRATER, VIENNA 1892
Lithograph, printed by S. Czeiger,
Vienna, 64 x 86 cm,
MAK – Austrian Museum of Applied
Arts/Contemporary Art, Vienna

**98**

JOSEF MARIA OLBRICH
(1867 TROPPAU, TODAY OPAVA, CZECH
REPUBLIC–1908 DÜSSELDORF):
POSTER FOR THE FIRST EXHIBITION
OF THE VIENNA SECESSION 1898
Lithograph, printed by A. Berger,
Vienna, 81,4 x 51 cm,
MAK – Austrian Museum of Applied
Arts/Contemporary Art, Vienna

**99**

POSTER FOR THE FIRST EXHIBITION
OF THE VIENNA SECESSION
(UNCENSORED VERSION) 1898
Lithograph, printed by A. Berger,
Vienna, 64 x 46,5 cm,
MAK – Austrian Museum of Applied
Arts/Contemporary Art, Vienna

**100**

POSTER FOR THE FIRST EXHIBITION
OF THE VIENNA SECESSION
(CENSORED VERSION) 1898
Lithograph, printed by A. Berger,
Vienna, 64 x 46,5 cm
MAK – Austrian Museum of Applied
Arts/Contemporary Art, Vienna

**101**

ALFRED ROLLER (1864 BRÜNN,
AUSTRIA–1935 VIENNA): POSTER FOR
THE 14TH EXHIBITION OF THE VIENNA
SECESSION (BEETHOVEN) 1902
Lithograph, printed by A. Berger,
Vienna, 95,5 x 62.5 cm,
MAK – Austrian Museum of Applied
Arts/Contemporary Art, Vienna

**102**

POSTER FOR THE 18TH EXHIBITION
OF THE VIENNA SECESSION (GUSTAV
KLIMT) 1903
Lithograph, printed by A. Berger,
Vienna, 93,1 x 29 cm,
MAK – Austrian Museum of Applied
Arts/Contemporary Art, Vienna

**103 AND 104**

THE WIENER WERKSTÄTTE ROOM
Reconstruction of the Installation at
the "Kunstschau 1908."
Belvedere, Vienna, 2008/09

**103A AND 104A**

THE WIENER WERKSTÄTTE ROOM,
AS ORIGINALLY INSTALLED AT THE
"KUNSTSCHAU 1908"

**105**

CARL OTTO CZESCHKA
(1878 VIENNA–1960 HAMBURG):
LEATHER JEWELBOX WITH
INTARSIA 1908
Ernst Ploil, Vienna

**106**

CARL OTTO CZESCHKA
(1878 VIENNA–1960 HAMBURG):
HAMMERED AND GILDED COPPER
PANELS FOR THE SKODA VITRINE 1906
Ernst Ploil, Vienna

**107 A–D**

JOSEF HOFFMANN
(1831 VIENNA–1904 VIENNA):
FOUR BLUE GLASSES WITH
POLISHED SURFACE
Ernst Ploil, Vienna

**108**

JOSEF HOFFMANN
(1831 VIENNA–1904 VIENNA):
MARBLED CARDBOARD BOX FOR
THE WOODCUT SERIES "BEETHOVEN-
HOUSES" BY CARL MOLL 1902
Ernst Ploil, Vienna

**109**

JOSEF HOFFMANN
(1831 VIENNA–1904 VIENNA): BOX
MADE OF CROCODILE SKIN C. 1908
Ernst Ploil, Vienna

**110 A–D**

JOSEF HOFFMANN
(1831 VIENNA–1904 VIENNA):
SIX-PIECE TABLE SETTING FOR
THE "FLEDERMAUS" CAFÉ 1907
(Only four pieces are illustrated)
Ernst Ploil, Vienna

**111A AND 111B**

JOSEF HOFFMANN
(1831 VIENNA–1904 VIENNA):
BOX FOR PLAYING CARDS 1906
Crocodile skin,
Ernst Ploil, Vienna

**112**

JOSEF HOFFMANN
(1831 VIENNA–1904 VIENNA):
ALBUM 1907
Snakeskin,
Ernst Ploil, Vienna

**113**

JOSEF HOFFMANN
(1831 VIENNA–1904 VIENNA):
"THE REVELATION OF ST. JOHN" C. 1906
Frogskin,
Ernst Ploil, Vienna

114 A–F
JOSEF HOFFMANN
(1831 VIENNA–1904 VIENNA):
SIX "GITTERWERK" VESSELS
1905–07
White lacquered tin,
Ernst Ploil, Vienna

NOT ILLUSTRATED
JOSEF HOFFMANN
(1831 VIENNA–1904 VIENNA):
CIGAR BOX
Grey painted fishskin,
15 x 25 x 12 cm,
Ernst Ploil, Vienna

NOT ILLUSTRATED
JOSEF HOFFMANN
(1831 VIENNA–1904 VIENNA):
PHOTOGRAPH ALBUM FOR LILLI
WAERNDORFER
Yellow stained oxhide, 18 x 18 x 6 cm,
Ernst Ploil, Vienna

NOT ILLUSTRATED
JOSEF HOFFMANN
(1831 VIENNA–1904 VIENNA):
SIX BOTTLESTOPPERS WITH
CONTAINER
Silver and silver-plated alpacca,
35 x 8 x 14 cm,
Ernst Ploil, Vienna

NOT ILLUSTRATED
JOSEF HOFFMANN
(1831 VIENNA–1904 VIENNA):
NUT BOWL 1905
Silver, 8 x 8 cm,
Ernst Ploil, Vienna

115
BERTOLD LÖFFLER (1874 LOWER
ROSENTAL, BOHEMIA–1960 VIENNA):
SQUARE VASE C. 1909
Ernst Ploil, Vienna

116 A–C
BERTOLD LÖFFLER (1874 LOWER
ROSENTAL, BOHEMIA–1960 VIENNA):
THREE TUBULAR VASES:
WHITE BLUE AND YELLOW
Design c. 1903, Execution c. 1905
Ernst Ploil, Vienna

117 AND 117A
BERTOLD LÖFFLER (1874 LOWER
ROSENTAL, BOHEMIA–1960 VIENNA):
TWO VASES: BLUE AND YELLOW
c. 1906
Ernst Ploil, Vienna

NOT ILLUSTRATED
BERTOLD LÖFFLER (1874 LOWER
ROSENTAL, BOHEMIA–1960 VIENNA)
AND MICHAEL POWOLNY (1871 JUDEN-
BERG/STEIERMARK–1954 VIENNA):
CENTERPIECE
Ernst Ploil, Vienna

118 AND 118A
KOLOMAN MOSER
(1868 VIENNA–1918 VIENNA):
TWO SMALL BOXES 1905–06
Ernst Ploil, Vienna

NOT ILLUSTRATED
KOLOMAN MOSER
DECORATIVE FLOWERPOT FOR THE
STONBOROUGH-WITTGENSTEIN VIL-
LA 1904
White lacquered nickel-plated tin
alloy, 25 x 25 x 30 cm,
Ernst Ploil, Vienna

119 AND 119A
OTTO PRUTSCHER
(1880 VIENNA–1949 VIENNA):
GLASS VASE AND GLASS BOWL 1908
Crystal glass with gold paint,
Ernst Ploil, Vienna

120
POSTER ROOM
Reconstruction of the Installation
at the "Kunstschau 1908."
Belvedere, Vienna, 2008/09

120A
POSTER ROOM, AS ORIGNALLY IN-
STALLED AT THE "KUNSTSCHAU 1908"

121 TO 124 A–D
WIENER WERKSTÄTTE POSTCARDS
Detlef Hilmer, Munich

# 5. KLIMT'S INFLUENCE ON HIS CONTEMPORARIES

**125**

RICHARD GERSTL
(1883 WIEN–1908 WIEN):
PORTRAIT OF MATHILDE SCHÖNBERG
BEFORE THE SUMMER 1907
Tempera on canvas, 95 x 75 cm,
Belvedere, Vienna

**126**

MAXIMILIAN KURZWEIL
(1867 BISENZ, MORAVIA–
1916 VIENNA):
FEMALE NUDE IN FRONT
OF A MIRROR 1907
Oil on canvas, 88 x 69,5 cm,
Schütz Kunst & Antiquitäten, Vienna

**127**

KAROLA NAHOWSKA
(1877 WIEN–UNKNOWN):
PORTRAIT OF A LADY 1909
Oil on canvas, 50 x 50 cm,
Belvedere, Vienna

**128**

KOLOMAN MOSER
(1868 VIENNA–1918 VIENNA):
PORTRAIT OF A WOMAN
IN PROFILE C. 1910
Oil on canvas, 50 x 50 cm,
Belvedere, Vienna

**129**

MAXIMILIAN OPPENHEIMER
(1885 VIENNA–1954 NEW YORK):
HALF-LENGTH PORTRAIT OF ERNST
KOESSLER 1908
Oil on canvas, 86,5 x 75 cm,
Belvedere, Vienna

**130**

EGON SCHIELE (1890 TULLN,
LOWER AUSTRIA–1918 VIENNA):
MOTHER AND CHILD 1909/10
Oil on canvas, 57,7 x 50,7 cm,
courtesy Kunsthandel
Wienerroither & Kohlbacher, Vienna

**131**

KOLOMAN MOSER
(1868 VIENNA–1918 VIENNA):
BLOOMING SAPLING C. 1913
Oil on canvas, 50 x 50 cm,
Belvedere, Vienna

**132**

EGON SCHIELE (1890 TULLN,
LOWER AUSTRIA–1918 VIENNA):
TRIESTE FISHING BOAT 1912
Oil and pencil on canvas, 75 x 75 cm,
(Kallir P. 247), private collection;
courtesy Galerie St. Etienne, NY

**133**

KOLOMAN MOSER
(1868 VIENNA–1918 VIENNA):
THE BATHERS C. 1913–1914
Oil on canvas, 76 x 76 cm,
monogrammed bottom right,
Estate of Koloman Moser, Schütz
Kunst & Antiquitäten, Vienna

**134**

KOLOMAN MOSER
(1868 VIENNA–1918 VIENNA):
SELF-PORTRAIT WITH MERMAID 1914
Oil on canvas, 37,6 x 50,5 cm,
Schütz Kunst & Antiquitäten, Vienna

# 6. PHOTOGRAPHS

**135**
MARIA ZIMMERMANN WITH HER
SON GUSTAV C. 1903

**136**
INSIDE GUSTAV KLIMT'S STUDIO
AT FELDMÜHLGASSE 1917/18

**137**
GUSTAV KLIMT WITH A TELESCOPE
ON THE DOCK AT THE VILLA PAULICK
IN SEEWALCHEN AT ATTERSEE 1904
photograph, private collection

**138**
GUSTAV KLIMT IN A MOTORBOAT
ON THE ATTERSEE 1904

**139**
EMILIE FLÖGE IN A MOTORBOAT
ON THE NORTHSIDE OF THE
ATTERSEE 1904

**140**
GUSTAV KLIMT AND GERTRUDE
FLÖGE ON THE JETTY OF THE VILLA
PAULICK IN SEEWALCHEN ON THE
ATTERSEE, EASTER

**141**
GUSTAV KLIMT AND GERTRUDE
FLÖGE ON THE JETTY OF THE VILLA
PAULICK IN SEEWALCHEN Easter 1912

**142**
GUSTAV KLIMT AND FRIEDERIKE
BEER-MONTI IN WEISSENBACH ON
THE ATTERSEE 1916

Organized by ARTEG, Copenhagen, in cooperation with Österreichische Galerie Belvedere, Wien, MHHD, Seoul, and The Newspaper Dong-A Daily.

**belvedere**

M H D [주] 문화에이치디
Arts & Edutainment

This book has been published in conjunction with the exhibition Gustav Klimt – In Search of the "Total Artwork," held at Hangaram Art Museum, Seoul Arts Center, South Korea, from February 1 to May 15, 2009.

All essays, copyright © 2009, the authors.

The exhibition is curated and conceived by Jane Kallir, co-director of The Galerie St. Etienne, New York City, together with Dr. Alfred Weidinger, Vienna, and Teit Ritzau, Director of The Art Exhibit Group, Denmark.

Catalogue edited by Jane Kallir, with the cooperation of Alfred Weidinger.

Consultant for ARTEG: Professor Stephen Joh, Exhibition Coordinator, Seoul. The ARTEG team was headed by Vibeke Petersen, Curator and further supported by Katrine Møllehave, Michael Lillevang Andreasen and Mia Holm Kristensen.

Sponsored by:
MCST (Ministry of Culture, Sports and Tourism, Republic of Korea)
Seoul Metropolitan Government
Korea Tourism
The Austrian Embassy, Seoul
Swarovsky

Supported by:
Bundesministerium für Wissenschaft und Forschung, Wien
Bundesministerium für Auswärtige Angelegenheiten, Wien

© for design and layout by Prestel Verlag,
Munich · Berlin · London · New York 2009
© for illustrations see Picture Credits, page 239

The right of Jane Kallir to be identified as chief editor and Alfred Weidinger as co-editor of this work has been asserted in accordance with the Copyright, Designs and Patents act 1988.

Front cover: Judith I, detail see page 79
Back cover: Seated Woman, Resting, detail see page 112
Spine: Gustav Klimt – In Search of the "Total Artwork",
Hangaram Art Museum, Seoul Arts Center, South Korea, 2009

Frontispiece: Gustav Klimt in the garden of his Josefstädterstrasse studio, 1912/14
Page 4: Johanna Staude, detail see page 92
Page 10/11: Sonja Knips, detail see page 30
Page 12: Medicine, detail see page 44

Page 58: Promenade in Schloss Kammer Park, detail see page 89
Page 60: Beethoven Frieze (Middle Wall), detail see page 82
Page 96: Seated Semi-Nude, Facing Left, detail see page 115
Page 152: New Year's Print by Ru Sheng Han, China, c. 1900
(Estate of Gustav Klimt)
Page 164: Roses under Trees, detail see page 39
Page 206: Emilie Flöge, detail see page 33
Page 218: Inside Gustav Klimt's studio at Feldmühlgasse, 1917/18

Prestel Verlag
Königinstrasse 9
80539 Munich
Tel. +49 (0)89 24 29 08-300
Fax +49 (0)89 24 29 08-335
www.prestel.de

Prestel Publishing Ltd.
4 Bloomsbury Place
London WC1A 2QA
Tel. +44 (0)20 7323-5004
Fax +44 (0)20 7636-8004

Prestel Publishing
900 Broadway, Suite 603
New York, NY 10003
Tel. +1 (212) 995-2720
Fax +1 (212) 995-2733
www.prestel.com

Library of Congress Control Number: 2008944211
Cataloguing-in-Publication Data: a catalogue record for this book is available from the British Library; Deutsche Nationalbibliothek holds a record of this publication in the Deutsche Nationalbibliografie; detailed bibliographical data can be found under: http://dnb.ddb.de

Project management: Anja Besserer, in collaboration with Sabine Gottswinter
Translated from the German by: Jeffrey Wisdom, Munich
Text by Alfred Weidinger translated by: Ishbel Flett, Edinburgh
Edited/Copyedited by: Jane Michael, Munich
Production: Simone Zeeb
Art Direction: Cilly Klotz
Design and layout: Liquid Agentur für Gestaltung GBR, Augsburg
Cover design: SOFAROBOTNIK, Augsburg & Munich
Typesetting: Bernhard Schnüriger, bookwise medienproduktion gmbh, Munich
Origination: Lanarepro GmbH, Lana
Printed and bound in Korea by TRI VISION COMPANY

ISBN 978-3-7913-4232-0 (English trade edition)
ISBN 978-3-7913-6230-4 (English museum edition)
ISBN 978-3-7913-4231-3 (German trade edition)
ISBN 978-3-7913-6229-8 (German museum edition)
ISBN 978-3-7913-4233-7 (Korean edition)